# THE HANOK

# THE

## 도심 속에서 다른 삶을 짓다

# HANOK

## 더 한옥

### 행복이 가득한 집 편집부 지음

*design* **house**

# 한옥은 많은 답을
# 알고 있다

한옥이라는 단어에서 '한韓'은 '하나'라는 의미도 있지만 '한가득', '한 아름' 과 같이 '전체'라는 의미도 있다. 또한 '한가운데', '한낮'처럼 '정점'을 뜻하기도 한다. 하늘도 하나고 땅도 하나이며, 우주도 하나다. 하나에서 모든 것이 시작하고 모든 것이 하나인 사상은 고대부터 줄곧 동북아시아와 중앙아시아에 넓게 공유되었다. '옥屋'은 하늘에서 집 안으로 화살이 날아 와 박힌 모습을 표현한 글자다. 화살은 하늘의 기운을 땅에 전달하는 매개체로 조상이나 신을 집에 모시는 것을 상징적으로 묘사한 것이다. 두 한자의 의미를 결합하면 한옥은 '시작이면서 모든 것이기도 한 생명 정신을 담은 집'으로 이해할 수 있다. 너무 거창하게 들릴 수도 있지만 미지의 '우주'도 집이라는 뜻을 품은 단어다. 사람들에게 집은 우주이며, 시작이면서 모든 것이다.

집은 '생활을 담는 그릇'으로 종종 묘사되지만 '나의 생활을 닮은 그릇'이기도 하다. 같은 음식도 그릇의 형태나 재료에 따라 음식을 담는 양과 온도가 변화하고 색감이 달라지면서 음식의 맛 역시 달라진다. 아파트라는 그릇에 담긴 생활과 한옥에 담긴 생활은 비슷한 일상이라고 하더라도 전혀 다른 맛이 난다. 수많은 요구를 수용해서 변화해 온 아파트와 비교해서 한옥이라는 그릇은 무엇이 다른 것일까?

우선 50년 된 아파트를 상상하면 낡았다는 생각이 들지만 80년 된 한옥은

멋지다는 생각이 든다. 시간을 더할수록 가치를 더하는 것이 클래식, 즉 전통의 힘이다. 세월을 함께할 수 있는 재료는 삶의 흔적을 켜켜이 담을 수 있다. 마감재의 디테일 역시 간결한 선을 우선하기보다 각 재료가 가지고 있는 특성을 오랫동안 지탱할 수 있는 방식으로 접근한다면 좀 더 깊은 맛이 나는 집을 만들 수 있다. 한옥에 쓰이는 나무, 흙, 한지, 기와 등의 재료와 공예적인 집 짓기는 시간이 지날수록 깊은 맛을 낸다. 이것을 '시간의 촉감'이라고 말하고 싶다. 시간의 촉감은 한옥이라는, 일상을 담는 그릇을 특별하게 만든다.

두 번째로 도시에 살면 거의 대부분의 시간을 건물 내부에서 보내게 되는데 외부 공간에서 보내는 시간의 결핍은 몸과 마음에 부정적인 영향을 준다. 짧은 점심시간에 밖으로 나오면 숨이 편안히 쉬어지는 것도 그 때문이다. 하지만 집 마당과 같은 사적인 외부 공간은 공원과 같은 공적인 외부 공간과는 쓰임이 다를 뿐만 아니라 심적인 면에서도 다르다. 집 마당에서는 닫힌 공간에서의 답답함을 해소할 수 있고, 복잡한 머릿속을 비울 수도 있다. 동시에 조그만 정원을 가꾸거나 바깥 공기를 느끼며 취미 활동을 할 수도 있어 집에서 할 수 있는 활동을 다양하게 만들어 준다. 한옥에서 매우 중요한 공간 구조의 특징은 내부 공간과 외부 공간이 톱니바퀴처럼 서로 맞물려 있다는 것이다. 안마당, 뒷마당, 사랑 마당, 행랑 마당 등 다양한 마당은 내외부가 교차된 풍경을 만든다. 계절과 날씨를 느끼고 아침과 밤을 느낄 수 있는 집은 내 몸과 마음이 하늘과 땅에 연결되어 있음을 저절로 느끼게 해 준다. 너무나도 당연한 이 사실이 특별하게 여겨지는 것에서 한옥이 가진 보편적 가치가 있다.

한옥의 규모를 이야기할 때 몇 칸 집이라는 표현을 쓴다. 칸間은 기둥과 기둥 사이의 공간을 기본 단위로 표현한 것으로, 초가삼간은 볏짚을 엮은 지붕에 방 한 칸, 마루 한 칸, 주방 한 칸으로 구성된 최소한의 집을 말한다. 칸은 용도에 따라 자유롭게 벽이나 창을 설치하여 내부 공간으로 만들 수도 있고, 대청마루와 같이 벽을 없애 내부와 외부가 교차된 공간으로도 만들 수 있으며, 바닥의 높이를 낮추어 아케이드와 같은 통로로 사용할 수도 있다. 동궐도형東闕圖形이라는 창덕궁을 그린 도면을 보면 칸에는 방, 청, 누, 고, 측, 문, 랑 등 다양한 용도를 적은 한자가 적혀 있다. 칸은 구조적으로 동일하지만 벽과 바닥의 변화에 따라 공간의 용도

와 기능, 내부와 외부를 쉽게 바꿀 수 있는 것이다. 칸의 가변성은 근대 공간 개념인 공간의 유연성과 공통적 속성을 가지고 있다. 이것은 오늘날까지 한옥의 생명력을 유지할 수 있는 중요한 바탕이 된다. 칸의 가변성은 개인의 라이프스타일에 맞는 다양한 해석을 통해 앞으로 더욱 한옥의 가치를 높일 것이다.

요즘 기후 위기를 실감하고 있다. 집은 기후 위기에 우리가 대응할 수 있는 진정한 시작점이다. 집을 짓거나 고치면서 처음 하는 고민이 '어떻게 집이 숨을 쉬게 만들지?'라면 어떨까? 너무나도 당연한 이런 생각이 불행히도 현재는 당연한 것이 아니다. 생명 건축은 생명이라는 것을 전제로 주변 장소의 목소리를 듣는 건축이다. 태양은 어느 방향에서 뜨는지, 가장 멀리 보이는 풍경은 무엇인지, 바람의 방향은 어떤지, 집 깊숙이 빛이 들어올 수 있는 적절한 창은 어떤지 등을 헤아리며 만든 집은 외부와 단절되지 않는다. 이런 질문에 한옥은 이미 많은 답을 알고 있다. 살아 있는 것은 변화한다. 이 책에 소개된, 오래됨을 바탕으로 한 새로운 한옥에 대한 시도들은 우리의 일상을 비출 수 있는 거울이 될 것이고, 과거와 미래를 연결해서 현재를 튼튼히 지지하는 미의식의 바탕이 될 것이다.

2023년 10월
김대균

---

### 김대균

건축사무소 '착착 스튜디오' 대표. 한국예술종합학교 건축과 전문사를 졸업한 뒤 현재 파주타이포그라피배곳에 출강 중이다. 대표적인 프로젝트로는 '천주교 서울대교구 역사관', '이상의 집 레노베이션', '해남 유선관', '하우스비전 재배의 집', '풍년빌라' 등이 있다.

# 차례

취향대로 고쳐 사는 옛집

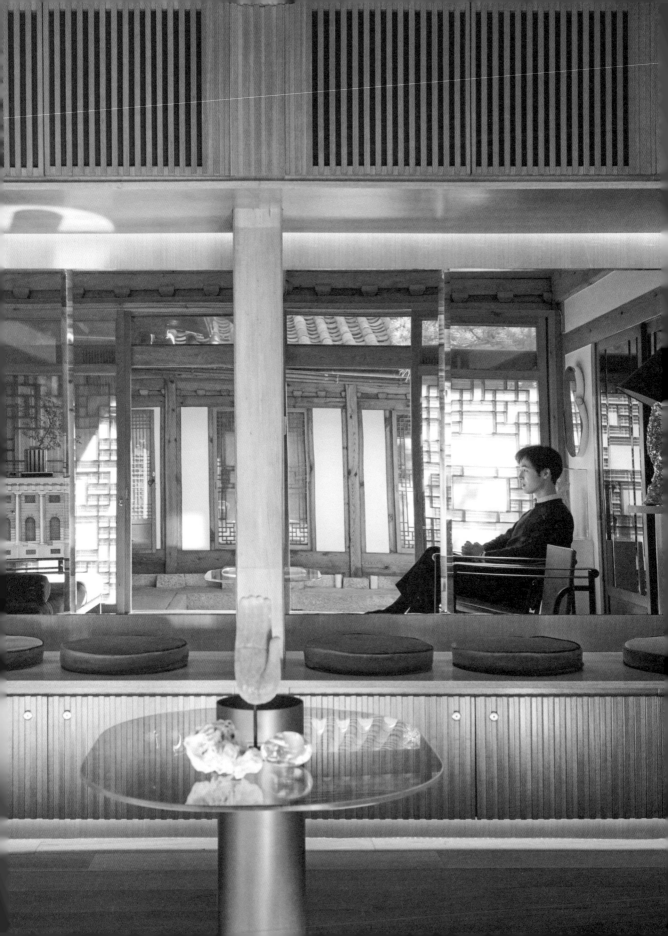

# 한옥에 살며 비로소 눈뜬 것들

---

디자이너에게도 팬덤이 필요한 시대. 방송에 잘 나오는 스타 셰프가 있듯 라이프스타일 분야에서도 자신을 스스로 프로모션하는 디자이너가 있다는 것은 분명 두 팔 벌려 환영할 일이다. 미디어의 숱한 러브콜을 받으며 국내외 다양한 브랜드와 협업을 이끌어 내고, 셀럽의 공간을 디자인하다 스스로 '셀럽'이 된 디자이너. 이제 '양태오'라는 이름 뒤에 가려진 진짜를 봐야 할 때다.

알레산드로 멘디니, 재스퍼 모리슨, 부홀렉 형제⋯. 모두 한국의 기업과 일을 한 적이 있는 스타 디자이너다. 디자이너의 명성은 곧바로 비즈니스와 연결된다. 현대 디자이너의 덕목 중 자신의 재능을 프레젠테이션하는 능력, 즉 셀프 프로모션이 중요한 이유다. 하지만 한국은 유독 라이프스타일 분야에서 자신을 드러낼 줄 아는 디자이너가 많지 않다. 그렇기에 디자이너 양태오의 등장은 존재 자체로 신선한 이슈였으며, 그의 작업과 행보는 늘 주목의 대상이었다. 물론 관심의 깊이만큼 다소 삐딱한 시선도 있다. '금수저다, 연예인 병에 걸렸다, 럭셔리 인테리어만 한다⋯.' 이번 만남은 그런 삐딱한 시선에 대한 반문으로 시작했다.

### 한옥에 지금의 생활을 담으려면?

계동 골목길. 나무 대문을 밀고 들어서면 작은 정원을 품고 있는 ㅁ 자 모

양의 한옥이 눈에 들어온다. 능소화와 소나무 한 그
루가 있어 능소헌과 청송재라 이름 지은 한옥. 건축
가 김영섭 선생이 해외로 떠나면서 새 주인이 된 디
자이너 양태오는 10년 전 100살 된 한옥을 '모던 한
옥'으로 근사하게 탈바꿈했다. 능소헌과 청송재는 두
채의 아담한 고택이 나란히 연결된 형태로 능소헌은
사무실 겸 생활 공간으로, 청송재는 미국에 오가는
부모님이 머무는 공간이자 지인들을 위한 게스트하
우스로 사용한다.

먼저 능소헌의 주거 공간을 살펴보면, 줄리언
오피의 그림이 걸린 현관 왼편으로는 주방과 다이닝
룸이, 오른편엔 리빙룸이 자리한다. 모던한 벽난로 앞
에 한스 베그네르 소파와 장 프루베 의자가 자리한
리빙룸 안쪽으로 침실과 사무실이 이어지는 구조다.
리빙룸과 다이닝룸 모두 창문의 창호지를 떼고 통유
리를 넣어 중정의 풍경을 감상할 수 있다. "집이 소개
되면서 한옥을 망쳤다는 이야기를 종종 들었어요. 하
지만 이 집은 조선 시대 후기, 지금의 아파트 개념과
비슷하게 만든 보급형 한옥이에요. 고택이나 박물관
이 아니기에 잘 보존하는 것보다 현대인의 삶에 맞춰
함께 살아가는 한옥을 만드는 일이 중요했죠."

한옥은 생활하기에 불편하지 않고 현대인의
취향과 라이프스타일을 멋스럽게 담아낼 수 있다. 라
이프스타일 매거진《행복이 가득한 집》에서 북촌 일
대 한옥을 오픈 하우스 형식으로 전시하는 행사인 '행
복작당'의 관람객에게 기꺼이 대문을 열어 준 뒤 양태
오 디자이너는 한옥에 대한 독자들의 관심과 열망이
크다는 것에 감동했고, 그런 관심을 이끌어 내는 일

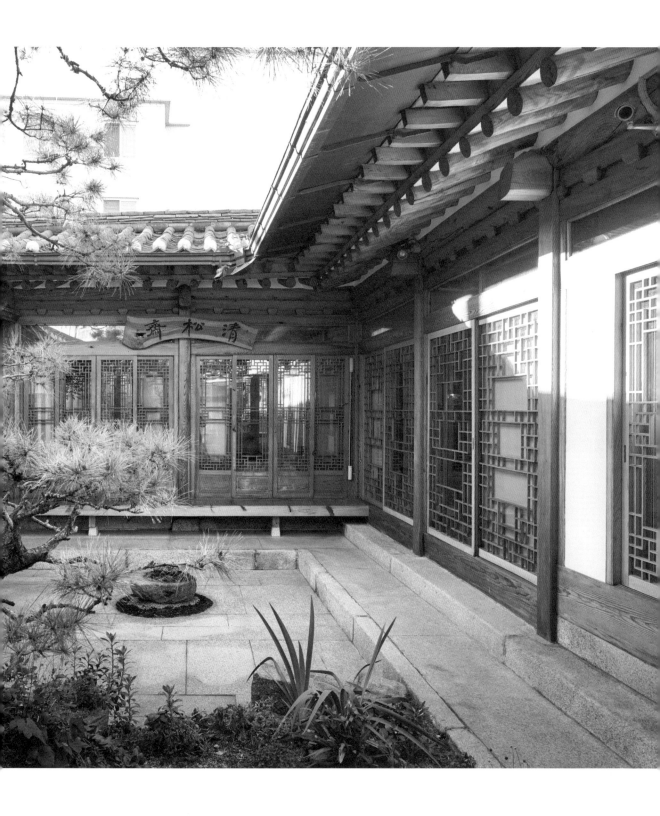

중정에 소나무가 있어 청송재라 부르는 ㅁ 자 한옥. 나란히 자리
한 능소헌과 미로처럼 연결되는 동선이 재밌다.

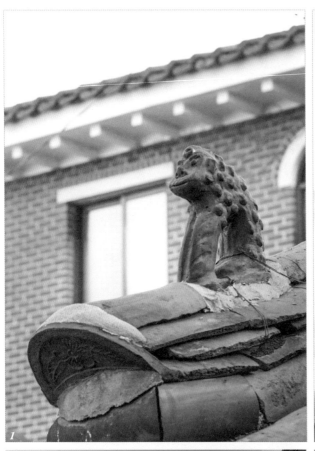

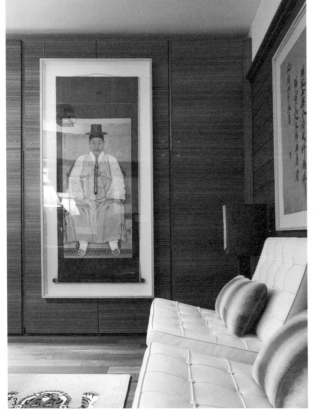

역시 디자이너의 역할이라는 점을 깨달았다. 그래서 청송재를 외국인을 위한 게스트하우스로 다시 레노베이션했다. 실제 외국 손님들은 그의 집을 자주 찾았다. 어맨다 사이프리드가 도자를 사러 태오홈 쇼룸에 방문했고, 톰 브라운이 내한했을 때 능소헌을 빌려서 디너 파티를 했다. 마사 스튜어트도 그의 집을 보고 한옥의 아름다움을 극찬했으니, 한국 문화를 알리는 데 한국의 의식주를 담은 '한옥'만큼 중요한 아이콘이 또 있을까? 당시의 레노베이션은 외국인이 한옥을 경험한다면 어떤 점을 보여 주고 또 어떤 점을 개선해야 할지 고민한 결과다. 한옥에 대한 외국인의 호감은 무척 높지만, 좌식에 대한 부담감으로 호텔을 선택하곤 한다.

청송재는 능소헌과 마찬가지로 입식 공간이 주를 이룬다. 사랑채는 직접 디자인한 콘솔을 중심으로 원목 테이블을 배치해 티룸으로 꾸몄다. 안채 대청에는 직접 디자인한 벤치형 소파와 르코르뷔지에의 라운지체어를 두고, 골드 빛이 도는 흑경으로 마감해 우아하면서도 신비로운 느낌을 자아낸다. 거울을 열면 안쪽으로 침실이 나타나는데, 널찍한 침대와 책상 등 북유럽 빈티지 가구와 패브릭 요소가 어우러져 한눈에 봐도 편안한 느낌이다. 맞은편 별채 침실은 화장실 디자인이 백미다. 옷장인 줄 알고 턱 열었는데 아주 고급스러운 욕실이 짠 나타난다면? 마치 워크인 클로짓처럼 마감해 나무 문을 열고 불을 켜야 비로소 그 안이 화장실임을 알 수 있다.

"거울은 굉장히 오래된 소재이면서 가장 모던한 소재인 만큼 한옥에 매치하면 재미있을 것 같았어요. 인테리어에는 환상이 존재해야 한다고 생각해요. 거울이 많은 공간은 초를 하나 켜는 것만으로도 그 공간에 특별함을 부여할 수 있죠."

1   기와 지붕 추녀마루마다 잡상이 놓여 있다.
2   도자야말로 동양 예술의 꽃이라 말하는 양태오 디자이너.
    모던한 철제 랙에 토분을 장식한 감각이 돋보인다.
3   물건은 언제나 영감의 원천! 집안의 가보로 내려오는 초상
    화는 고종 황제의 어진을 그린 채용신 화백의 작품이다.
4   능소헌의 지하층 계단 입구에는 세계 곳곳에서 모은 컬렉션
    이 자리한다.

## 럭셔리 브랜드를 편애한다?

그는 2016년 DDP에서 열린 포르나세티 특별 전시의 VIP 오프닝 사회를 맡았다. 같은 해 바카라 코리아와의 친분으로 프랑스의 바카라 샤토에 초대받아 한 방송사 프로그램에 소개되었고, 영국 사보이어 베드와 협업해 스페셜 에디션을 제작하기도 했다. 이쯤 되면 해외 명품 브랜드를 편애한다는 얘기를 들을 법도 하다.

"학부 때 소더비에 견학을 갔는데, 경매 제품 중 하나가 지오 폰티가 만든 포르나세티 가구였어요. 제가 막연히 생각한 유럽의 아름다움이 마치 예술 작품처럼 가구에 녹아들어 있었죠. 정확히 말하면 럭셔리가 아닌 타임리스에 대한 동경이에요. 학부 때 과제물이 한 학기만 지나도 촌스럽고 형편없어 보이는 게 싫었어요. 수백 년간 하나의 목소리로 가치와 철학을 이어 온 브랜드에 대한 존경심이랄까요? 혼이 담긴 제품을 마주할 때면 저 역시 좋은 기운을 얻죠."

양태오 디자이너는 옛 문화에 대한 경외심이야말로 창조의 바탕이 된다고 강조한다. 어릴 때부터 오래된 물건에 대한 관심이 유독 많았던 그다. 능소헌 지붕 위에 얹은 잡상은 무려 중학교 때 컬렉션한 것으로 아파트에 살 때는 방문 앞에 살포시 두었단다. 시카고 미술대학 재학 시절, 부전공으로 동양 미술사를 듣고 도자의 매력에 빠졌다. 집이 그리울 때면 시카고 미술관 아시아관을 찾곤 했는데, 고려청자와 조선 달항아리 사이에서 우연히 시노 타이 도자가 눈에 띄었다. 중국 도자가 태국에 전해져 금테를 두르고 코끼리 살가죽을 표현하기 위해 크랙을 넣는 등 그들만의 시각으로 해석한 시노 타이 도자에 매료됐다. 그리고 10년 후 태국을 여행하면서 다시 만난 시노 타이 도자는 양태오 디자이너의 리빙 제품을 선보이는 태오홈의 모태가 된다.

"저희 태오홈에는 가상의 인물이 있어요. 1920년대 상하이에서 자란 유럽 부호의 아들이죠. 만약 그가 이 태국의 도자를 봤다면 어떤 느낌을 가미했을까? 몽골의 품질 좋은 캐시미어를 발견하고 이를 어떻게 활용할까? 태국 도자에 베네치아, 바티칸 문양을 덧입히고 갓을 달아 스탠드로 변형하거나 몽골산 캐시미어로 담요를 만들고, 인도의 소뼈로 수납 박스를 만드는 등 이질적 문화, 시간이 중첩되어 탄생한 제품이 바로 태오홈의 리빙 아트워크죠."

시간의 테이스트를 견뎌 낸 것에서 많은 영감을 얻는다는 양태오 디자이너.

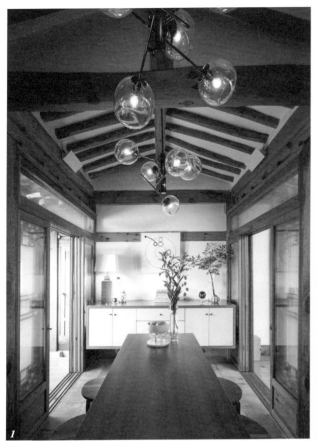

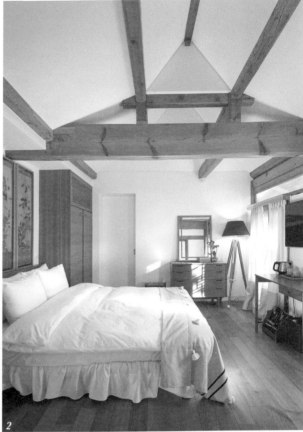

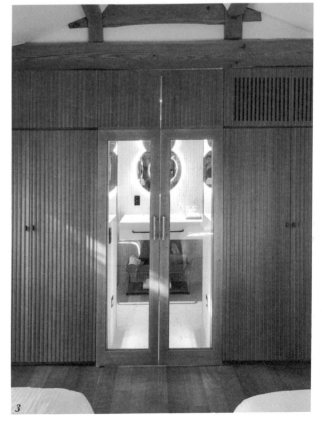

1   청송재 사랑채에 작은 티룸을 꾸몄다. 한옥과 조화를 이루
    는 콘솔은 양태오 디자이너가 직접 디자인하고 제작했다.
    스웨이드로 마감해 모던하면서도 우아한 멋을 풍긴다.
2   외국인도 편안하게 머물 수 있도록 침대, 책상 등 입식 가구
    로 꾸민 침실. 서까래 일부와 박공 구조를 살려 답답하지 않
    고 개방감이 느껴진다. 안쪽에 작은 욕실을 구성했다.
3   청송재 별채 침실의 옷장 문을 열면 화장실이 나타난다. 워
    크인 클로짓 형태의 욕실 디자인이 감각적이다.

주거 공간 능소헌에는 지하층이 있어 AV룸으로 활용한다. 자연을 볼 수 없어 아쉽지만 디자인적으로 가장 마음에 드는 공간이다.

세계 곳곳에서 모은 컬렉션도 자리해 놓은 이곳은 늘 최상의 휴식을 취하도록 완벽한 상태로 정리 정돈되어 있다.

1905년 출시해 영국 왕실에서 사용하는 사보이어 베드와 협업할 때의 목표는 유럽 최고의 침대에 아시아 시장에 대한 이해와 아시아의 미감을 불어넣는 것이었다. 더불어 컨템퍼러리 호텔에서도 환영하는 아방가르드한 디자인을 구현하기 위해 한국의 '달'에서 모티프를 얻었다. "잠 문화와 관련해 동서양의 가장 큰 차이가 뭘까 생각했을 때 달이 떠올랐죠. 서양에서 달은 불길한 의미를 상징할 때가 많지만 아시아에서 달은 포용을 의미해요. 보름달이 뜨면 강강수월래를 추며 환영했고, 걱정되는 일이 있으면 정화수를 떠 놓고 기도를 드렸어요. 디자인을 통해 서로 다른 문화를 융합하는 일은 정말 짜릿해요."

## 지원보다 든든한 믿음

리빙 브랜드뿐 아니라 화장품 브랜드 오휘와의 협업 등 그 많은 스케줄을 소화해 내는 비결은 프로젝트와 비즈니스의 완벽한 분리다. 사실 외국은 디자이너는 디자인에만 치중할 수 있도록 에이전시 시스템이 잘 구축되어 있다. 디자인 팀에 홍보 전문가가 따로 있어 프로젝트를 진행하면서 돈 문제를 얘기할 필요도 없고, 홍보 방향을 정하는 것 역시 가이드라인이 명확하다. 예전에는 스튜디오를 운영하며 온종일 전화만 받는 날도 많았다는 양태오 디자이너. 뻔한 말처럼 들릴 수 있지만 오로지 디자인만 하고 싶어 소속사를 둔 뒤로는 컴퓨터 앞에 앉아 있는 것이 너무 행복하다.

태오양 스튜디오는 롯데월드타워 123층 라운지와 중국 베이징 한국문화원 VIP 접견실을 디자인했다. 청송재 게스트하우스를 레노베이션하면서 프로젝트와 상관없이 자신의 이름을 건 짜맞춤 가구도 선보였다. 태오홈 리빙 제품 중 '비스포크' 시리즈는 중요한 의미가 있다.

"가족의 히스토리를 만드는 데 가장 쉬운 방법이 일상 소품을 이용하는 것이에요. 어릴 때 엄마가 식탁 위에 깔던 매트에 나의 이니셜이 새겨져 있다면, 그 기억은 영원할 거예요. 엄마가 아이에게 그 매트를 물려주면, 그것은 곧 가족의 역사가 되겠죠. 저 역시 어머니의 영향을 많이 받았어요. 하굣길에 어머니를 따라 인사동에 오래된 물건을 보러 다니고, 갤러리에 그림 보러 다니던 일이 일상이었죠. 주말이면 어머니와 함께 가구 배치를 바꿨고요."

양태오 디자이너를 이야기할 때 부모의 든든한 지원을 빼놓을 수 없다. 이는 단순히 경제적 원조나 맹목적 보살핌과는 다르다. 부모님은 언제나 곁에서 조용히 응원할 뿐 어린 시절부터 배우고 싶은 것, 하고 싶은 것, 직장을 구하는 일 모두 스스로 결정하게끔 했다. 물론 이런 관계에는 무한한 신뢰가 전제되어야 한다. 압구정동 아파트에서 평창동 주택으로, 계동 한옥까지 늘 아들의 첫 번째 클라이언트가 되어 준 부모님. 취향 좋은 어머니가 디자인을 꿈꿀 수 있게 했다면, 건축 사업을 하는 아버지는 언제나 실리적 조언을 하는 선배다.

"일을 시작했을 때는 단순히 예쁜 공간을 만드는 것에 치중했다면, 이제는 디자이너로서 책임 의식을 느껴요. 그래서 사회적으로 공헌할 수 있는 일에 최대한 참여하려고 노력하죠. 망향휴게소 시설 개선 프로젝트는 많은 사람이 이용하는 고속도로 휴게실을 호텔 수준의 명품 화장실로 탈바꿈하는 것이 미션이었죠. 지역 자연환경을 실내에 최대한 끌어들이고, 전통 한옥 디테일을 적용했어요. '인테리어'가 작게는 누군가의 취향에서 시작해 한 가족의 삶, 기업의 문제까지 해결할 수 있는 도구가 될 수 있다는 걸 많이 실감하게 됐어요."

## 나만의 세계를 만들어 주는 곳

한옥에서 살게 된 이후 참 많은 일을 하고, 많은 것을 배울 수 있었다. 한옥에 살다 보니 모임에서도, 학생들을 가르치는 수업 시간에도 한옥에 대한 질문을 많이 받았다. 그래서 사람들이 왜 한옥을 좋아하는지, 한옥이 21세기 힐링 아이콘으로 떠오른 이유가 무엇인지 진지하게 고민하기 시작했다. "한옥에서는 '집'이라는 말이 주는 의미를 충실히 느끼면서 살아요. 계동 골목이 복작복작하잖아요. 한옥 문을 닫고 들어오는 순간 나만의 시간, 나만의 세계가 되죠."

한옥은 건축학적 요소를 제대로 갖춘 집이다. 아무리 평범한 한옥일지라도 공간 구성과 건축 요소가 유명 건축가가 지은 웬만한 현대 건축물보다 우수하다. 하늘이 보이고 땅을 밟을 수 있는 자연과 가장 가까운 집이면서 창과 문이 차지하는 비중이 높아 집 안팎의 구분을 개방적으로 확장시킨다. 마당과 대청은 열려 있어 사고를 유연하게 만들고, 대신 방은 아주 내밀해 꽤나 사적인 적막을 즐길 수 있다. 양태오 디자이너가 주거와 사무 공간을 겸하며, 일에 더 집중할 수 있는 비

결이다.

"기본적으로 사람들이 쉽게 반응할 수 있는 공간의 언어들이 있어요. 좁았다 넓어지고, 어두웠다 밝아지고, 높았다 낮아지고, 낮은 데서 높아지고…. 그러한 일상의 건축 언어를 정말 잘 차용한 집이 바로 한옥이라는 생각이 들어요. 좁은 문을 통해 들어오면 큰 마당이 펼쳐져 먼저 자신을 낮추고, 작은 방에서 트인 대청으로 나가면 어깨가 절로 펴지니까요. 예전에는 디자인을 하면서 좀 더 다르게, 좀 더 잘하고 싶었다면 요즘은 그런 마음을 많이 털어 낸 것 같아요."

물건이 놓이는 것에 따라 다른 에너지를 경험할 수 있는 집, 늘 질문하는 집. 한옥을 다시 주목해야 할 이유가 바로 여기에 있다. 겉으로는 화려해 보이지만 들어서는 순간 나 자신을 최대한 낮출 수 있는 곳, 우아함과 실용성이 조화롭게 어우러진 균형의 미학. 이것이 한옥의 매력이자 디자이너 양태오가 표현하고픈 공간의 진짜 언어다.

# 계동 골목에서 인생을 굽다

햇살 같은 웃음으로 전국구 로컬 빵집의 부드러운 카리스마를 보여 주는 이성당 김현
주 대표 부부가 서울 계동 골목길에 작은 한옥을 마련했다. 겉모습은 소박하되, 들여
다볼수록 기품 있는 내공이 느껴지는 집. 둥글넓적한 이성당의 단팥빵처럼 담백하면
서도 깊은 풍미가 느껴지는 그곳에서 또 어떤 일이 펼쳐질까?

장면 1. 대구에 사는 A 씨의 집에는 한 달에 한 번 택배 상자가 도착한다. 멀
리 군산에서 온 노란 상자를 열면 먹음직스러운 빵이 한가득 들어 있다. 쌀과 물,
소금, 소량의 설탕을 넣어 만든 신기한 이 빵은 10년을 먹어도 질리지 않는다. 장
면 2. 생선 가게 사장님은 매일 새벽 일터보다 먼저 찾는 곳이 있다. 하루도 빼놓
지 않고 제빵사와 함께 출근 도장을 찍으니, 단골 빵집의 모닝커피와 빵 한 조각
은 그에게 따뜻한 집밥과 다름없다. 장면 3. 대체 빵이 뭐길래! 비가 와도, 줄을 오
래 서도 그냥 지나칠 수 없다. 혹여나 빵이 떨어질까 마음이 조마조마하다.

군산의 명소 이성당 빵집에서 매일같이 펼쳐지는 일들이다. 78년 전통의 이
성당은 국내에 현존하는 빵집 중 가장 오래된 곳으로 유명하다. 특히 야채빵과 단
팥빵은 하루에 많으면 1만 개씩 팔릴 정도로 인기가 높다. 사람들이 너도나도 몰
려 주말에는 기본 30분 이상 줄 서는 경우도 많다. 김현주 대표는 노란 이성당 봉

부엌에서 바라본 거실. 거실 너머 왼쪽으로 침실, 오른쪽에 드레스
룸이 자리한다. 편안하고 쾌적한 호텔 콘셉트의 집을 완성하기 위
해 화이트 컬러, 내추럴한 패브릭과 나무 소재를 최대한 활용했다.
거실 소파는 고재로 프레임을 제작하고, 시트와 쿠션을 화이트 리
넨 원단으로 맞춤 제작했다.

투의 물결을 볼 때마다 감사하면서도 한편으로는 마음이 무거워지곤 했단다. "10년 넘게 대구에서 매해 1년 치 빵값을 미리 지불하고 '블루빵'을 받아 드시는 손님이 계세요. 언젠가는 빵을 선물할 일이 있는데 이성당의 오랜 역사를 적어 넣어 주면 어떻겠냐며, 편지를 써서 보내 주셨어요. 저희도 미처 생각지 못한 이성당의 역사를 그분이 정리해 주신 셈이죠."

본래 군산은 서해의 대표적 개항지로 일제 강점기에 일본인이 많이 거주했다. 서양에서 제빵 기술을 배워 온 일본인이 너도나도 군산에 빵집을 냈고 그중 가장 유명한 가게가 '이즈모야'였다(《빵의 백년사》에 기록). 고 이석우 씨가 광복 직후 이즈모야를 인수해 이성당으로 바꾼 뒤 이종사촌인 조천형 씨가 물려받았다. 조천형 씨의 아들 조성용 씨는 1980년대 초 이성당을 물려받지만, 이내 어머니와 아내에게 가게 운영을 맡기고 팥소를 전문으로 생산하는 대두식품을 창업했다. 2003년 조성용 씨의 아내 김현주 씨가 이성당의 3대 사장으로 취임했고, 2006년부터 밀가루 대신 쌀로 빵을 만들면서 이성당은 전국적으로 주목받기 시작했다. 우리 쌀로 만든 웰빙 빵, 쌀빵의 시작이 바로 '블루빵'이다. 단순히 빵을 먹는 행위를 넘어 그 빵에 깃든 기억을 맛보고 싶은 고객의 마음에 응답하기 위해, 눈이 오나 비가 오나 빵을 찾아온 전국구 손님들이 잠시라도 쉬어 갈 수 있게, 붐비는 시간을 피해 새벽이나 밤늦게 찾는 단골손님이 부담 없이 들를 수 있도록…. 이성당 서울 매장에 이어, 2016년 겨울에 오

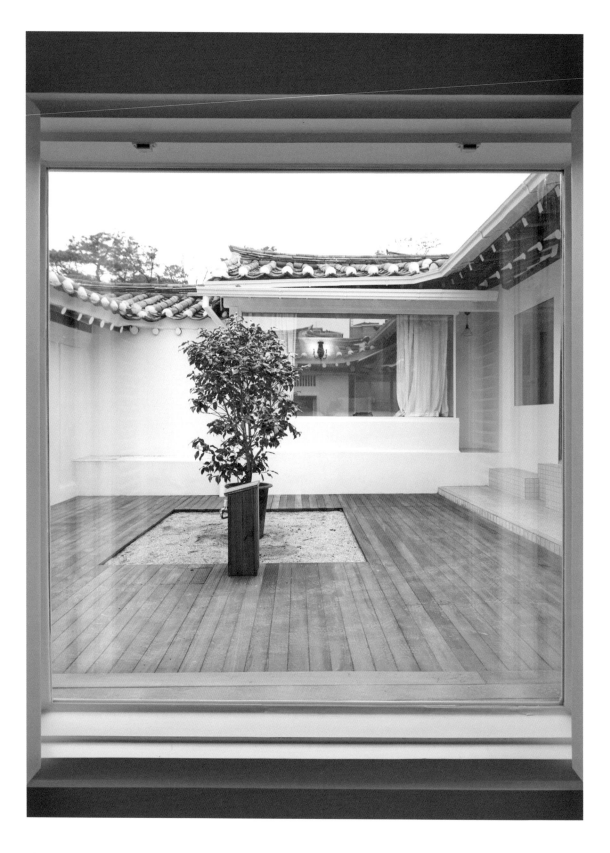

역 ㄷ 자 구조의 한옥에 별채가 붙어 ㅁ 자 형태를 띠는 작은 한옥
으로 마당에 덱을 깔고 정사각형의 작은 화단을 마련했다.

픈한 이성당 신관은 고마우면서도 죄송스러운 복합적 감정이 응집된 결정체라 할 수 있다.

## 단출하게, 시간을 담아 가는 생활

이성당 서울 매장을 오픈하며 서울과 군산을 오가는 일이 잦아진 김 대표는 작은 한옥을 개조해 세컨드 하우스를 마련했다. 물나무사진관에 가기 위해 우연히 찾은 계동 골목에서 만난 집. 군산에서 보낸 어린 시절을 떠올리게 하는 계동의 고즈넉함이 좋았고, 관리하기 편한 자그마한 집이라는 점이 마음에 들었다.

"시집와서 어머니와 함께 이성당을 맡았는데, 장사가 잘되는 게 마냥 좋지만은 않더라고요. 처음 보는 사람한테 '어서 오세요, 안녕히 가세요' 하고 인사를 건네야 하는데, 그게 왜 그렇게 힘들었던지…. 그때부터 지금까지 직원들이 먹을 된장, 고추장, 간장, 김치는 모두 이성당에서 직접 담그는데, 늘 해 왔던 그런 과정이 바로 지금의 이성당을 있게 한 것 같다는 생각이 들어요. 30년 정도 지나니까 이성당을 생각하면 울컥울컥하고요. 아, 어머니가 그랬듯 이제 나도 자리를 내줘야 할 때가 왔구나! 그때 이 집을 만났어요."

단출하고 홀가분하게 생활할 수 있는 작은 한옥은 평생 큰살림을 해 온 김 대표에게 안식처가 되기에 충분했다. 고요하고, 절도 있고, 정돈된 삶이 가능하기 때문이다. 작은 공간에서 우아하고 편리하게 살기 위해서는 영리한 구성이 필요할 터. 이성당 서울 프로젝트에 이어 한옥 레노베이션을 맡은 신경옥 디자이너는 '언제, 누가 와도 편안하게 쉬다 갈 수 있는 공간'을 디자인 콘셉트로 잡았다. "호텔 객실에서도 얼마든지 영감을 받을 수 있죠. 집에는 작은 부엌과 세탁 공간이 추가될 뿐! 빳빳한 시트가 깔린 침대, 탁자와 의자 두 개, 서랍 속에 필기도구가 약간 들어 있는 책상, 조명등, 비누와 샴푸, 하얀 타월이 있는 욕실이면 충분하잖아요? 가끔 오는 집이지만 아무것도 빠진 것이 없도록, 그러면서도 아무것도 넘치지 않도록 구성하는 게 중요했어요."

대문에서 바라봤을 때 역 ㄷ 자형 구조의 한옥은 정면에 주방과 거실이 있고, 왼편으로 드레스룸과 침실이 이어지는 구조. 침실에서 단 차이가 나는 욕실은 원래 따로 떨어져 있던 별채를 연결하기 위한 브리지로 메인 침실과 화장실, 게스

트룸으로 이어지는 재미있는 동선을 완성한다. 또한 작은 집 개조 전문가이자 주부로서 살림 내공을 드러내는 디자이너의 아이디어도 곳곳에서 엿볼 수 있다. "내가 이곳에 살면 뭐가 필요하고, 뭐가 필요 없을까를 생각하면 아주 쉬워요. 필요한 부분은 과감히 확장하고, 필요 없는 부분은 막아 동선과 시선을 정리하면 디자인의 반은 해결되죠."

한옥이라고 해서 군이 좌식 생활을 고집하고 싶지는 않다는 부부의 의견을 반영해 가구는 모두 입식으로 선택했다. 문제는 한옥 특유의 작은 방. 침대를 두려면 2m 이상의 폭이 필요하므로 쪽마루를 변형한 자그마한 통로까지 침실을 확장한 뒤 통로 바깥으로 창을 30cm 정도 내어 달았다. 침대 옆에는 부부가 앉을 수 있는 원형 테이블을 두고, 그 위에 작은 거울을 달아 재미를 주었다. 책을 읽으며 차 한잔 마시거나 TV를 설치할 경우 필요한 코지 공간이다. 주방 가구는 가장 심플한 디자인으로 고르고, 상부 장의 문짝을 나무 프레임 창으로 교체했다. 다이닝 테이블 옆 냉장고와 에어컨 자리 역시 가전의 깊이에 맞춰 벽을 뒤쪽으로 밀어냈다. 전체적으로 하얀색으로 도장하되 한옥의 골조와 목재 창 일부를 살려 따뜻한 느낌을 배가한 것도 개조 포인트다. 보통 한옥을 개조할 때 가장 난감한 것이 어우러지는 입식 가구를 고르는 것인데, 침대와 소파는 고재 나무로 틀을 제작해 이를 해결했다.

한옥에서 몇 번의 주말을 보낸 김 대표 부부는 무엇보다 세상과 단절된 듯 고요한 적막감에 반했단다. 이는 보이지 않는 단열 등의 기능과도 연결되는 대목이다. "옛날 한옥을 떠올리면 겨울에 추운 기억뿐이잖아요. 마당으로 씻으러 나가기도 싫고…. 한옥이지만 아파트처럼 동선이 연결돼 편리하고, 단열을 잘해 따뜻한 것은 물론, 외부 소음을 염려할 필요도 없죠. 남편은 황토방을 만들지 않아 아쉬워했는데, 타일을 깐 작은 방은 보일러를 켜면 온돌처럼 금방 뜨끈해져 좋아요. 마치 리조트에 온 듯 잘 쉬고 갑니다."

## 줄 서서 먹는 빵집의 편안한 아지트

다시 군산. 본관 바로 옆에 자리한 신관 건물에는 원래 이성당과 한집처럼 지내 온 이웃이 운영하던 슈퍼마켓이 있었다. 하지만 몇 년 동안 아침 첫 빵을 사

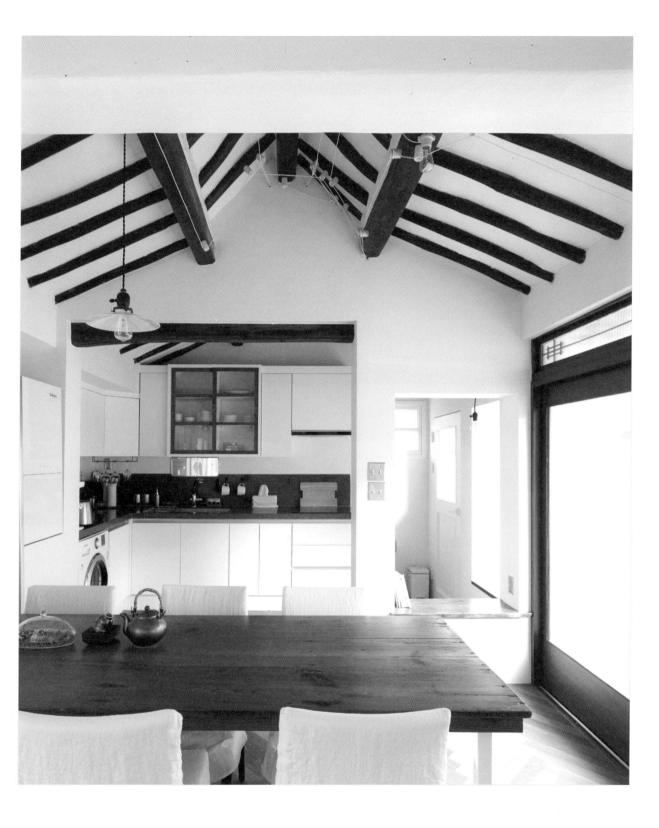

거실에서 바라본 부엌과 현관. 가벽을 설치해 싱크대와 현관을 분리하되, 서까래 구조를 살려 답답하지 않다.

싱글 침대를 나란히 배치하기 위해 통로를 확장하고, 창을 바깥쪽으로 내어 달았다.

기 위해 기다리는 인파로 옆 건물까지 줄이 똬리를 틀고 있으니, 이웃에게 늘 미안 했던 김 대표 부부는 옆 건물이 매물로 나오자 고민한 끝에 매입하고 신관을 오픈 했다. 리모델링은 역시 신경옥 디자이너가 맡았다. 김 대표가 원한 것은 세 가지였 다. 첫째, 동네와 이질감이 없도록 옛 모습을 그대로 유지할 것. 둘째, 콘셉트가 아 닌 이성당 자체로 이야기가 되는 공간일 것. 셋째, 손님이 잠시라도 편안하게 머물 수 있는 쉼터가 될 것.

"예전에는 단팥빵, 야채빵 등 시그니처 빵 외에도 새로운 빵을 기다리는 손 님이 많았거든요. 이성당에 새 빵이 나왔다고 하면 맛보러 오던 군산 주민들이 여 전히 편안하게 들를 수 있도록 본관과 신관의 빵 메뉴를 구분했어요. 본관은 기존 처럼 시그니처를 포함한 빵을 선보이고, 신관은 신메뉴를 선보여요."

신관 1층에 마련한 쌀빵 시연 공간은 오랜 시간의 가치를 품은 이성당의 철 학을 보여 주는 상징적 쇼케이스다. 쌀 식빵을 만들려면 48시간의 숙성과 발효 과 정을 거쳐야 한다. 쌀은 물이나 소금 등 다른 재료를 받아들여 섞이는 시간이 더 오래 걸리는 재료인데, 서두르지 않고 천천히 오랜 시간을 기다린 만큼 좋은 식감 과 풍미가 난다. 2층 카페는 멀리서 온 손님들의 지친 발걸음을 달래 주는 쉼터요, 지역 주민의 아지트다. 김 대표는 사실 신관이 너무 예쁘게 변신할까 봐 걱정도 됐 단다. 오랫동안 몸담은 일터에 대한 관심과 애정이다.

"미국 여행 때 갔던 한 음식점이 오래 기억에 남아요. 가격에 비해 맛도 좋 고, 여행객이 찾기에 분위기도 위압적이지 않고 편안했죠. 요즘 가성비를 많이 따 지잖아요. 맛과 가격은 기본에 서비스까지 삼박자를 충실히 갖췄다면 굳이 트렌 디한 인테리어가 필요할까요? 신관은 신관대로 편안해서 좋고, 본관은 본관대로 시간이 지닌 공력만으로 충분히 아름답다는 생각이 들어요."

## 미션! '작지만' 즐거운 일을 찾아라

"사실 이성당 서울 진출을 앞두고 고민이 많았어요. 이성당의 맛을 후대에 전하는 것 역시 우리의 역할이고 책임이라면 젊은 친구들과 교감하려는 노력을 해야겠지요." 일을 완전히 내려놓으면 계동 한옥에 아주 작은 카페를 하나 차리고 싶다는 바람도 덧붙였다. 이성당이 자그마한 화과방에서 시작했듯, 계동 골목에

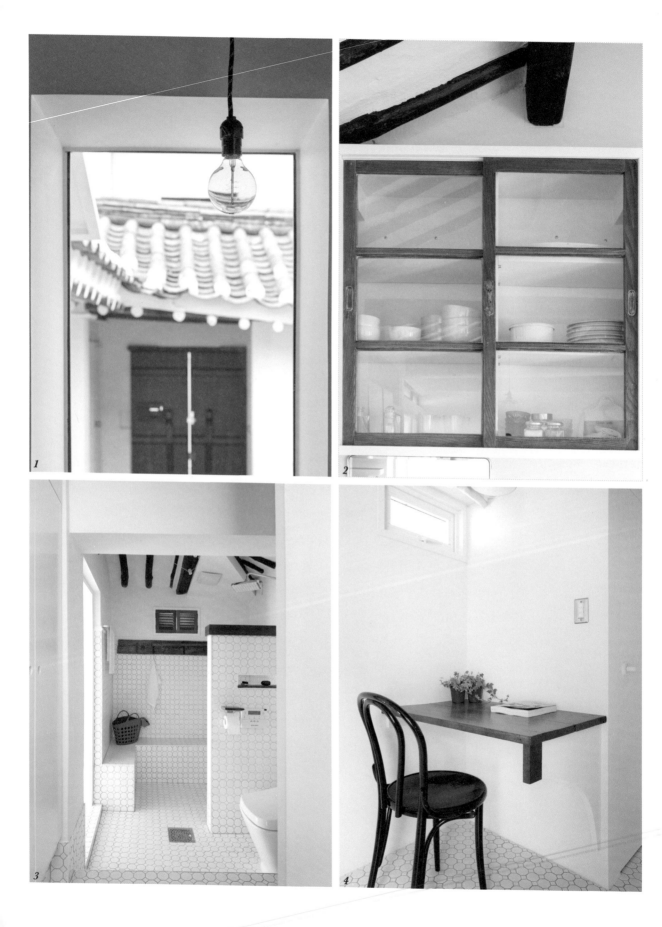

서 쌀로 만든 디저트를 파는 노부부의 작은 카페가 김 대표 부부가 꿈꾸는 청사진이다. 사실 이성당의 성공기는 수많은 자영업자의 흔한 성공기와는 다른 특별함이 있다. 무리하지 않고, 자신을 믿는 일과 그곳에서 할 수 있는 일을 최선을 다해가며 만족하는 생활. 나눔과 채움, 미안함과 고마움, 일과 생활이 즐겁게 섞이고 제대로 발효된 모습을 보여 준다고 할까? 빵의 풍미는 빵을 만드는 최소한의 재료와 발효 과정에서 결정된다. 발효와 숙성 시간을 줄이지 않고 빵마다 필요한 시간을 기다리는 것, 팥과 야채, 물과 소금 등 기본적으로 들어가는 재료를 충분히 사용하는 것. 바로 이것이 기본을 지킨 빵 맛으로 이성당이 오랜 시간 사랑받는 비결이리라.

"이 나이가 되고 보니 문득 이런 생각이 들어요. (장사가 뭔지 모르고 시작한) 젊었을 때도 행복했고, 지금도 참 행복하구나. 그래서 다음 세대에게도 이 풍요로움을 전해야겠구나. 10년 뒤에는 이 계동 한옥에서 이뤄지지 않을까요?" 계동 한옥에서 또 어떤 구수한 냄새가 풍길지 자못 기대된다.

1   현관 앞 전구 조명등이 아날로그 감성을 더한다. 대문은 붉
    은 칠을 벗겨 내고 스테인으로 마감했다.
2   화이트 싱크대도 특별하게 만들어 주는 나무 창의 힘.
3   선이 굵어 자칫 남성적으로 느껴지는 한옥에 육각 타일을
    장식해 여성스러운 분위기를 완성했다.
4   딱 필요한 가구만 최소한으로 둔 것이 특징. 선반처럼 벽에
    매단 책상이 재밌다.

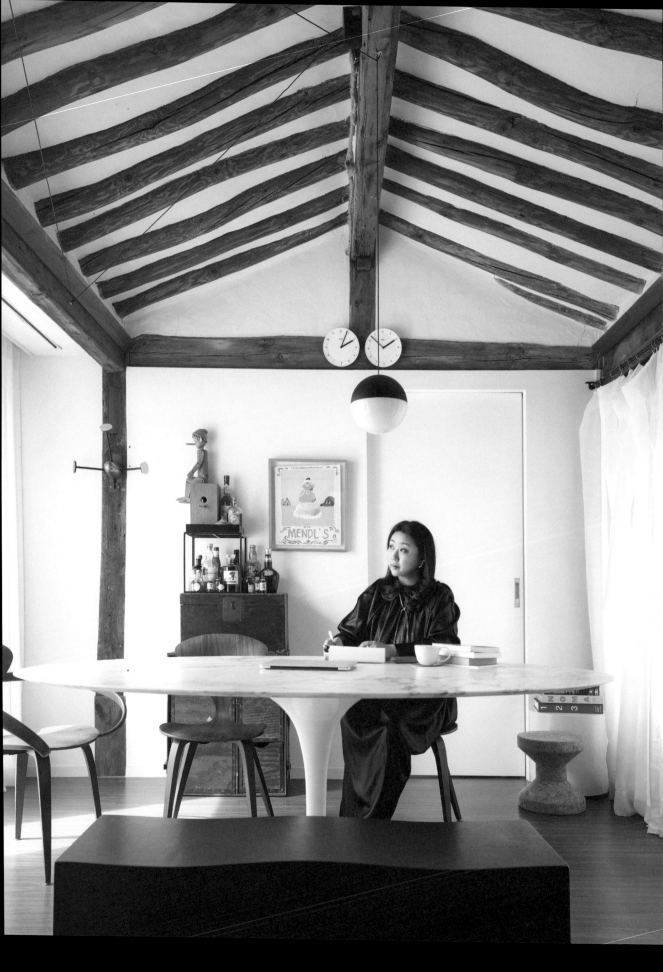

# 옛집과 사적 취향의 조우

검고 긴 찻상 하나 단출하게 놓인 방에 앉으면 네모난 하늘이 눈에 꽉 찬다. 내게 필요
한 생활용품을 촘촘히 넣으니 침실, 부엌, 마당도 충분하다. 오래된 것과 새로운 것이
공존하는 스물다섯 평 한옥에서 기억 저편의 옛집과 완전히 새로운 한옥 스타일을 함
께 만났다.

언젠가 본 적이 있는, 어디선가 마주한 장면인 것 같아 자꾸 기억을 되짚어
보는 순간이 있다. 마치 사랑에 빠진 것처럼 설명할 수 없는 어떤 분위기로 가득한
장소에 흐르는 시간. 오랜 세월의 흔적이 역력한 대문을 열고 중정에 들어섰을 때
그런 공간과 시간이 내게 다가왔다. 아늑하지만 왠지 낯설게 느껴지는 ㅁ 자 구조
의 한옥은 국내 리빙 스타일리스트를 대표하는 '세븐도어즈'의 공동 대표 민들레
실장의 집이다. 작업실 겸 거주 공간으로 사용하던 이곳은 공동 대표인 민송이 대
표의 주거 독립과 새 사무실 이전으로 한 사람을 위한 공간으로 재배치되었다. 먼
저 중정 너머 다이닝 공간을 중심으로 양옆에 침실과 부엌이 자리하고 침실 옆으
로는 이 집에서 가장 넓은 리빙룸이 위치한다. 미닫이문을 사이에 두고 방 세 칸,
화장실 두 개, 마당으로 사용하는 중정을 포함해 25평 남짓한 아담한 한옥이다.
민들레 실장과 나는 정확히 16년 만에 다시 만났다. 당시 '리빙'과 '푸드' 두

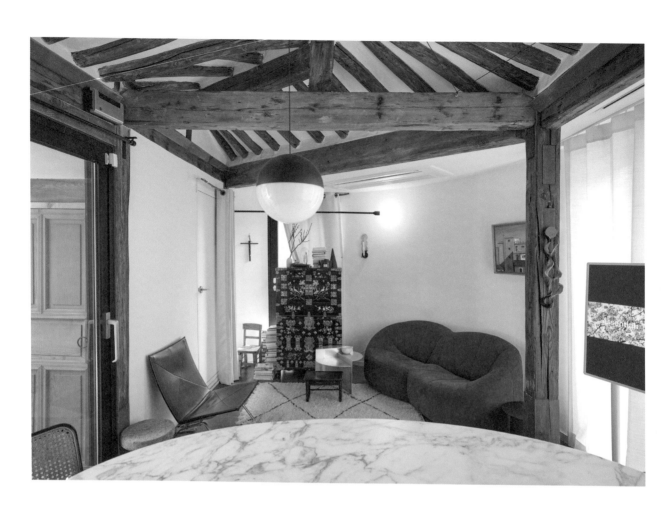

고가구를 중심으로 현대적 소재와 컬러의 가구들이 조화를 이루는 리빙룸.

분야의 동시 연출이 가능한 스타일리스트 듀오로 유명한 세븐도어즈는 회사명보다 '민 자매'로 더 많이 불렸다. 화보 촬영을 위해 준비한 트렌디한 물건으로 늘 넘쳐 나던 그들의 대치동 첫 작업실에 대한 기억이 선명하다. 당시 우리 눈을 사로잡은 가구와 물건은 유행이 지나고 각자의 취향이 바뀌며 대부분 잊혔다. 지금도 여전히 그의 공간을 채우고 있는 사물이 궁금해 천천히 공간을 살피다가 중정 너머 보이는 차를 마시는 용도의 작은 방 앞에 시선이 멈췄다.

"원래는 침실이었어요. 실내에서 쓰기에 너무 거친 돌바닥인 데다가 중정을 향해 완전히 열리는 구조라 침실로 쓰기에 적합하지 않았지만, 제가 너무 좋아하는 공간이라 그렇게 했어요. 이 집을 저 혼자만의 주거를 위해 가구를 재배치하면서 더 안쪽으로 침실을 옮기고, 제가 가장 좋아하는 이 공간의 매력을 좀 더 오롯이 느낄 수 있도록 했지요."

찻상 앞에 앉으면 이 집에서 유일하게 어떤 건물도 시야를 가리지 않는 나만의 하늘을 감상할 수 있다. 비 오는 날은 차 한 잔 앞에 두고 두 다리를 쭉 뻗고 앉아 기와를 타고 흘러내리는 섬세한 빗소리를 하염없이 듣기만 해도. 참 좋다. 그 고즈넉한 분위기를 만들어 주는 것은 다름 아닌 낮게 배치한 찻상이다. 민들레 실장은 임정주 작가의 개인전에서, 시소에서 영감을 받아 만든 이 낮고 긴 테이블을 보고 완전히 매료되었다. 균형을 잘 맞춰야만 쓸 수 있다는 이 찻상 앞에서 요즘 그는 '밸런스'에 대해 자주 생각한다. 공간 스타일링은 이를테면 문장 끝에 점을 찍는 작업이다. 어떤 의도와 콘셉트로 잘 기획한 공간 안에 마지막까지 긴장감을 놓지 않고 적절한 물건과 그 위치를 치열하게 찾는 과정을 거쳐야 스타일링은 마침표를 찍는다. 그 순간을 위해 스타일리스트는 작은 디테일을 매만지고 마지막 터치와 숨결을 불어 넣는다. 부족한 것도 넘치는 것도 없이, 꼭 있어야 할 곳에 사물이 놓일 때 그는 비로소 만족감을 느낀다. 그런 정교한 밸런스가 공간 연출에서, 그리고 삶에서도 매우 중요하다고 생각한다.

## 한옥과 고가구의 낯선 표정을 찾아서

체부동을 거쳐 성북동 주택가에 숨어 있던 한옥들이 세븐도어즈의 작업실로 낙점된 것이 우연은 아니다. 민 자매 아버지의 고향은 충북 영동이다. 영동은

매년 국악 축제가 열리는데, 집안 어른과 친지 중 관련 전공자가 많아 우리 전통음악과 가야금 연주를 익숙하게 듣고 자랐다. 일가친척이 한 지역에 모여 살아 명절이 되면 북적북적했다. 커다란 한옥에 모여 제사를 지낼 때면 오래된 고가구나 살림살이를 구경하는 것을 좋아했다. 누군가에게 한옥과 고가구는 좀 특별한 것일지도 모른다. 하지만 민 자매에겐 어쩌면 가장 편안한 오랜 추억의 공간과 사물이다. 하지만 이곳에 방문한 손님은 한옥의 편안함이 아니라 낯선 매력을 먼저 발견한다.

"개인적으로 반전 매력을 즐기는 편이에요. 파티션을 헤드보드로 사용한다든지, 고가구를 현대적 소품과 함께 둔다든지 하는 식이죠. 전혀 다른 배치나 연출을 통해 새로운 분위기를 찾아내 공간의 표정을 만들어 준다고 할까요. 리빙룸 중앙에 가장 많은 자리를 차지한 놀 사리넨의 튤립 테이블은 정말 오래 기다려 받은 제품이에요. 흙과 나무가 주재료인 한옥에 굉장히 현대적인 소재를 두고 싶었거든요."

스테인리스로 만든 프라마 의자나 차가운 금속 소재 사이드 테이블을 매치한 것도 현대적 요소를 더하기 위한 장치다. 바이올렛 컬러의 2인용 펌킨 소파는 형태와 부피가 놓일 공간에 적절하고, 채도가 너무 높지 않아 공간 속에 조용히 스며들면서도 새로운 느낌을 만들어 주어 특히 만족도가 높은 가구다. 그는 펌킨 소파를 디자인한 피에르 폴랭의 독특하면서도 우아한 곡선 느낌의 디자인을 특히 좋아한다.

1   펠릭스 곤살레스 토레스의 작품에서 영감을 받아 서촌 작업
    실에서부터 10년을 나란히 걸어 둔 시계가 있는 리빙룸.
2   화장실 앞 자개장에는 동양적 느낌의 화병과 종교적 기물을
    포함해 오랜 시간 모아 온 주인장의 컬렉션을 올려 두었다.
3   거울과 세면대, 수건걸이와 새 오브제로 단출하게 연출한
    화장실.

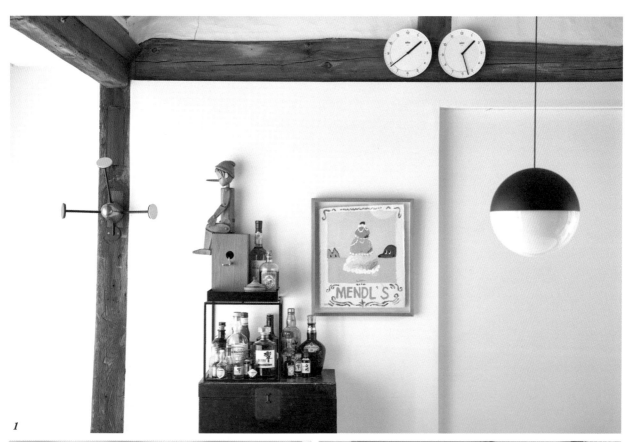

1

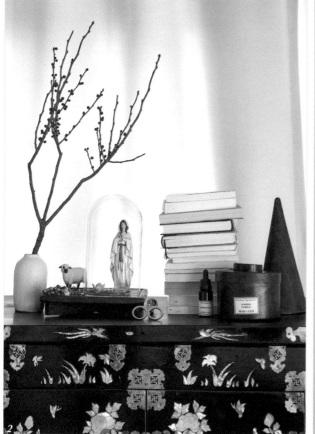

2

3

작지만 충분한 나만의 하늘을 감상할 수 있는 ㅁ 자 한옥.

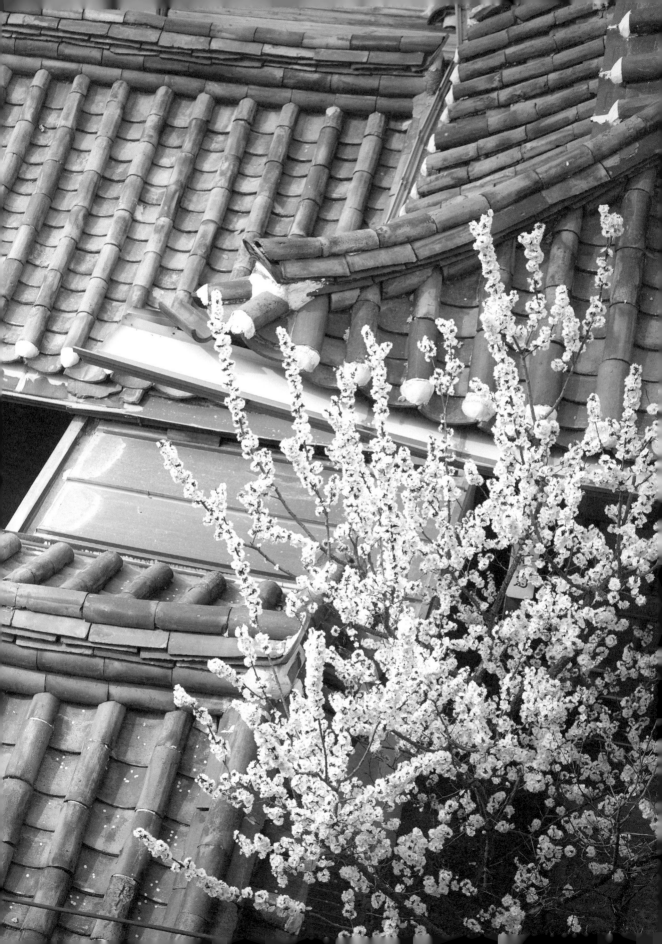

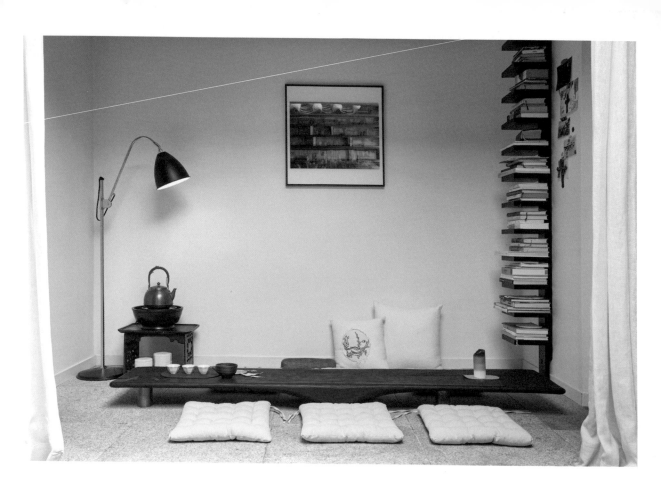

낮고 긴 찻상과 책꽂이가 놓인 차 마시는 방은 마치 한 편의 시처
럼 고요하고 평화로운 느낌을 자아낸다.

## 공간에 생활을 맞춰 충분하게

한옥은 과거의 생활 방식에 맞추어 지었기 때문에 현대 기성 가구와 가전을 두기 어렵다. 집에 가구를, 공간에 생활을 맞춰야 한다는 얘기다. 그리하여 생활에 필요한 최소한의 가전을 두기로 했다. 가장 작은 사이즈의 빌트인 냉장고 하나를 두고 부엌과 다이닝 공간을 나누는 역할을 하는 아일랜드 하단에 반찬 냉장고와 와인 냉장고, 그 옆에는 휴지통과 재활용 수납공간을 딱 들어맞게 구성했다. 수십 년을 모아 온 많은 그릇은 벽면장과 아일랜드장을 맞춤 제작해 한눈에 보이도록 수납했다. 보이지 않는 곳에 두면 결국 사용하지 않게 된다. 곁에 두면 필요한 것과 필요 없는 것이 분명해지고, 궁극적으로는 둘 곳을 생각하고 새로운 물건을 들이는 것이 습관이 된다. 그렇게 물건은 하나씩 제자리를 찾아가고 있다.

민들레 실장은 스타일링 업무가 끝나면 몸과 마음을 내려놓는 나만의 한옥으로 퇴근한다. 마지막 인사를 나누며 그는 이 집의 또 다른 주인인 반려견 오복이 덕분에 다른 생명체를 받아들이는 일은 삶의 작은 부분까지 살피고 돌보는 일임을 알게 되었다는 얘기를 들려주었다. 한 사람의 어린 시절과 사적 취향이 고스란히 담긴 이 아름다운 한옥은 과거와 현재를 잇는다. 매일매일 충실한 일상을 살아가는 주인장과 함께 부족하지도 넘치지도 않게 단단한 시간을 쌓아 가고 있다. 10년이 흐른 뒤에도 오랜 시간 그가 곁에 둔 반질반질 윤이 나는 옛 물건과 함께 새로운 사계절과 취향을 담으며 이곳에 그대로 있을 것만 같다.

# 오래된 도시에서 새로 쓰는 한옥

오래된 도시에서 공간을 기획하고 만드는 공간 아트 디렉터가 자신의 집을 꾸민다면
어떤 모습일까? 1961년에 지은 근대식 한옥을 개조해서 살기 시작한 정규태 씨. 그는
예순두 살 한옥에 자신이 살고 싶은 삶을 담았다.

안국역 2번 출구를 나와 북촌으로 향하는 길. 골목마다 다닥다닥 붙어 있는
한옥은 언제나 정겹게 다가온다. 손 내밀면 닿을 만큼 북촌과 가깝지만 이곳의 한
옥은 북촌의 전통 한옥이 아닌 근대식 한옥이다. 이곳에서 정규태 씨는 예순 살 넘
은 한옥을 개조해 살고 있다. '정규태, 정뽀리'라 적힌 문패를 지나 마당으로 들어
서면 도시의 소음은 온데간데없이 사라지고 고즈넉한 정취만 남는다. 집주인 정
규태 씨는 도시 재생과 연계해 식음료 공간을 기획하고 만드는 '글로우 서울'의 공
간 아트 디렉터로 일했다.

### 첫눈에 반한 한옥

서울에서 핫 플레이스로 꼽히는 카페 '청수당'과 식당 '온천집'에도 그의 손
길이 닿아 있다. 좋아하는 일을 업으로 삼는 것은 보람되지만, 쉼 없이 앞만 보고

대문에서 바라본 한옥 내부 풍경. 뿌리를 꼭 닮은 석상이 용맹한 자태로 집을 수호한다.

달려온 그는 퇴사하고 온전히 자신만을 위한 시간을 보냈다.

"이사하기 전에는 삼청동 언덕배기에 살았어요. 창 너머로 궁궐과 한옥의 모습이 한눈에 들어오는 집이었는데, 그 풍경에 익숙해지니 자연스럽게 이곳으로 오게 되네요."

이사할 집을 알아볼 때 그에게는 오래된 주택 또는 한옥, 이 두 가지 옵션이 있었다. 둘 다 살아 보고 싶은 곳인데, 운 좋게도 이 집을 만나게 되었다. 1961년에 지은 근대식 한옥을 게스트하우스로 사용하던 곳으로, 한쪽은 기울어지고 언뜻 보기에도 예쁜 한옥은 아니었다. 하지만 그런 건 아무 상관이 없었다. "이 한옥을 처음 본 그날이 정말 좋았어요. 처마 너머로 파랗게 하늘이 보이는데, 꼭 제임스 터렐의 작품을 보는 것 같았지요. 하늘이 제 것처럼 느껴졌어요." 그는 곧장 계약을 하고 무작정 이곳으로 이사 와 살기 시작했다. 2020년 12월의 추운 겨울날이었다.

### 먼저, 살아 보겠습니다

공간을 만들 때 디자이너가 직접 살아 보고 디자인하는 일은 흔치 않다. 자신이 좋아하는 '이미지'대로 꾸밀 뿐. 하지만 이번엔 달랐다. 그는 4개월 가까이 살면서 집을 알아 가기 시작했다. 빛이 어느 방향으로 드는지, 무엇이 좋고 불편한지 끊임없이 살펴보고 설계에 반영했다. 4월에 철거를 끝낸 뒤에도 한 달 정도를 더 고민하고 5월부터 본격적으로 공사를 시작했다. 지인이 소개해 준 리소건축 김대일 소장에게도 도움을 받았다. 공간에 대한 이야기를 나눌 때마다 집주인의 의견을 지지해 주고, 그가 원하는 방향으로 이끌어 주었다. 특히 단열, 창호, 마감재 등 주거 건축에 대한 전문적 조언이나 한옥에서 주의할 점 등 조언을 아끼지 않았다. 하지만 정원만큼은 이견을 보였다.

"기존 한옥은 작은 마당이 있는 ㅁ 자 구조였어요. 저는 실내 공간을 좀 포기하더라도 정원을 넓게 만들자고 했는데, 소장님을 비롯해 주위에서는 만류했지요.(웃음) 훗날 한옥을 되팔 때를 생각하면 그대로 살려 두는 게 낫다고요. 자그마치 다섯 평 정도 되는 공간이었으니까요."

하지만 정원과 관련해서 그도 호락호락하게 물러서지 않았다. 공간 아트

디렉터로서, 늘 공간의 마지막을 책임지면서 조경이 미치는 영향을 몸소 체험했기 때문이다. 그는 돌과 이끼, 대나무로 원래 있던 것처럼 자연스러운 정원을 꾸미고 한쪽에는 저쿠지를 설치했다. 실내는 안방을 제외한 나머지 공간을 오픈형으로 개방감 있게 개조했다. 여기에는 반려견 뿌리의 영향이 크다. 열여섯 살인 뿌리와 앞으로의 시간을 더욱 의미 있게 보내기 위해 공간의 많은 부분을 뿌리에게 맞춘 것. 벽과 문지방을 없애 편하게 드나들도록 한 것도, 바깥 구경을 마음껏 할 수 있도록 정원을 향해 통창을 설치한 것도 이런 마음에서 비롯된 것이다.

"쾌적한 주거 환경을 만드는 것도 좋지만, 제게는 시각적으로 보이는 부분도 굉장히 중요해요. 더 넓은 시야를 확보해 정원과 하늘을 온전하게 즐길 수 있다면 단열 성능은 좀 떨어져도 괜찮다고 생각하고요. 난방을 하거나 보조 난방 기구를 사용하는 방법도 있으니까요."

수많은 프로젝트를 통해 도시 재생 작업을 해 온 터라 한옥 수리에 대한 그만의 원칙도 생겼다. 쓸 수 있는 것은 최대한 재사용하고, 환경에 해를 끼치지 않는 것이다. 철거하면서 나온 목재로 가구를 만들고, 오랜 시간 그대로 방치된 서까래도 스테인을 칠해서 다시 사용한다.

### 당신은 어떤 삶을 살고 싶나요?

보통 우리는 자신의 삶에 맞춰 집을 꾸미지만 그의 생각은 좀 다르다. "사용자의 라이프스타일에 맞춰서 공간을 만든다고 생각하지만, 전 그 반대예요. 오

---

1 　아일랜드 키친에는 그만의 작은 키친 가든이 있다. 아일랜드 키친을 비롯해 주요 요소는 친구의 아버지이자 오랜 경험을 지닌 목수의 솜씨다.
2 　철거 공사 중 나온 고재로 천장을 지지하는 장식을 만들었다.
3 　집 안 곳곳에는 자연의 물성을 지닌 오브제가 자리한다.
4 　정원에 저쿠지를 설치해 노천탕을 꾸몄다. 추운 겨울일수록 더욱 운치 있는 공간이 된다.

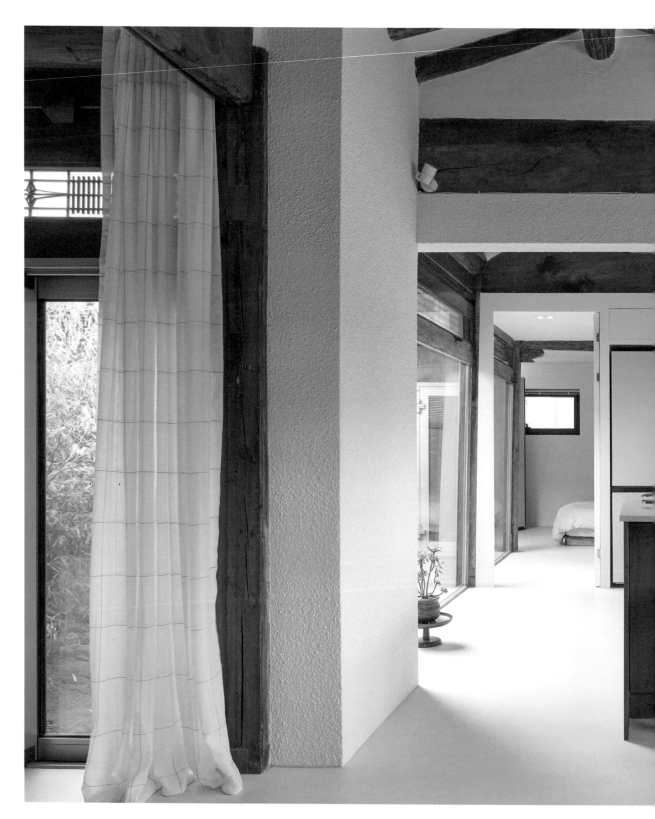

거실과 연결되는 주방. 침실을 제외한 나머지 공간은 하나로 연결
해 오픈 스튜디오처럼 꾸몄다.

히려 내가 어떤 삶을 살아야겠다고 먼저 생각하고 거기에 맞춰 공간을 꾸미면 삶이 변하지요." 몇 해 전, 미니멀 라이프를 실천한 적이 있는 그는 그때의 경험을 떠올리며 한옥을 미니멀한 삶을 위한 공간으로 구성했다. 수납공간을 최소한으로 만드니 물건도 적게 소유하게 되고, 하나를 사더라도 기능과 오브제 역할을 겸하는 것으로 고르게 된다. 마치 여행 온 것처럼 물건에서 벗어날수록 우리는 자유로워진다.

실내는 재료의 물성을 활용해 풍성하게 채웠다. 흰 벽은 페인트와 스타코를 사용해 서로 다른 질감으로 완성했다. 마음껏 게을러질 수 있도록 누웠을 때 몸에 착 감기는 소파를 고르고, 가구와 소품 색깔도 미색을 사용해 힐링을 위한 최적의 조건을 갖추었다. 시간이 느리게 흐르는 듯한 한옥에서 만끽하는 게으른 일상이란 이런 것. 아침에 일어나서 낙엽을 줍고, 정원에 물을 주고, 뿌리와 함께 오래된 동네를 산책하는 시간이 그에게는 소중하다.

"예전부터 저 스스로가 '연결 지점'이 되는 사람이면 좋겠다고 생각해 왔어요. 공간을 만들 때도 안팎의 구분이 없도록 만들기를 바랐죠. 미술을 하는 사람뿐만 아니라 다른 분야에서 활동하는 사람들이 모여 새로운 작업을 해 보면 좋겠다는 생각에 별채를 옛 살롱처럼 꾸며 볼까 합니다."

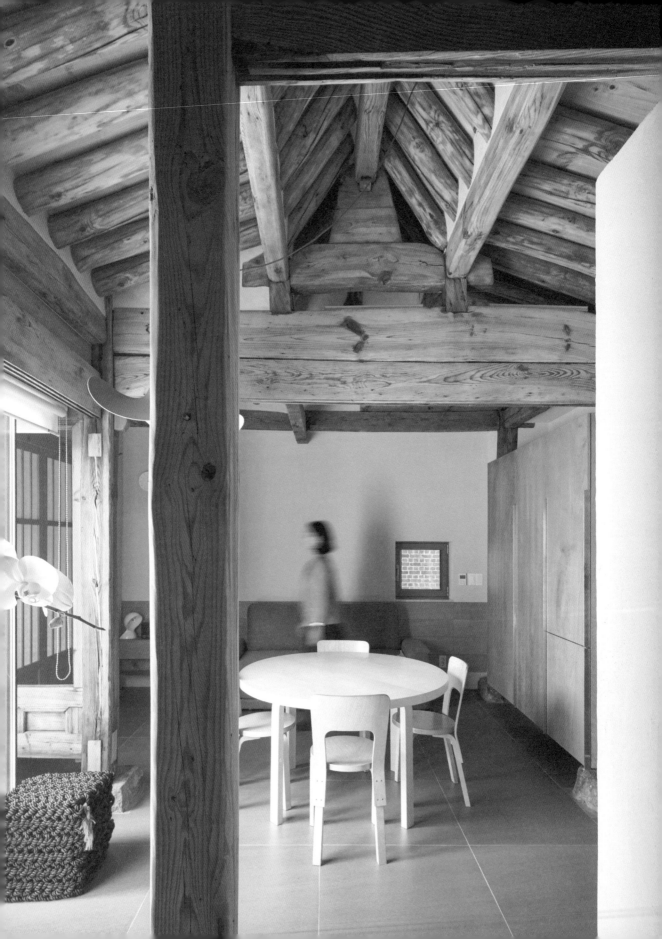

# 디자이너, 지금의 한옥을 묻다

디자인의 목적은 쓰임새를 시각적으로 구현하는 데 있다. 디자인 자체의 아름다움이나 스타일을 만드는 데 집착하기보다 "어떻게 쓰일 것인가?"라는 근본적 물음에 응답하는 것이 우선되어야 한다. 집을 짓는 일도 마찬가지다. 낙산 성곽길에 자리한 한옥 '지금'은 전통의 재구성을 넘어 '집이란 무엇인가'에 대한 담백한 성찰의 결과다.

제품 디자인을 전공하고 대학에서 디자인을 가르치는 집주인 김성곤 씨는 사실 한옥을 좋아하지 않았다. 춥고 불편하다는 인식을 넘어 공간 자체가 지닌 강한 조형 요소가 부담스러웠기 때문이다. 한편으로는 디자인 종사자로서 한옥의 우수성을 누구보다도 잘 알기에 아쉬움과 책임감도 컸다. 자연 친화적 건축물이자 평면을 자유롭게 구성할 수 있고, 무엇보다 빈 공간의 가치를 발견할 수 있는 집. '한옥'의 아름다움을 해치지 않는 범위에서 지금 이 시대에도 충분히 살기 편한 집을 구성하는 것이 레노베이션의 목표였다.

"한옥 붐이 일기 전 작업실 용도로 이 한옥을 구입했어요. 세를 주는 동안 개·보수를 했지만 집이 워낙 낡아 계속 문제가 발생했고, 근본적 해결책이 필요했죠. 아내와 의논한 끝에 은퇴 후 계획을 앞당겨 재미있는 공간을 만들어 보자 했죠. '지금'에 충실하자는 의미를 담아 집 이름도 'zikm'이라고 지었어요."

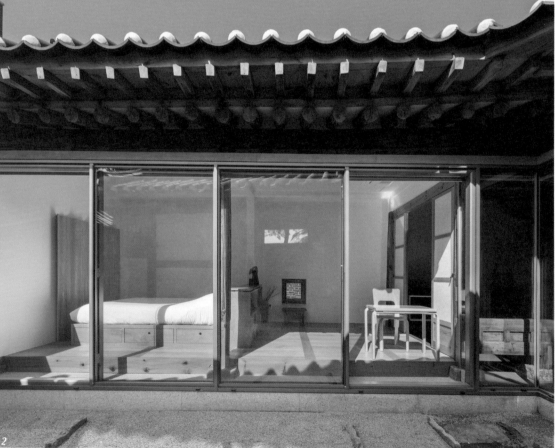

## 낮추고 비운 집

김성곤, 이성민 씨 부부는 대수선을 결정한 뒤 집 짓기 관련한 책을 수없이 읽었다. 하지만 책은 책일 뿐, 실전에는 전문가가 필요하다. 혹자는 디자인을 전공했다면 응당 자신이 살 집 정도는 디자인할 수 있을 거라 생각하는데, 신중히 고민해 봐야 할 문제다. 제품 디자이너는 기본적으로 '인체 치수'에 대한 감각이 없다. 공간 디자이너는 이미 머릿속에 입력된 수치를 바탕으로 창의 위치나 가구와 가구 사이, 통로의 폭 등을 쓱쓱 결정하는데, 아마추어는 일일이 앉아 보고, 걸어 보고, 줄자로 재어 봐야 안다는 얘기다. 부부는 먼저 마음에 맞는 건축가를 찾기 위해 페이스북을 검색했다. 유명세보다는 건축가 고유의 감성, 조형성과 비례감을 살펴보고 싶었기 때문이다. 대부분 한옥을 고치거나 짓는다고 하면 대목이나 한옥 전문 건축가를 찾지만, 군이 범위를 한정하고 싶지 않았다. 때론 서로 다른 영역이 부딪치며 훨씬 큰 시너지를 발휘하기도 하니까. 한옥에서 살아 본 경험이 있는 현대 건축가에게 설계를 맡기고 한옥의 정신을 해치지 않는 선에서 시공을 해 2017년 5월에 완공했다.

한옥은 ㄱ 자로 꺾인 안채와 사랑채, 작은 마당으로 이뤄졌다. 안채는 침실과 거실 겸 주방으로 구성, 전체적으로 현대식 통창 새시를 시공하고 입식으로 꾸몄다. 사랑채는 전통 방식을 유지하되 편의를 위해 화장실과 수납장을 추가했다.

"한옥의 단점 중 하나가 지금의 입식 생활에 맞지 않은 낮은 천장이에요. 작은 공간도 천장고가 확보되면 답답해 보이지 않고 개방감이 느껴지죠. 거실과 주방은 주춧돌이 드러날 때까지 바닥 높이를 최대한 낮췄어요."

---

1   거실 겸 주방, 화장실을 오픈식으로 구성했다. 큐브 타입 화장실은 세면대와 샤워실을 분리한 것이 특징. 한국의 모던 디자인을 경험할 수 있도록 현관 입구에 유화성 작가의 모자 조명등, 이광호 작가의 스툴을 두었다.

2   안채 침실은 한쪽 창을 통창으로 완전히 개방하고 반대편 벽면은 창 크기를 최소한으로 줄여 여백의 아름다움을 살렸다. 침대와 침대 헤드보드 역할을 하는 낮은 장 등으로 간결하게 꾸미고 한지 도배로 마감했다.

서까래, 대들보 등 한옥 자체의 조형성이 강해 공간을 구성하는 다른 요소는 최대한 존재감을 줄이는 방법을 선택했다. 바닥 타일과 새시는 물론(소파, 커피포트까지!) 기와와 같은 진한 회색을 선택하고, 새시는 바닥 레벨보다 깊게, 천장 레벨보다 높게 끼워 넣어 틀이 보이지 않도록 했다. 공간에 가구를 최소화한 것도 특징이다. 주방 가구, 거실 붙박이장, 박스 형태의 화장실은 윗부분을 띄워 여백을 두고 시공했는데, 여백 너머로 또 다른 공간이 펼쳐질 것 같은 상상력을 자극하며 공간이 넓어 보이는 효과가 있다. "한옥은 특유의 조형성이 강해 가구를 매치하기가 어려워요. 스틸 소재와 섞이기도 힘들고요. 비움의 미학이라는 말이 괜히 나온 게 아닙니다. 건축가의 조언처럼 수납장을 더 짜야 하나 마지막까지 고민도 많았지만, 이참에 생활 방식을 바꿔 보는 걸로 결론을 냈어요. 너무 많은 걸 갖지 않고, 최소한으로 누리는 삶에 대해 고민이 필요한 때니까요."

## 둥글게 모이는 집

안채에서 가장 먼저 마주하는 공간은 주방이다. 주방은 두 식구가 밥해 먹기 불편하지 않을 정도의 조리대와 최소한의 도구를 수납할 수 있는 상부 장 등 아주 콤팩트한 구성이 눈에 띈다. 알바 알토가 디자인한 아르텍의 원형 테이블은 부부가 한옥에서 가장 많은 시간을 보내는 장소이기도 하다.

"무인양품이 제품을 개발할 때 벽으로 향하는 것은 사각으로, 사람에게 향하는 것은 둥글게 디자인한다는 말이 인상적이었어요. 원형 테이블은 공간을 입체적으로 만들어 줄 뿐 아니라, 실제 사람을 모이게 하는 효과가 있어요. 상석, 하

1    낙산 성곽이 보이는 사랑채의 파노라마 창이 인상적이다.
2    천장고를 확보하기 위해 주춧돌이 드러날 정도로 바닥을 낮췄다.
3    이성민, 김성곤 씨의 이름 중 초성과 받침을 기호화해 담벼락에 표식했다.

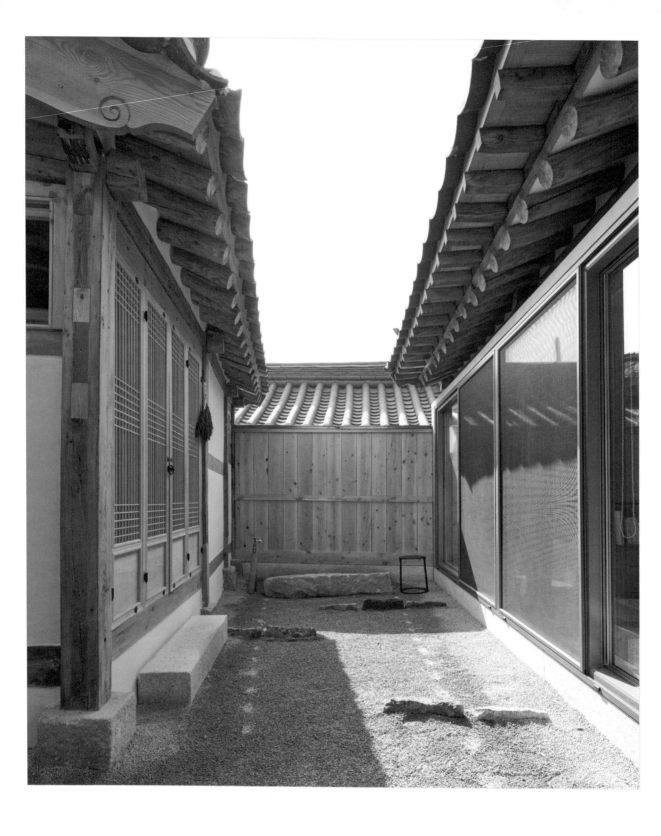

마당을 중심으로 왼쪽이 별채, 오른쪽이 안채 침실이다. 공사하
며 나온 주춧돌과 구들돌을 스툴처럼 툭툭 배치했다.

석 구분 없이 누구나 편하게 둘러앉아 이야기를 나누기 좋지요."

영국 유학 시절부터 부부의 집은 늘 학생들이 북적이는 아지트가 되곤 했단다. 다양한 분야의 사람과 자유롭게 이야기를 나누는 것이 좋다는 부부는 이 공간을 재미난 일을 도모할 수 있는 장으로 이용한다. 또 해외에서 오는 디자이너나 친구들이 한국의 디자인을 경험하면서 쉴 수 있도록 게스트하우스로도 활용하기도 한다.

"모 교수님이 은퇴식에서 은퇴 준비는 서두를수록 좋다고 하셨는데, 그 말이 뇌리에 남아요. 아이들이 자라 독립하면 트렁크 몇 개 정도로 정리할 수 있도록 짐을 최소한으로 줄여 미니멀하게 살아 보려고요. 은퇴하기 몇 년 전부터는 이 집을 베이스캠프 삼아, 살아 보고 싶은 도시를 정해서 한두 달씩 살아 볼까 싶기도 해요. 반대로 한옥을 경험하고 싶은 분들이 이 집을 그렇게 이용하면 좋겠다는 생각도 들고요."

안채 지붕을 덮었던 옛 기와를 얹어 집의 흔적을 남긴 사랑채는 낙산 성곽이 눈앞에 펼쳐지는 파노라마 창이 인상적이다. 문을 모두 열어 놓으면 안채 침실에서도 사랑채 창 너머 성곽길이 훤히 보인다. 한옥 특유의 빗물받이를 생략하니 하늘 평수도 넓어졌다. 비가 오면 마당의 마사토 위로 낙숫물이 똑똑 떨어져 자국이 생기는데 그 모습이 제법 운치 있다. 침대에 누우면 깜깜한 하늘 너머 별을 셀 수 있는 집, 비가 오면 처마 끝에서 똑똑 떨어지는 빗방울의 운율을 서라운드로 듣는 집, 옛집이지만 자연과 대응하는 데는 최첨단에 있는 집. 단순하고 심플하게 비우고 낮춰 공간의 가치를 재발견하는 것이야말로 우리가 한옥을 통해 이야기하고픈 '집'의 진정한 의미일 터. 시대의 요구에 맞게 새로운 모습으로 탄생한 '지금'이 반가운 이유다.

# 작은 집에서 누리는 최대한의 즐거움

작은 집은 낭비할 틈이 없다. 꼼꼼한 수납으로 짐을 효율적으로 정리 정돈하고, 사는
이의 취향을 간결하고도 명확하게 반영해야 한다. 작은 한옥을 고쳐 삶에 꼭 맞는 집
을 만든 이 부부처럼.

광고 아트 디렉터 김상주와 카피라이터 배은영 부부가 효자동으로 이사를
왔다. 살 집을 정할 시점, 부부는 삶을 효율적으로 산다는 것에 대해 고민했다. "야
근이 많다 보니 집에선 휴식해요. 때론 친구들과, 때론 부부끼리 술 한잔하고요.
큰 거실과 주방이 필수이고, 방은 잠잘 수 있으면 되겠더군요." 그래서 작은 집을
택했다. 1920년대에 지은 10평대 한옥이었다. 워낙 낡은 집이라 레노베이션이 필
수였다.

이들이 떠올린 건 서촌을 배경지 삼아 '서촌차고', '한권의 서점' 등 작은 상
점과 '누와', '일독일박'처럼 색다른 경험을 주는 숙박 공간을 만들어 온 지랩. "평
소 지랩이 만든 공간들을 좋아했어요. 본연의 낡은 것을 지키면서도 현대의 삶을
담아내는 것이 저희 취향과 잘 맞거든요." 지랩의 노경록 대표도 같은 생각이었
다. 첫 미팅 후, 기쁜 마음으로 이 프로젝트를 맡기로 했다.

1

2

3

## 한눈에 들어오는 작은 집

경복궁 돌담길을 따라 한참 들어간 조용한 효자동 골목에 자리한 집에 다다랐다. 문처럼 보이는 곳이 두 군데였다. 새로 낸 듯 멀끔한 철문이 하나, 외벽 끄트머리에 붙은 낡은 초인종이 있는 곳이 하나. 저 낡은 초인종은 왜 붙어 있을까? "본래 마당과 대문이 있던 곳에 벽을 새로 세웠어요. 초인종은 그대로 두었지요." 집의 역사를 존중하는 부부 나름의 방식이다. 철문을 열고 들어서니 작은 오솔길처럼 세로로 길게 난 자그마한 마당 끝에 애기동백이 서 있었다. 나무로 짠 문을 드르륵 열면 간결한 집의 구조가 한눈에 들어온다. 반듯한 서까래 아래 소파 베드와 수납장, 슬라이딩 도어로 구분한 작은 방이 있다. 부엌 천장에 난 창으로 빛이 들어왔다. "곁에 높은 건물이 있어 채광이 좋지 않은 집이에요. 그걸 보완하기 위해 천장에 창을 냈지요. 집의 정면을 정원 방향으로 바꾸면서 채광은 더 좋아졌어요." 노경록 대표가 설명했다.

부부 삶에 맞게 고친 집이지만, 집을 위해 부부가 변한 부분도 있다. "소파와 침대, 책장을 버렸어요. 옷도 많이 버렸고요. 이러다 아내가 저까지 정리해 버리는 것 아닌가, 할 정도로 짐을 많이 줄였죠." 김상주 씨의 말이다. 그런 아쉬움을 보상받을 만큼의 즐거움이 있기에 두 사람은 이곳에서 살 수 있다고 했다. 집에 대한 부부의 애정이 남다른데, 그래서인지 이 집에는 이름이 있다. 카피라이터인 아내 배은영 씨가 지은 이름에, 광고 아트 디렉터인 남편 김상주 씨가 로고를 만들어 집 앞에 붙여 두었다. 게으를 라懶, 운치 운韻, 땅 지地를 쓴 효자 라운지. "말 그대로 효자동에 게으르게 퍼져 술도 마시고, 편하게 놀 수 있는 공간으로 집을 만들고

1  정원에 서서 나무 덧창을 열면 이런 광경이 펼쳐진다.
2  부부 침실로 쓰는 왼쪽 방은 단순하지만 조밀하게 설계했다. 토퍼를 깔았을 때의 높이에 맞춰 콘센트와 작은 무드 조명을 달았다.
3  애기동백 있는 현관 앞 작은 정원.

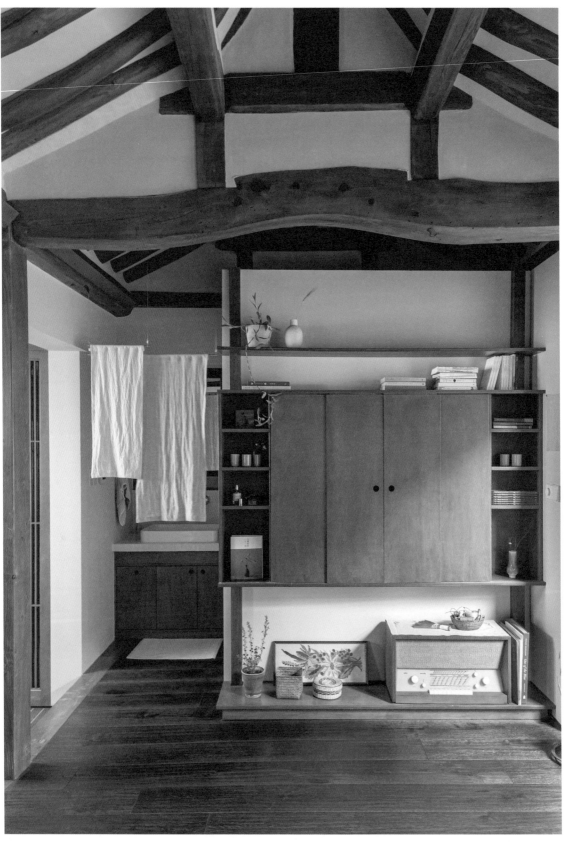

정면에 보이는 장의 가운데 문을 열면 큰 TV가 들어 있다. 직업상 TV가 꼭 필요하지만, 이 집의 중심에 TV가 있길 바라지 않았던 부부의 의견을 수용한 것.

싶었어요. 작은 집이다 보니 치밀하게 쓰기 위한 방법을 많이 고민했는데, 결국은 편하고 즐거울 수 있는 공간에서 살고자 연구한 셈이지요."

## 군더더기를 뺀 자리에 더한 취향

현대 건축의 아버지라 불리는 르코르뷔지에는 그의 저서《작은 집》에서 삶의 효율성에 대해 "정밀하고 조직적으로 배열해야 가치를 얻는다"라고 했다. 이집 역시 같은 맥락에서 기능에 집중했다. "작은 집은 공간을 복합적으로 기능하게 하는 것이 중요해요. 주거 공간이면서 세탁실인 동시에 다이닝룸인 이 집의 주방처럼요."

집을 마무리한 후, 부부는 지랩 구성원에게 카피라이트를 선물했다. '우리한번 해 봅시다', '이 우체통 어때요?', '이건 그냥 둘까요?' 등. 시공자도 현장 공사중 찍은 사진을 앨범으로 만들어 부부에게 선물했다. 맨 앞장에는 마르셀 뒤샹의말을 적었다. "예술에서 게으름을 찬미하며 실천한 것을 뽐내자!" 부부는 재택근무를 할 때 집을 즐기는 시간을 보냈다. 매일 아침 눈을 떠 천장의 서까래를 올려다보며 잠시 편안한 안정감을 갖게 되었다고. "저희에겐 집이 곧 영감이에요. 날마다 기분 좋게 사는 것이 저희에겐 중요한 일이지요." 효자 라운지는 그렇게 수지타산도 효율적 공간 활용도 아닌, 진정한 집의 의미로 모두에게 남았다.

# 풍경이 되는 예술

갤러리스트의 집은 갤러리와는 다르다. 시대를 초월하는 예술 작품이나 디자인 가구
만이 아니라, 누군가의 삶이 머무는 공간이기 때문이다. 공간이 문화를 포개고 예술
과 일상이 함께 풍경이 되는 호흡하는 풍경. 그 견고한 삶의 미학을 서미 갤러리 홍송
원 대표 부부의 한옥에서 마주했다.

가회동 초입, 갤러리가 드문드문 섞인 주택가 골목에 고즈넉한 한옥 한 채
가 숨어 있다. 안마당을 돌아 마루에 오르면 세계적 미니멀리즘 아티스트들의 작
품이 곳곳에 포진해 있고, 수목이 우거진 앞뜰에는 디자인의 기능성과 실현 가
능성을 가장 중요하게 여긴 프랑스 실용주의 디자인의 거장 장 프루베가 설계한
1950년대 조립식 주택이 별채처럼 서 있다. 더욱 놀라운 건 이 모든 것이 너무나
자연스럽게 조화를 이룬다는 사실. 동네의 정서를 품은 오래된 한옥이 문화와 예
술, 그리고 삶을 담는 그릇으로써 하나의 생명처럼 서로를 유기적으로 연결하는
까닭이다. 이곳은 갤러리가 아닌 갤러리스트의 집, 홍송원 대표와 박담회 목사 부
부가 거주하는 가회동 한옥이다.

## 낡은 한옥의 재발견

사실 부부가 이 한옥을 처음 발견한 2000년대 초반만 해도 이곳은 1만 원짜리 한정식 백반을 파는 밥집이었다. 1930년대에 지은 유서 깊은 건물을 1950년대 중반 재건축한 이후 오랜 시간에 걸쳐 조금씩 개조했는데, 그 마지막 모습은 이러했다. 대청마루를 사이에 두고 작은 방이 다닥다닥 붙은 ㄷ 자 형태의 공간. 당시 바로 옆 갤러리 건물에서 종종 이곳을 내려다보던 부부는 오래된 한옥이 주는 아늑함, 마당을 감싸는 여유로운 햇살에 마음을 뺏겼다. 처음부터 '집'을 염두에 두고 구입한 건 아니지만 갤러리 창고로만 쓰기엔 공간이 아까웠고, 레지던스로 개발하려던 계획도 번번이 현실적 문제에 부딪히는 동안 자연스레 직접 살아야겠다는 생각이 들었다고 한다.

부부는 건축가 최욱의 도움으로 기존 한옥을 해체한 뒤 다시 조립했다. 목조를 보강하고 수리해 단열이나 방음 같은 한옥의 고질적 문제를 해결하는 한편, 부부의 라이프스타일에 맞게 공간을 재구성하기 위해서였다. "집이란 존재를 떠올릴 때 콘셉트상 꼭 필요하다고 생각하지만 실제로는 잘 쓰지 않는 공간이 많잖아요. 그런 공간을 최소화하고 싶었어요." 덕분에 현재 한옥 내부는 무척 심플하다. ㄷ 자 형태의 건물 왼쪽 날개엔 침실을 중심으로 드레스룸과 화장실이 숨어 있고, 중간 다리 부분은 소파와 테이블이 자리한 거실 공간, 오른쪽 날개는 부엌 및 다이닝 공간이다.

1  대문을 열고 들어서면 바로 오른쪽에 보이는 것이 사랑채 형태의 장 프루베 하우스. 그 너머에 본채인 한옥이 자리한다.

2  장 프루베 하우스는 이 집이 품은 아트 컬렉션의 정점이라 할 만하다. 제2차 세계대전 당시 피해를 본 지역 주민과 난민을 수용하기 위해 프랑스 디자이너 장 프루베가 설계한 조립식 주택으로 이동하기 용이하고 가변성이 뛰어난 것이 특징이다. 박담회 목사의 아지트나 다름없는 이곳에서 그는 집필도 하고, 책을 읽거나 음악을 들으며 휴식을 취하기도 한다.

3  주방 쪽 유리창을 통해 바라본 안마당과 침실 공간.

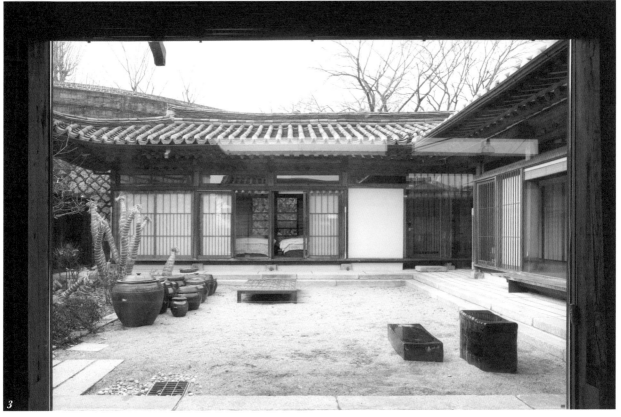

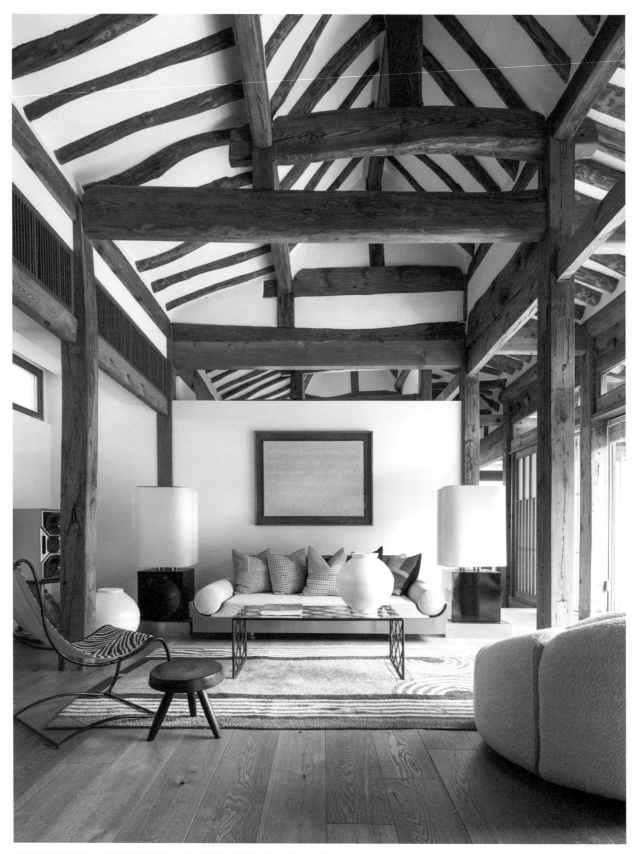

거실로 꾸민 대청마루는 디자인 가구와 빈티지 소품이 공간과 적절하게 조화를 이룬다. 이곳에는 드로잉 작품만 걸어 두어 간결한 맛을 살렸다.

한옥의 다양한 레이어를 평면화하는 사이, 고유의 정체성을 잃지 않으려 노력한 면도 엿보인다. 대표적 예가 천장이다. 각 공간을 벽으로 구분하긴 했지만 천장 쪽은 막힌 곳 하나 없이 전부 통하게 되어 집 전체가 유기적으로 연결되는 것.

또 하나의 포인트는 장 프루베 하우스다. 홍 대표가 이미 갖고 있던 장 프루베의 조립식 주택 골조를 대문과 한옥 사이 공간에 설치했는데, 이때 현관과 화장실을 내고 바닥에 온돌을 놓는 등 일부 생활 요소를 추가했다. "장 프루베 하우스도 세계대전 직후인 1950년대에 주택을 보급하기 위해 만들었잖아요. 이 한옥과 동시대 작품인 셈이죠. 같은 시대의 서양식 건물과 한국 전통 건물이 조화롭게 어우러진 공간을 만드는 것도 의미 있겠다 싶었어요." 과연 두 근대 건축 유산의 만남은 예상보다 훨씬 자연스러웠다.

## 예술을 일상으로, 일상을 예술로

갤러리가 예술 작품을 위한 캔버스라면, 집은 그 자체로 살아 있는 생명체에 가깝다. 공간이 저마다의 역할과 개성을 지녀 작품과 매치하기가 쉽지 않은데, 특히 천장이 낮고 시각적 요소가 많은 한옥의 경우 그 과정은 더 어렵고 복잡해진다. "실제로 그림을 걸기에 적당한 공간이 거의 없어요. 결국 크고 화려한 작품보다는 최대한 집과 어울리는 작품을 들이기로 했죠." 홍 대표는 각각의 작품이 한옥의 전체 분위기에 묻혀 하나로 어우러지길 바랐다. 이를테면 주방 쪽 작은 화장실에만 총 네 점이 숨어 있지만, 직관적 형태로 '벽에 걸린' 건 그중 절반(조각가 윤성진과 사진작가 토마스 데만트의 작품)뿐이다. 바닥에는 칼 앤드리의 블록 작품이 마치 바닥의 일부처럼 놓여 있고, 벽과 벽 사이엔 프레드 샌드백의 실 작품이 마치 벽의 일부처럼 설치돼 있다. 이 두 미니멀리즘 조각가에 대해 잘 알지 못한다면 그저 발 받침이나 수건걸이라 오해해도 놀랍지 않을 모양새다. 부부가 가장 아끼는 작품이라 입을 모은 진 실버손의 조각품 역시 마찬가지다. 수납장 위 손바닥만 한 노부부의 형상이 어찌나 주방 그림자 속에 잘 숨어 있는지, 부러 가리키기 전까진 존재조차 깨닫기 힘들다.

"늘 식탁에 앉아 노부부의 모습을 보는데, 시간대에 따라 빛의 음영이 달라지면서 매번 다른 느낌으로 다가와요. 어쩌면 우리의 미래 모습 같기도 하고요. 남

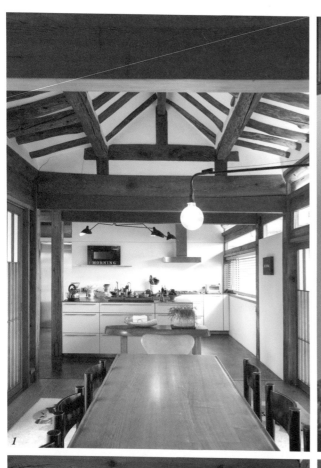

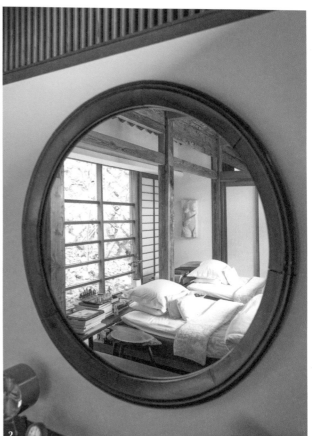

들 눈에 잘 띄지 않고 투자 가치도 없지만, 저런 것이 우리에겐 소중하죠." 남편이 아내의 말을 잇는다. "하루하루 그저 같은 곳을 바라보며 묵묵히 앉아 있잖아요. 둘이 함께한 세월이 있으니 서로 말하지 않으면서도 대화를 나누는 거죠. 그런 모습이 매번 무척 감동적이에요. '누구의 작품을 얼마에 샀는지'가 아니라 '우리 집과 얼마나 잘 맞는지', '내 삶과 얼마나 밀접한 관계를 갖고 그 의미를 부각해 주는지'가 작품에 가치를 부여한다고 생각하거든요."

가구나 소품은 물론 식기를 고를 때도 마찬가지다. 하다못해 눌은밥 한 그릇을 끓이더라도 최대한 멋진 그릇에 멋지게 담아내는 것이 포인트. 그릇의 가치를 모르는 이는 예술품을 살 이유가 없다는 것이 이 부부의 단호한 조언이다. 집에 담긴 문화란 단순히 그림 한 점, 조각품 한 점이 아니라 '삶과 연결되는 모든 것에 관한' 문화이며 전체적인 조화, 즉 밸런스 측면에서 그 가치가 완성된다고 믿기 때문이다. "비싼 집에 비싼 가구, 비싼 작품을 놓고 산다면 먹는 음식과 입는 옷, 생활 습관이며 행동거지도 거기에 맞춰야 해요. 그게 우리가 말하는 '조화'예요."

## 아내의 놀이터, 남편의 작업실

실제 한옥에서의 삶은 부부의 일상을 한결 단순 명료하게 만들어 주었다. 이들은 이곳에서 잠들고, 일어나 무언가를 해 먹고, 마주 앉아 담소를 나눈다. 크게 셋으로 분할한 내부를 오가며 각자 편애하는 공간에 양껏 시간을 투자한다. 예를 들면, 홍 대표는 집에 있을 때 주방의 아일랜드 식탁 주변에서 대부분의 시간을

1  홍송원 대표가 가장 좋아하는 공간은 한옥의 동쪽 날개에 위치한 다이닝룸. 부엌에는 세르주 무이 조명이, 식탁 위에는 장 프루베의 포텐스 조명이 공간과 조화를 이룬다.
2  앞뒤로 크게 창을 내어 사계절 풍광을 담아낸 침실에는 미국 조각가 조지 시걸이 자기 아내를 모델로 제작했다는 누드 작품이 자리해 공간의 깊이감을 더해 준다.
3  조지 시걸의 드로잉과 조지 나카시마의 책상, 이 두 가지만으로도 거실 한쪽이 꽉 찬 느낌을 준다.
4  ㄷ 자 형태의 공간 왼쪽 모퉁이에 햇살을 한껏 품은 욕실이 자리한다.

1   팝아트 거장들의 유산을 미니어처 크기로 축소해서 복제하는
    리처드 페티본의 작품.
2   부부가 가장 아끼는 소장품이라 밝힌 진 실버손의 조각품.
    평온하게 같은 곳을 바라보는 노부부의 모습이 이 부부의
    미래를 상상하게 한다.
3   현관에 들어서면 가장 먼저 마주하는 조지 시걸의 작품.

보낸다. 냄비에 밥을 짓고, 텃밭에서 채소를 뜯다가 버무리고, 김치를 썰어 멋들어진 접시에 담는다. 비단 식사 시간만이 아니라 틈만 나면 주방을 찾아 바질로 페스토를 만들고, 커피를 내리고, 커피에 곁들일 만한 주전부리를 꺼낸다. 그에게 주방이란 가족을 행복하게 해 주는 공간, 주부로서 삶을 즐길 수 있는 놀이터 같은 공간이다. 주방이 아내의 주요 무대라면, 남편의 공간은 장 프루베 하우스다. 애초부터 박 목사의 서재 겸 작업실로 설치한 터라 이곳만큼은 가구부터 소품, 스테레오 시스템까지 오롯이 그의 취향에 맞췄다. 건물이 사랑채처럼 대문 가까이에 자리 잡은 것도 그 때문이다. 그는 틈만 나면 장 프루베 하우스에 틀어박혀 책을 읽고 글을 쓰거나 음악을 듣는다. "나만의 영역이라기보단 나를 편안하게 해 주는 공간이에요. 스피커를 통나무로 제작해서인지 여기서 듣는 음악도 거실에서보다 훨씬 따뜻하고 감성적인 느낌을 주죠." 부부는 이 공간이 워낙 아늑해 한번 들어서면 쉬이 나올 생각을 못 한다고 입을 모은다.

사실 13년 전 이 집에 처음 들어왔을 때만 해도 박 목사는 한옥의 제한적 공간에 답답함을 느꼈다. "천장이 더 높고 벽과 벽 사이의 간격이 더 넓으면 좋겠다고 생각했어요. 그런데 1년쯤 지나니 이 집의 장점이 보이기 시작했죠. 보다시피 이곳에선 창문을 다 열어 놓으면 내가 지금 밖에 있는지 안에 있는지 모를 정도로 안과 밖이 하나가 돼요. 밖의 공기도 그대로 집 안에 들어오고요. 이젠 이 모든 것이 너무나 자연스러워졌어요."

이 부부가 생각하는 좋은 집이란 거주자의 삶에 적합한 공간, 그곳에서의 삶 자체가 문화가 될 수 있는 공간이다. 가회동의 오래된 한옥이 아트 하우스로 변모한 이유가 바로 여기에 있다. 한옥과 장 프루베 하우스, 자연과 예술을 품은 갤러리스트의 집에선 햇살 한 줌, 그림자 한 줄기조차 모두 작품이 되었다.

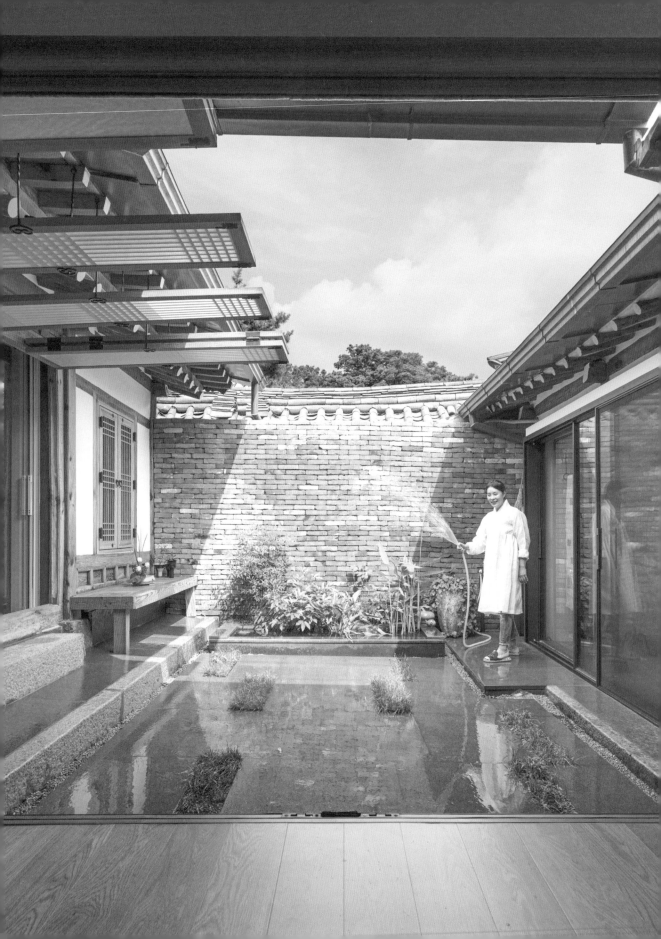

# 안에서 빛나리

한옥이라 하면 궁궐이나 절, 기와를 얹은 전통 양식의 집을 떠올리지만 사실 한옥은
우리나라 사람들이 오랫동안 살아온 일상 주거 공간을 의미한다. 한복도 마찬가지다.
일상의 옷, 한복을 짓는 한복 디자이너 외희가 북촌 한옥에서 특별함이 아닌 '보통'의
날들을 보내는 이유다.

어느 나라에나 도저히 양보할 수 없는 고유한 생활 명품이 있다. 프랑스의
바게트, 영국의 정원, 독일의 맥주 등 지극히 소소한 일상에서 비롯하지만 그 나라
의 자존심과 자부심으로까지 견주어지는 것들이다. 우리에게도 김치, 비빔밥 외에
일상 명품이 존재한다면 과연 무엇일까? 일상의 옷 '한복'을 짓는 한복 디자이너
외희가 평범한 골목길에 자리한 우리의 주거 공간 '한옥'에서 만들어 가는 보통의
날들이야말로 가장 아름다운 일상성을 대표한다.

## 매일의 옷

한복을 입고 여행하는 것이 지금처럼 트렌드가 되기 전, 이미 2007년에 한
복을 입고 해외에서 프리 허그를 자청한 이가 있었다. 한복 디자이너 이외희. 민간
문화 외교 같은 묵직한 명제가 아닌, 단순히 자신이 한복 짓는 일을 의미 있게 이

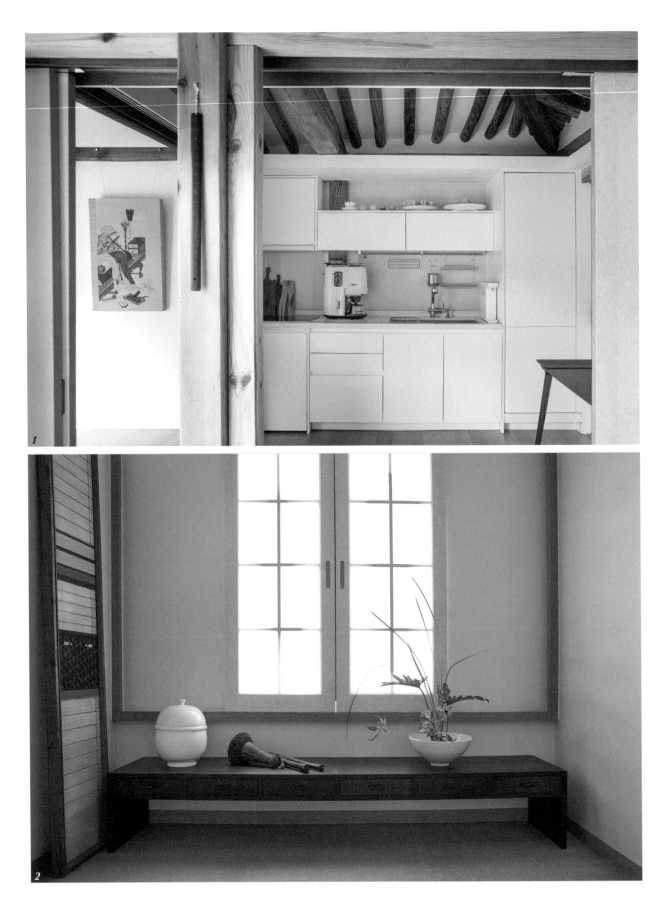

어 갈 수 있을지에 대한 반문으로 도전한 일이었다.

"어릴 때 시골에 가면 할아버지가 저를 자전거에 태워 온 동네에 손녀를 자랑하며 다니셨는데, 그때 모시 자락이 바람에 나풀거리며 사각사각 소리를 내곤 했어요. 할머니를 따라 광장시장에 가서 옷감을 고르던 것도 생각나요. 할머니가 옷을 지어 주면 저는 똑같이 인형 옷을 만들어 입혔죠. 30대 초반, 문득 손으로 만드는 일을 해야겠다고 생각했을 때 아주 자연스럽게 한복이 떠올랐어요."

대학원에서 한국 복식사를 공부하고 한국궁중복식연구원을 거쳐 중요무형문화재 구혜자, 박선영 선생께 전통 복식을 배웠다. 전통 복식의 고증을 위해 박물관을 훑고 며칠 동안 꼼짝하지 않고 바느질을 해야 할 때도 있었지만, 작은 바늘에 에너지를 담는 일이 행복했다. 함께 공부한 이들과 갤러리를 열고 한복 강좌 아이디어를 모았다. 엄마가 아이에게 지어 주는 한복, 일상적으로 입는 저고리 등 의상을 전공하지 않아도, 바느질을 처음 접한 이도 자신의 옷을 지어 입을 수 있는 클래스를 열었다.

"요즘 세상에 누가 한복을 지어 입느냐는 걱정 어린 얘기도 많이 들었지만, 쇼를 위한 한복보다는 일상에서 입을 수 있는 한복을 만들고 싶었어요. 한복 프리허그 여행은 그런 결심을 굳히기 위한 나름의 퍼포먼스였죠. 특별한 날을 위해 짓는 비일상적 한복보다는 평소 입을 수 있는 한복을 만들고, 가르치면서 가치를 공감하는 일이 중요하다는 생각은 더욱 확고해졌고요."

궁 근처에서 한복을 빌려 입고 관광을 다니는 젊은 층을 바라보는 시선이 곱지 않은 경우도 있다. 한복 디자이너라면 전통을 왜곡했다는 비판적 시각이 앞

---

1 주방은 간단하게 구성했다. 거실과 주방 사이 문을 닫으면 거실 또한 하나의 독립된 방이 된다. 왼쪽에 걸린 민화는 홍경희 작가의 작품으로, 안으로 행복해지라는 의미를 담아 '내희'라는 제목을 붙였다.

2 안방에는 빛이 은은하게 들어온다. 왼쪽에 세워 둔 책가도는 뒤로 돌려놓으면 거울이 된다.

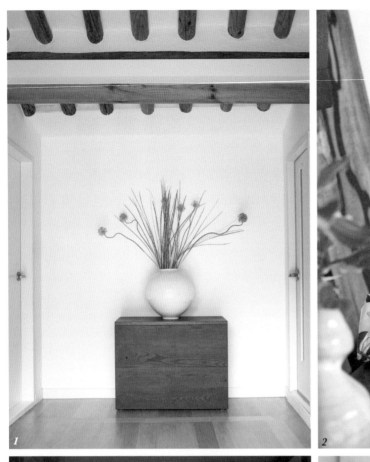

설 텐데, 그는 외려 반가운 마음이 크다. 분명한 건 우리의 일상에 지극히 전통적으로 아주 오래된 일상복이 조금씩 자리를 차지하고 있다는 사실 아닌가. 전통 한복은 전통 한복대로 격을 지키되, 일상 한복은 말 그대로 편안하게 접할 수 있는 보편적 미감과 기능이 따라야 한다는 게 그의 지론이다.

외희의 한복은 전통 한복의 구조와 비례는 그대로 따르되, 소재나 디테일에 변화를 주는 것이 특징이다. 직선 고름을 양장 기법인 사선 바이어스로, 충무누비 대신 다이아몬드 누비를 적용하는 식이다. 원색보다는 무채색으로 배색을 넣거나 원색에 무채색을 중첩해 오묘한 색감을 만들어 내는 것도 특징이다. 세탁하기 쉬운 소재를 선택하는 것은 물론이다. 게다가 마름질, 재단, 바느질까지… 몇 번의 수업으로 직접 만들어 입을 수도 있다!

"한복을 만들어 팔거나 대여하는 일을 하면 돈도 더 많이 벌 수 있고 일도 편하겠죠. 일회적인 일보다는 같이 즐기고 가치를 공유할 수 있는 놀이가 됐으면 하는 바람이 컸어요. 한복 짓기를 배우는 게 어렵다고 생각하지만 막상 배우기 시작하면 재밌어서 1년, 2년째 수업을 듣는 분도 많았어요. 배냇저고리부터 시작해 아이가 자랄 때마다 전통 한복을 지어 입히는 분도 계셨는데, 아이들도 같이 와서 놀고 가곤 했어요."

## 지금 우리의 살림집

외희는 2017년부터 가회동 한옥을 작업실로 사용했으나 현재는 세컨드 하우스로 쓰고 있다. 일상에서 입기 쉬운 한복을 만들 듯 40평 남짓한 전통 한옥에 편리한 기능을 담아 모던하고 심플하게 고쳐 지었다. 한옥의 전통 방식은 지키되,

1   이정섭 목수의 나무 장과 김형규 장인의 달항아리 작품을
    장식했다.
2,3 만든 이의 정성이 느껴지는 공예품과 자연 향을 품은 식물
    을 곳곳에 장식했다.
4   주칠로 마감한 서안은 양병용 작가의 작품으로 찻상과 책
    상으로 두루 사용한다.

들개문을 들어 올리면 탁 트인 마당과 하늘을 보며 휴식을 취할 수 있다.

어떻게 하면 현대의 라이프스타일에 불편하지 않을까를 고민하니 디자인은 저절로 풀렸다.

좁은 공간을 활용할 수 있도록 곳곳에 수납장을 짜 넣고 여닫이문을 미닫이문으로 교체했다. 춥거나 덥지 않도록 단열을 보강하니 동시에 방음이 해결됐다. ㄴ 자 안채는 안방과 거실, 주방으로 연결된다. 사랑채의 경우 마당과 레벨을 맞춰 마당이 사랑채까지, 사랑채가 마당까지 연장되는 듯한 시각적 효과를 냈다. 전시 공간이나 다실 등 다양한 용도로 활용할 수 있도록 바닥에 온돌을 깔고 타일로 마감했다. 마당은 물이 잘 빠지도록 물길을 내어 비가 많이 와도 걱정 없다. 날이 무더울 때는 잠깐씩 마당에 물을 뿌려 열기를 식히는데, 아무 생각 없이 물을 뿌리는 행위 자체가 안식이 된다.

"작은 바늘을 잡고 실을 꿰고, 실크 원단을 다루는 것 자체가 무척 섬세한 일이기 때문에 아무리 무던해지려고 노력해도 뾰족뾰족 예민할 때가 많아요. 근데 이렇게 한옥에 지내면서 쉼이라는 여유가 생겼어요. 한옥은 비워야 하잖아요. 공간에 무언가를 채우지 않고 비워 내는 연습을 하면서 한 템포 내려놓으라고 공간이 저를 가르쳤죠. 또 창문이나 서까래, 디딤돌 등 나무와 돌 같은 소재가 강한 조형성을 만들어 내지만, 동시에 사람을 따뜻하게 보듬어 주죠. 마치 두꺼운 명주솜 이불을 덮은 것 같은 안온한 느낌이랄까요?"

그는 집은 보살피고 기다린 만큼 동글동글 포근해진다는 사실도 깨달았다. 아침이면 창문을 활짝 열어 집을 숨 쉬게 하는 것은 물론 정리 정돈을 생활화하니 입주할 때처럼 흐트러짐이 없고 시간이 흐를수록 생기가 돈다. 마당 한편에 있는 연못의 물고기가 겨울에도 살게끔 사랑채로 자리를 옮겨 주고, 식물도 정성껏 돌봐 꽃을 피운다.

그는 언젠가는 불을 그리고 싶다는 또 다른 꿈을 이야기했다. 한복을 통해 세상 밖으로 환하게 이름을 알린 '외희'는 한옥을 통해 비움을 배우고 안식을 얻었다. 애써 의미를 부여하거나 노력하지 않고도 그저 자연스러운 일상 모습을 아름다움으로 꿰어 내는 지금이 행복하다.

김태호·최수민 부부의 필운동 한옥

# 기억의 집, 자연 속의 방

할머니가 살던 80년 된 집을 손주 내외가 고쳐 지었다. ㄷ 자 한옥이 감싸 안은 작은
마당은 빛을 품은 또 하나의 방이다.

독일어로 공간을 뜻하는 '라움raum'은 이주를 목적으로 삼림 내 간벌지를
만드는 행위를 가리키는 동사 '로이멘räumen'에서 유래한 것으로, 울창한 숲속에
삶의 터전을 세운다는 것을 의미한다. 빛이 스미는 숲속의 빈터, 즉 나무로 둘러싸
인 유한한 생활 공간은 현재까지도 안온한 집의 상징이 된다.

참우리건축의 김원천 소장이 기억하는 필운동 한옥의 첫인상도 '라움'과
같았다. 차가 들어가지 못하는 골목길 끝자락에 자리 잡은 도시형 생활 한옥. 대문
을 열고 들어서면 문간채와 안채, 이웃 한옥에 둘러싸인 자그마한 마당을 마주하
는데, 마치 자연 속의 방처럼 느껴졌다.

"할머니가 사시던 집을 손주분이 고쳐 살겠다는 스토리가 무척 인상적이었
어요. 좋은 기억의 회복이랄까요? 80년의 세월을 이기지 못하고 여기저기 스러진
한옥을 되살리는 데 큰 의미가 있었죠."

작은 마당을 품은 필운동 한옥의 중심, 거실에는 세 식구가 가장 오랜 시간을 보내는 테이블을 두었다. 마당과 면하는 통로는 전체 유리 창호를 시공해 흐린 날에도 조명등을 켜지 않고 자연 채광을 즐길 수 있다.

## ㄷ 자 한옥이 품은 비밀 통로

힙한 공간에 전통 한옥의 디자인 요소를 적용하는 시대. 옥캉스(한옥+바캉스)라는 신조어가 생겨날 정도로 MZ 세대에게 한옥은 흥미로운 장소지만, 김태호 씨에게 한옥은 단순히 경험하고 싶은 공간이 아닌 '지키고 싶은 기억의 집'이다. "초등학교 때 할머니 댁에 자주 놀러 왔어요. 어린 시절 추억이 깃든 집인데, 할머니가 돌아가시고 방치된 모습을 보니 마음이 좋지 않았어요. 아내도 같은 생각을 하고 있었나 봐요. '우리가 고쳐서 살아 볼까' 하고 넌지시 물었더니 바로 그러자고 하더라고요."

평생 아파트에만 살던 젊은 부부가 작은 한옥을 고쳐 살겠다고 하니 양가 부모님은 걱정이 앞섰다. 춥고 불편할 거다, 늘 관리하고 돌봐야 한다, 아이 키우면서 점점 늘어나는 짐을 어떻게 감당할 거냐…. 취향과 안목을 넘어 지극히 현실적 문제를 해결해 줄 전문가가 필요했다. 서울시의 한옥 건축과 활용, 한옥살이 정보를 제공하는 온라인 플랫폼 '서울한옥포털'에서 우수 한옥으로 선정된 집을 둘러보다 참우리건축을 알게 됐고, 2020년 11월 대수선을 의뢰했다.

30평 대지에 문간채와 ㄱ 자형 안채가 나뉜 전형적인 도시형 생활 한옥은 문간채에서 마당을 거쳐 방, 대청, 방 등 각각의 생활 공간으로 직접 들어가는 구조였다. 김원천 소장은 나누어진 구조를 ㄷ 자로 연결하되, 마당과 각 부실 사이에 툇마루 같은 복도(통로)를 구성했다. 대문을 열고 현관 중문으로 들어서면 정면에 마당으로 나가는 문이, 왼쪽에 ㄷ 자형 주거 공간으로 들어서는 통로가 자리한다. 문간채와 안채를 잇는 비스듬한 통로 왼편으로 서재를, 정면으로 주방을 배치해 주방과 대청 역할을 하는 거실을 지나 화장실, 안방, 드레스룸, 아이 방이 연결되는 구조로 집의 모든 부실이 복도 너머 마당을 감싸고 있다. 아이 방 맞은편의 세탁실은 기존 장독대 구조를 활용해 집과 연결했다.

"한옥에서 가장 걱정하는 부분이 단열이죠. 앞면과 뒷면 모두 외부 공간과 맞닿아 있기 때문에 방을 복도 안쪽으로 밀어 넣었어요. 대신 마당과 맞닿는 문은 모두 유리 창호를 선택해 채광을 확보했고요. 덕분에 주방에서 설거지를 하거나, 서재에서 일할 때 언제든 마당을 바라볼 수 있죠. 복도를 사이에 두고 모든 부실과 대면하는 마당은 또 하나의 방이에요. 문을 열고 바깥으로 나가는 거죠."

## 기억이 스민 집

김태호 씨가 집의 본래 모습을 최대한 보존하면서 채광과 단열 등 불편한 점을 개선하길 원했다면, 최수민 씨는 수납과 대면형 주방 등 좀 더 세부적인 사항을 요청했다.

"저는 아주 다양한 취미를 얕게 즐기는 스타일이라면, 남편은 하나의 취미를 깊게 파고드는 사람이에요. 두 사람의 성향상 절대 미니멀리스트가 될 수 없기에 한옥에 과연 짐이 다 들어갈까 걱정이 컸죠. 다행히 세탁실과 드레스룸을 분리하고 다락방, 거실 반침(벽체를 밖으로 돌출시켜 만든 공간) 등 수납공간을 요모조모 잘 구성한 덕분에 늘 깔끔한 상태를 유지할 수 있어요."

가족이 가장 많은 시간을 보내는 장소는 거실 테이블이다. 테이블 뒷벽은 전체적으로 책과 차 도구를 수납하는 반침을 구성해 수납은 물론 단열 효과를 더했다. 최수민 씨의 바람대로 거실을 등지지 않고 주방 일을 할 수 있도록 조리대와 개수대를 ㄱ자로 배치했다. 거실을 향해 자리한 개수대는 주방과 거실을 구분하는 파티션 역할도 한다.

김원천 소장은 대들보와 집을 구성하는 주요 기둥은 본래 것을 최대한 살리면서 보강하되, 추가하는 기둥은 용도와 역할에 따라 마감을 둥글리거나 생략하는 등 변화를 줬다. 먼저 작은 면적의 공간감을 확보하기 위해 전체적으로 20cm 들어 올리고 기둥 하부를 보강했다. 또한 복도가 꺾이는 안쪽 면의 기둥은 모두 둥글게 마감해 공간이 분절되지 않고 하나로 연결되는 효과가 있다.

"기둥은 이 집이 품고 있는 고유한 기억이기도 합니다. 어린 시절 건축주가 쓰다듬던 기둥을 딸 유이도 끌어안고 놀아요. 개수대를 감싸는 기둥과 보는 마치 프레임처럼 생활의 장면 장면을 포착하고 기록하죠."

김태호 씨는 기둥뿐 아니라 다락방 구조도 그대로 살리길 원했다. 자신이 어릴 때 숨바꼭질하고 놀던 다락방은 유이가 좀 더 크면 놀이방으로 꾸며 줄 계획이다. 화장실 문밖으로 낸 작은 통로, 대문과 중문 사이의 틈새 공간 모두 유이가 뛰놀 수 있는 훌륭한 놀이터가 된다.

"처음에는 17평 남짓한 작은 평수가 답답하지 않을까, 아이가 복도를 오르락내리락하면서 다치지는 않을까 걱정도 됐어요. 유이가 움직이는 것에 소극적인

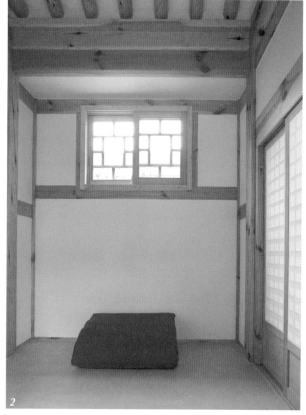

1 거실 전체에 수납장을 구성해 부부의 취미와 관심사를 알
  수 있는 차 도구와 책을 수납했다. 외벽과 만나는 부분에 반
  침을 구성하면 단열에도 효과적이다.
2 주방과 거실을 지나 안쪽에 내밀하게 구성한 안방. 아직은
  아이와 함께 자기 때문에 좌식이 익숙하고 편하다.

편이었는데, 한옥으로 이사하고 지금은 뛰어다녀요. 아이가 크는 모습을 보면서 남편의 어린 시절이 자연스럽게 오버랩되죠. 경제적, 투자적 관점에서 아파트가 낫지 않냐며 걱정하던 부모님도 저희 사는 모습을 보고 좋아하시고요."

세 살이 된 유이는 매일 마당에서 땅을 파며 논다. 마당은 대청(거실)과 비슷한 면적의 작은 크기지만 화분에 식물도 심고, 햇볕 좋은 날은 이불 소독도 한다. 유이를 데리고 산책을 나가면 동네 어르신들이 반겨 주는 골목길 풍경도 아파트 커뮤니티에서는 경험할 수 없는 장면이다. 아침, 점심, 저녁 빛의 변화는 물론, 봄과 여름 사이에도 더 많이 세부적으로 쪼개진 계절감을 느낄 수 있다는 부부. 유이도 그런 감성을 느끼고 즐길 줄 아는 아이로 자라길 기대한다.

1   원래 있던 집 모양 그대로 살린 천장 보. 짧게 자른 두 개의 보 머리가 기둥이 바깥쪽으로 뒤틀리는 것을 막아 준다.
2   옛 한옥에 있던 간유리를 화장실 문과 현관 창에 재활용했다.
3   집의 가장 안쪽 동쪽 끝에 자리한 유이 방. 맞은편 세탁실 위쪽으로도 창을 내어 온종일 환하게 빛이 들어온다. 사다리 위쪽 다락방은 수납공간으로 활용, 유이가 더 크면 놀이방으로 꾸며 줄 계획이다.
4   아이 키우는 집은 욕조가 필수. 왼쪽 외부로 통하는 문을 열면 아이가 숨바꼭질하기 좋은 비밀 공간이 나온다.

# 매일매일 한옥 스테이

한옥살이를 꿈꾼 결혼 4년 차 부부는 혜화동 골목 끝자락에 자리한 오래된 한옥을 고
쳐 살기로 결심했다. 그로부터 2년 후, 이들은 집에서 하루하루 스테이에 머무르듯 여
행하는 기분으로 산다.

오로지 한옥만이 채울 수 있는 따스한 정서를 좋아한 황오슬, 김혜림 부부
가 혜화동의 옛 한옥을 발견한 건 우연이 아니었다. 연애 시절부터 한옥 스테이를
찾아 여행을 다니곤 하던 이들은 일찍이 '한옥에세이 서촌', '일독일박' 등 전통 한
옥에 현대적 감성을 불어넣는 지랩의 프로젝트를 눈여겨보았다. 그러던 중 친한
선배 부부가 개조해 사는 '효자 라운지'를 방문하고서는 한옥에 대한 로망을 머나
먼 꿈으로만 제쳐 두지 않았다. "나중에 효자 라운지도 지랩에서 설계했다는 말을
듣고 놀랐어요. 언젠가는 한옥에 살고 싶다는 막연한 생각이 점차 손에 잡히기 시
작했지요."

1년 이상 발품을 팔며 서촌과 성북동 등지의 매물 한옥을 보러 다닌 부부는
예상외로 혜화동에서 작고 오래된 이 한옥을 마주했다. "먼저 지랩 노경록 대표님
께 이 집을 사면 고쳐 줄 수 있겠냐고 물어봤어요. 만약 대표님이 승낙하지 않았다

영화 〈리틀 포레스트〉에서 영감을 받아 빈티지 조명등과 그릇으로 꾸민 아기자기한 주방. 집으로 들어오는 좁은 골목이 내다보이는 창이 포인트. 양념통을 보관하는 오른쪽 수납장은 창고로 통하는 문이다.

면 구입하지 않았을 거예요."

　　노경록 대표가 이 집에서 좋은 첫인상을 받은 이유는 두 가지였다. 골목과 마당이다. "좁은 골목 안쪽으로 걸어 들어갈 때부터 기분이 좋았어요. 대문을 열고 들어가면 작은 중정이 보이는데, 크기 자체가 주는 포근함이 마음에 들었지요." 부부의 한옥 고쳐 살기는 여기서부터 시작되었다.

## 리틀 포레스트 부엌을 실현하다

　　두 사람 모두 광고 카피라이터이자 꽃꽂이, 그림 그리기, 엘피 음악 듣기 등 다양한 취미 생활을 즐기는 부부는 설렘을 안고 집의 밑그림을 하나씩 그려 나갔다. 특히 아내 김혜림 씨가 실현하고 싶은 가장 큰 이상은 영화 〈리틀 포레스트〉 속 부엌이었다. 맛있는 음식과 술, 그리고 사람들과 어울리기를 좋아하는 부부에게 집의 중심은 다이닝룸이어야 했다. 노경록 대표는 ㄷ 자 구조는 유지하되 기존 욕실이던 공간을 주방으로 계획했다.

　　"한옥은 기둥으로 이루어진 구조이기 때문에 어떤 배치든 포용할 수 있다는 것이 장점이에요. 골목에서 보이는 창문 쪽에 주방을 배치해 다이닝룸과 중정까지 소통할 수 있도록 했어요. 반대편은 거실과 침실로 계획해 프라이버시는 확보하면서 동선을 연결했지요."

　　짙은 원목과 화이트 타일로 꾸민 빈티지한 부엌은 과연 영화 속 아기자기한 분위기를 그대로 간직하고 있다. 부엌 양 끝으로 창을 낸 것은 부부의 아이디어다. "집 앞 골목이 내다보이는 창이 있으면 좋겠다고 생각했어요. 덕분에 가끔 사람들이 카페인 줄 알고 들어오기도 하지만.(웃음) 반대편에는 조그마한 창이 있었는데, 창 너머로 커다란 은행나무가 보였어요. 가을이면 노랗게 물든 풍경을 실내에 들일 수 있겠다 싶어 큰 창을 만들어 달라고 요청했지요."

　　10평형대(건축 면적 33㎡) 규모의 작은 한옥이기에 무엇보다 공간 효율성을 높이는 일이 주요했다. 주방과 다이닝룸 중심의 한정된 공간에 침실을 따로 두기에는 여러모로 딜레마가 있었다. 이에 공간을 더 이상 횡으로 넓힐 수 없으니 종으로 활용하는 방법을 찾았다. 거실을 복층 구조로 고안한 것이다. "침실로 쓸 다락을 만들어야 했기에 층고가 굉장히 중요했어요. 천장을 뜯어 보니 다행히 복층으

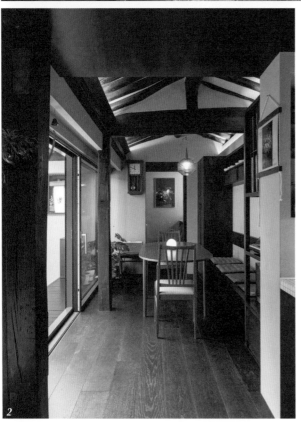

1   한옥 대문을 열고 들어가면 포근함을 주는 작은 중정이 보
    인다. 한옥은 차분한 분위기를 좋아하는 부부에게 잘 어울
    리는 짙은 우드 톤으로, 거실 쪽은 시스템 창호 대신 나무 창
    을 설치해 더욱 고즈넉하다.
2   부부가 가장 오랜 시간을 머무르는 다이닝룸. 이 집의 가장
    핵심 공간이다.

로 올릴 수 있겠더라고요." 거실과 다이닝룸에 단차가 생긴 것도 바로 최대한 층고를 높이기 위한 일환이었다. 덕분에 침실과 거실, 작은 서재는 자연스럽게 사적 공간으로 구분되면서 평상처럼 걸터앉을 수 있는 자리도 생겼다.

## 작은 한옥에 맞춘 살림살이

꿈에 그리던 한옥에 살게 되었지만, 한편으로 포기해야 하는 것도 물론 있었다. 우선 그간 쌓아 둔 세간살이를 대대적으로 정리했다. 이전 집은 지금보다 두 배 이상의 평형대에 지금의 거실만 한 드레스룸이 따로 있었기 때문이다.

"맥시멀리스트에서 미니멀리스트로 체질을 바꿔야 했지요. 사 놓고도 잘 쓰지 않는 물건과 옷은 모두 정리했어요. 예전에는 이것도 저것도 써 보고 싶었다면, 지금은 딱 좋아하는 것이나 좋은 것 하나만 사서 쓰자는 주의예요. 일단 둘 곳이 없으니까요.(웃음)"

대신 오래 두고 쓸 빈티지 가구와 소품은 심혈을 기울여 고르고 골라 집에 들였다. 소비 습관과 패턴도 자연스럽게 변한 것이다. "기나긴 시간을 머금은 빈티지는 보면 볼수록 예쁘고, 질리지 않는 것 같아요. 이 한옥도 부동산 등기를 떼 보니 준공일이 적혀 있지 않을 정도로 오래된 집이거든요. 그래서인지 이곳엔 새것보다는 오랜 세월을 보낸 빈티지가 잘 어우러지나 봐요."

노경록 대표는 부부가 자신들의 이름에서 끝 자를 하나씩 따와 소개한 '슬림 부부'라는 이름을 한옥에도 붙여 주었다. 이름하여 '슬림 한옥'이다. 부부는 슬림 한옥을 취향껏 꾸리면서 스스로에 대해 알게 된 것이 많다. "내가 이런 걸 좋아했구나, 나는 저것보다 이걸 더 좋아하는구나, 이렇게 제 취향에 대해서 알아 가고 우선순위를 정리할 수 있었어요. 아내는 옷과 화장품을, 저는 피겨를 많이 처분했거든요. 빈티지 가구나 꽃, 식물과 비교했을 때 순위에서 밀린 것이죠." 정리한다고 했지만 이사 와서 보니 여전히 마당은 짐으로 가득했다. "그걸 보면서 참 불필요한 것을 많이 가지고 살았다고 느꼈어요."

어떻게 보면 부부에게 한옥에서 산다는 건 비움의 연속이었을지도 모른다. 한옥은 그 자체로 비움의 미학을 담고 있으므로. "이번 프로젝트의 큰 의미는 작은 중정에 있다고 생각해요. 마당을 있는 그대로 비워 두고 온실이나 실내로 만들

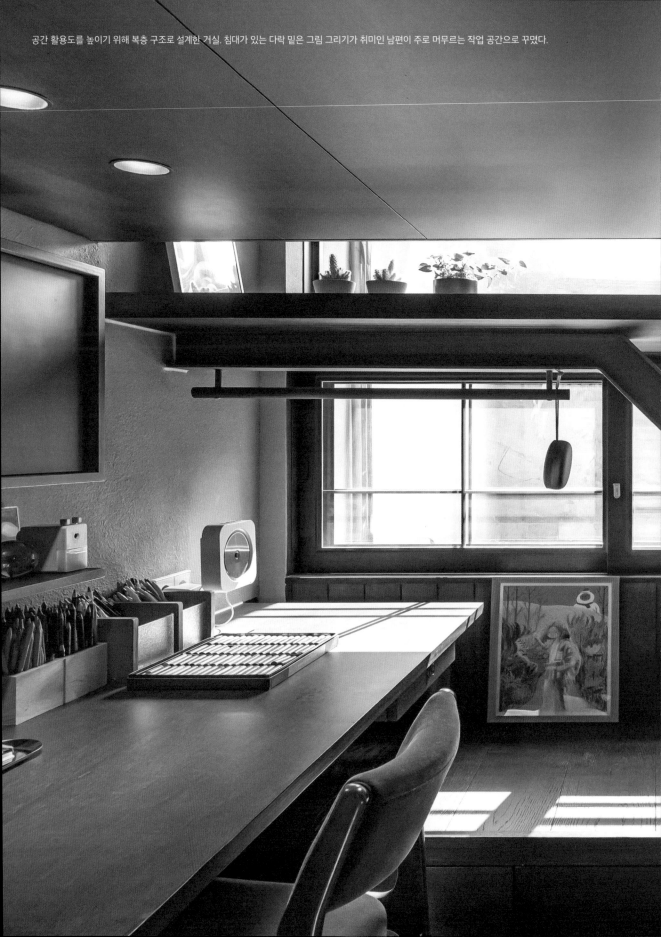

공간 활용도를 높이기 위해 복층 구조로 설계한 거실. 침대가 있는 다락 밑은 그림 그리기가 취미인 남편이 주로 머무르는 작업 공간으로 꾸몄다.

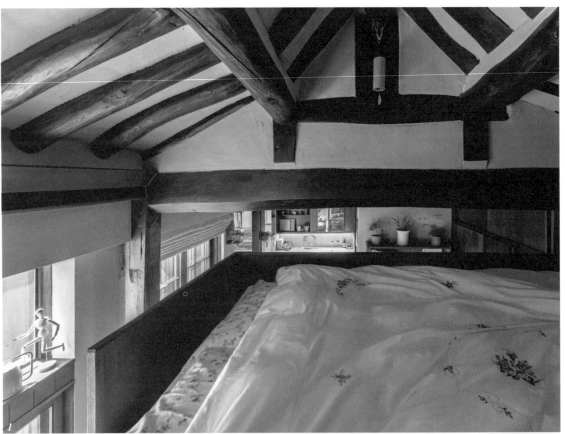

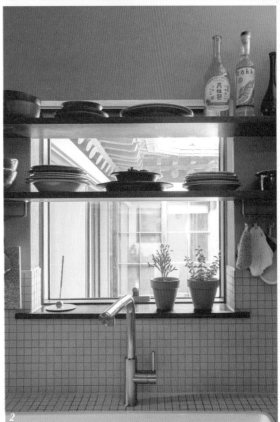

지 않는 자세. 운 좋게도 건축주와도 뜻이 통했죠. 실내 공간을 넓히기 시작하면 끝이 없거든요." 노경록 대표의 소회다. 잠시 여행을 온 것처럼 머무를 때만큼은 온전히 머리와 마음을 비울 수 있는 집. 그래서 다시 에너지를 충전하고 영감을 채울 수 있는 집. 겸손하게 비어 있기에 무엇이든 담을 수 있는 혜화동 한옥은 그렇기에 더욱 소중하다.

1  다락방처럼 아늑한 느낌을 주는 2층의 침대.
2  주방 개수대 쪽에도 작은 창을 내 좁은 주방이지만 답답한 느낌이 들지 않는다.
3  술과 책, 식물을 좋아하는 부부의 취향이 한눈에 드러나는 코너.

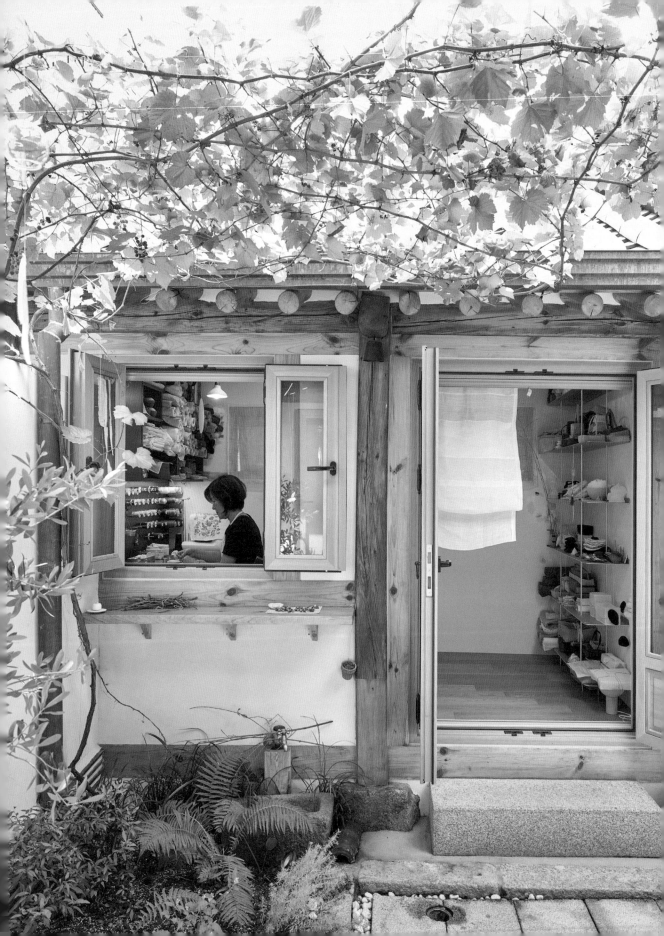

# 전통의 질감과 색감을 어루만지다

---

길가의 돌과 나뭇잎, 산과 강물이 그리는 선… 자연물에서 영감을 얻어 지은 작품으
로 위로와 응원을 건네는 작가 최희주. 서촌에 자리한 작업실은 그의 작품만큼이나
다정하게, 쏟아지는 햇볕만큼이나 따스하게 우리를 맞이한다.

수많은 인파로 늘 북적이는 서촌. 대로에서 한 켜 안쪽으로 들어가면 언제
그랬냐는 듯 조용한 주택가가 나타난다. 한 골목 들어갔을 뿐인데 분위기는 완연
히 다르다. 한 사람이 겨우 지나갈 만한 길을 지나 다닥다닥 붙은 집들 사이에 최
희주 작가의 작업실이 있다.

최희주는 모시와 삼베, 무명 같은 전통 섬유를 바느질해 일상의 기물과 오
브제를 만드는 작가다. 약하디약한 패브릭은 그의 손을 거쳐 때로는 액운도, 불운
도 척척 막아 주는 명태의 모습이 되었다가, 무겁고 단단한 돌로 변신해 휘청이는
마음에 가만히 추가 되어 주는가 하면, 휘영청 밝은 보름달이 되어 빛나기도 한다.
그는 이렇게 우리에게 익숙한 풍경을 단순하게 표현해 직물의 고유한 질감과 색
감을 담뿍 보여 준다. "모시나 삼베 같은 전통 소재의 고르지 않은 표면, 불규칙한
선이 살아 있는 모습이 좋았어요. 자연 원료를 그대로 섬유로 만든 것이라 이 풀

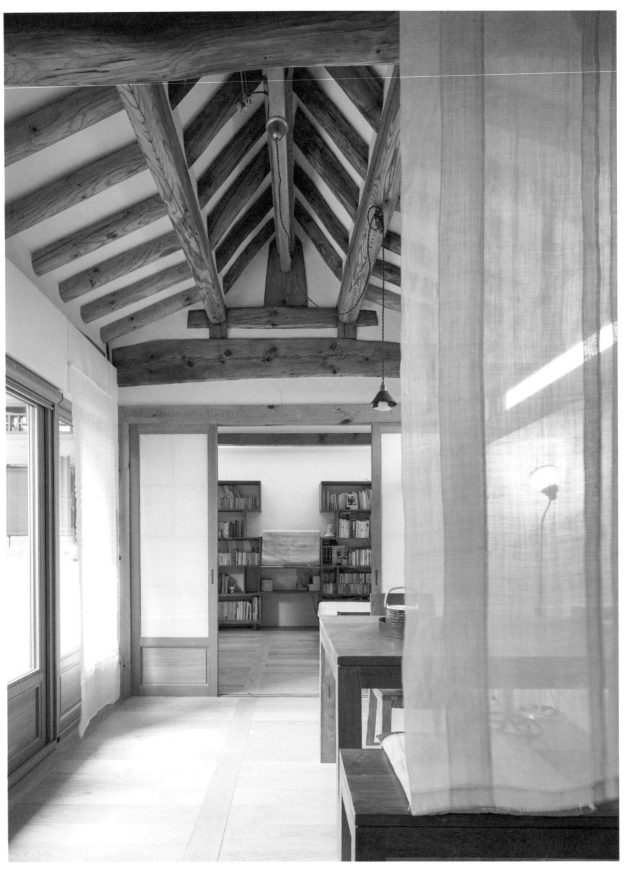

원래 집의 오량식 구조를 살린 지붕 모습.

은 어디에서 어떤 바람과 햇빛을 받으며 자라났을지 거쳐 온 과정을 상상하게 되고요. 그 본연의 아름다움을 내보이고 싶었습니다."

그래서 그는 기교를 부리고 싶은 마음을 참고, 많은 표현을 덜고 또 덜어낸 끝에 선 하나를 남겨 작품을 짓는다. 산책하다 주운 도토리 껍질, 나뭇잎과 열매, 구름과 달빛까지. 그에게는 자연이 작품의 주인공이자 영감을 주는 뮤즈다. 그리고 그 속에는 자연으로부터 얻은 더 큰 마음이 깃들어 있다. "저는 자연에서 가장 큰 위안을 받아요. 제 작업에 자연을 담는 이유는, 작품을 사용할 사람에게도 조금이나마 제가 느낀 위안을 주고 싶어서예요. 그래서인지 갤러리보다는 집에 두고 볼 때마다 기분이 좋아진다는 말을 들을 때 가장 기쁩니다."

사람들에게 든든함을 주고 싶다는 마음이 담긴 작품은 이를테면 이런 것. 삼베로 모양을 만들고 메밀껍질을 넣어 만든 일곱 개의 검은 돌, 〈공든 탑〉은 아침에 일어나 하나씩 쌓는 오브제다. 하루하루 공들여 살자는 마음으로 돌탑을 쌓듯 올리고, 일곱 개를 다 쌓으면 일주일을 잘 보냈다는 소소한 보람이 또 한 번 쌓인다. 어머니가 60년 동안 사용한 목화솜 이불 홑청으로 만들었다는 〈매일이 보름달〉은 또 어떤가. 풀을 먹이고 다듬질하던 어머니의 시간과 어린 시절 작가의 추억을 함께 품은 이불로 햇빛처럼 눈부시지 않으면서 포근하게 감싸 주는 달빛을 지었다. 틈을 선으로 표현한 작품 〈돌담〉에는 틈이 있어 더 올곧게 서 있을 수 있는 돌담처럼 우리도 틈을 지니고 살자는 뜻이 담겼다. 갤러리 늬은에서 열린 전시 〈돌 달 바람〉에서 선보인 작품인데, 한창 사회생활을 하는 젊은이들이 한바탕 눈물을 쏟았다고.

이렇게 마음을 담아 사람들을 울리고 웃게 하던 작업은 모두 작년 초 새로이 둥지를 튼 이곳 서촌 작업실에서 이뤄졌다. "아이들이 독립한 후에 남은 삶을 어디서 살아갈지 많이 고민했어요. 즐겨 드나들고 너무나 좋아하던 서촌과 북촌에 작업실을 알아보게 됐고, 간소하게 살고 싶은 마음에 작은 공간을 찾았습니다."

## 자연을 품은 집, 집을 닮아 가는 사람

그가 처음부터 한옥을 생각한 것은 아니었다. 원하는 조건이던 주차 공간이 없더라도 지하철역이 가까운 곳, 평지인 곳을 찾다 보니 대부분 한옥이었던 것.

그러다 발견한 곳이 지금의 작업실이 됐다. "골목 안쪽에 자리한 집이라 답답할 것 같아 큰 기대는 하지 않았어요. 그런데 대문을 열고 보니 웬걸, 비밀의 화원처럼 햇볕이 엄청 환히 드는 거예요. 답답하다는 말이 아늑하다는 표현으로 바뀌는 순간이었죠."

1923년에 지어 100세를 바라보던 한옥은 낡고 오래되기는 했지만, 여러모로 공들여 지은 집이었다. "보통 이렇게 작은 집은 지붕이 보 세 개가 지지하는 삼량식인데, 이 집은 오량식이에요. 공사를 하면서 없어졌지만, 색색깔의 기와와 전돌로 정성스레 무늬를 새긴 꽃담이 있었고, 가로로 길게 난 조그마한 창도 아름다웠어요."

하지만 그만큼 오래 사용한 집이었기에 수리를 피할 수는 없었다. 작업 생활에 맞춰 공간도 새로 짰다. 워낙 면적이 작다 보니 집을 고치는 일은 덜 원하는 것을 내어 주고 더 원하는 것을 얻는 과정의 연속이었다. 가장 먼저 들인 것은 별채다. 작은 집이었지만 작업 공간은 따로 두기 위해 대문을 줄이고 별채를 지었다. 햇볕이 가장 잘 드는 곳은 그가 가장 좋아하고, 또 많은 시간을 보내는 부엌과 다이닝 공간에 내어 주었다.

나머지 생활 공간은 1cm도 남기지 않고 테트리스 하듯 차곡차곡 채웠다. 우선 필수 요소인 소형 세탁기와 건조기, 찻장, 그리고 반신욕을 위한 욕조 놓을 자리를 확보했다. "홍차 도구와 찻잔을 두는 찻장은 폭이 30cm도 안 돼요. 일본

1   작업실 한쪽 벽면을 가득 채운 소재와 도구들.
2   가구에는 평소 좋아하는 금속 공예가 이윤정이 작업한 손잡이를 달았다.
3   부엌 한쪽 천장에는 어머니가 60년 동안 사용한 목화솜 이불 홑청으로 지은 〈매일이 보름달〉과 〈푸른바다 모시명태〉가 은은히 매달려 있다.
4   전시 〈돌 달 바람〉에서 선보인 돌 작업. 삼베에 메밀껍질을 채워 일곱 개의 검은 돌을, 솜을 채워 다섯 개의 하얀 돌을 지었다.

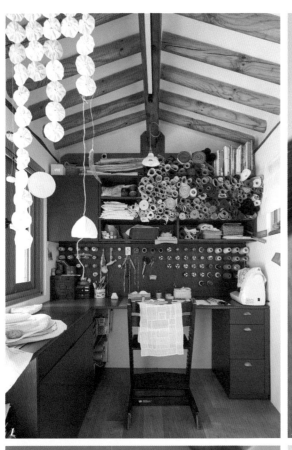

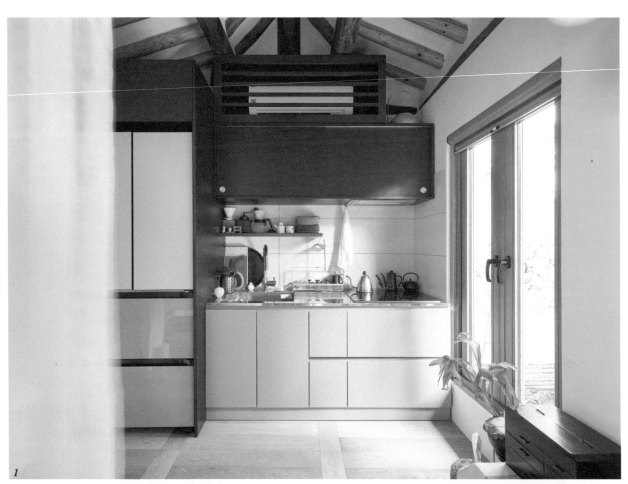

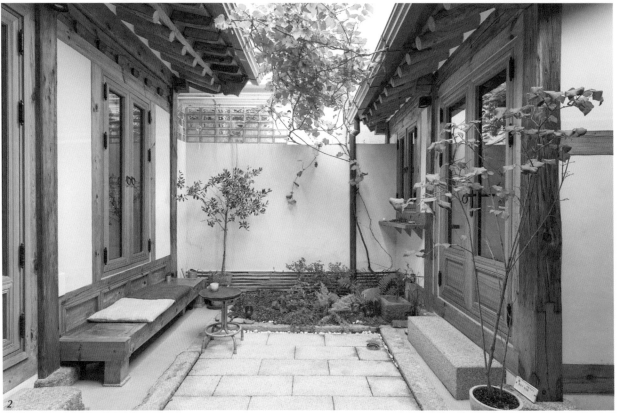

에서 지낼 때부터 너무 아끼던 가구라 먼저 놓을 자리를 정했어요. 모자란 공간은 수납장의 크기를 줄이고 물탱크가 없는 직수형 도기 제품, 돌출형 세면대를 열심히 찾아 보완했습니다."

목재로 지은 한옥이라 수평과 수직이 정확하지 않았기 때문에 가구부터 창문까지 일일이 실측하고 공간에 맞춰 제작했다. 그렇게 설계와 시공에 쏟은 기간만 1년 6개월. "한옥이다 보니 외관 디자인도 쉽지 않았어요. 돌이나 나무 같은 재료만 써야 했고 옆집과 마감재 색상을 통일해야 하는 등 수많은 시행착오를 거쳤어요."

그렇게 어렵게 지었지만, 그만큼 이곳에서 얻은 결실도 가득했다. 1년 넘는 시간을 보내는 동안 수많은 소중한 것을 만들어 냈다. "예전에 살던 아파트에서는 한강이나 산이 멀리 그림처럼 보였는데, 여기는 인왕산도, 북악산도 바로 제 옆에 있는 느낌이에요. 주변 풍경이 달라지니 작업도 바뀌더라고요. 여기 와서 바위산을 많이 보다 보니 돌을 작업하게 된 것 같기도 하고요. 어디서 어떤 모습으로 사는지가 저라는 사람에게도, 작업에도 아주 큰 영향을 준다는 것을 실감했습니다."

어떤 공간은 작아서 오히려 더 아름답다. 최희주 작가의 한옥도 그런 곳이다. 일상에 기쁨을 주는 자그마한 작품과 이를 짓는 사람, 그리고 이들 모두를 아늑하게 품은 장소. 앞으로는 이곳에서 또 어떤 아름다움이 탄생하게 될까.

1   최희주 작가가 가장 많은 시간을 보내는 부엌.
2   햇볕이 환히 드는 아늑한 마당.

전통 재료로 모던하게 새로 지은 집

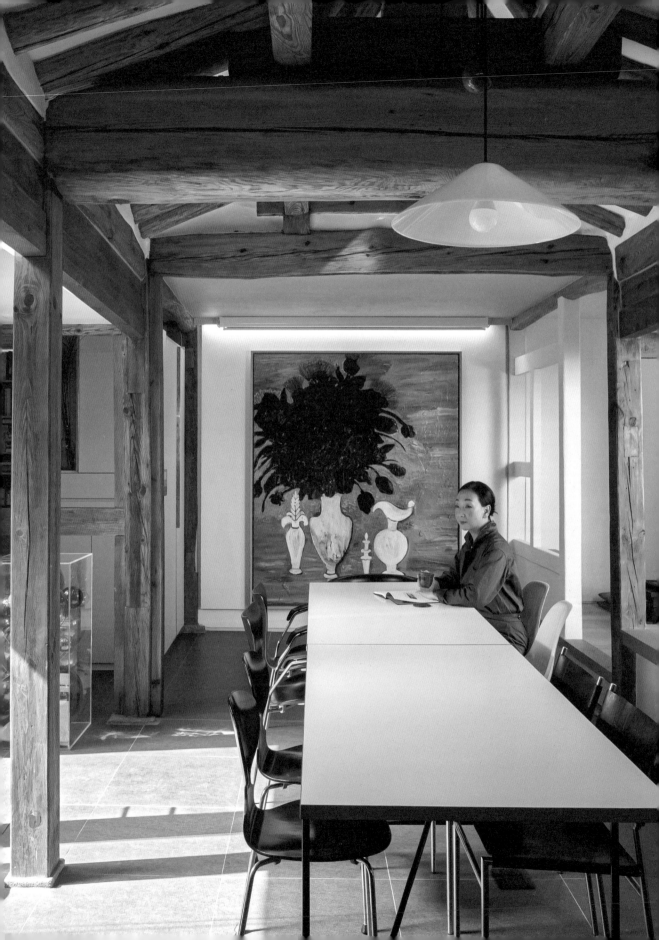

# 영혼까지 자극받아야 진짜 좋은 집

일단 마당을 비우고 시작하는 한옥에서는 누구나 크리에이터가 되고, 그렇게 성실하게 가꾼 공간은 저마다의 아름다움으로 빛이 난다. 착착 건축사무소 김대균 건축가와 건축사사무소 로그의 신민철 소장, 그리고 미술 평론가 유경희 대표가 합심해 완성한 서촌의 한옥은 전통적이면서도 모던해서 그 창의력과 상상력에 유독 큰 지지를 보내고 싶은 곳이다.

"제게 절대적으로 중요한 것이 있는데, 그중 하나가 집이에요. 2018년 평창동에서 전세살이를 할 때도 5,000만 원을 들여서 집을 고쳤어요. 정원을 만드는 데만 600만 원이 들었지요.(웃음) 집이 그만큼 중요해요. 이런 공간이면 좋겠다는 기준도 명확하고요. 일단 시적詩的이어야 해요. 어둠이 섞인 빛에 로망이 있지요. 약간 어두운 데 가만있으면 서서히 형체가 드러나는 곳 있잖아요. 그런 곳에서 책을 읽는 일, 그것이 제가 생각하는 최고의 사치이자 럭셔리예요. 의식과 무의식, 영혼과 영성이 함께 깨어나고 진화하는 것이 중요하지요. 온갖 작품과 아트에도 욕심이 많지만, 그런 집을 위해서라면 기꺼이 다 포기할 수 있어요. 내가 예술 작품이 되는 거잖아요. 고대 이집트에 《사자의 서》(이집트어로《빛을 벗어나는 책》)라는 책이 있어요. 인간이 죽어 지하 세계로 내려가 삶을 심판하는 오시리스를 만나면, 그가 그런대요. '너는 다른 사람을 얼마나 기쁘게 해 줬느냐?' 단순히 웃고 떠드는 게

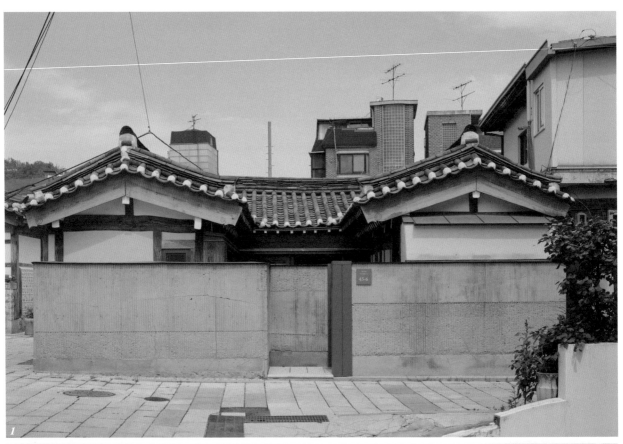

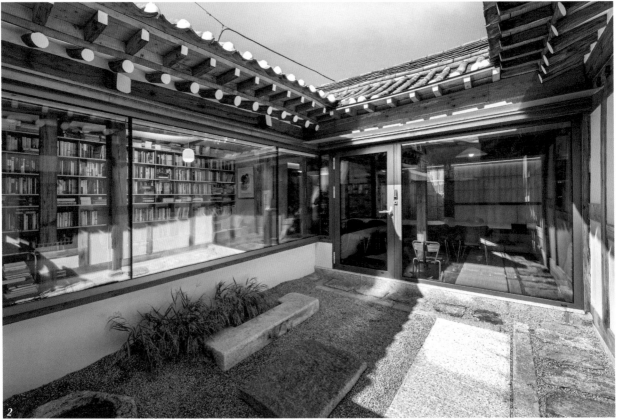

아니라 누군가를 고무해서 한 차원 높은 사람으로 만들어 줬느냐를 묻는 거에요. 집도 똑같아요. 단순히 편하고 쾌적한 것만으로는 부족해요. 진짜 좋은 집이라면 나를 영적으로 보듬고 한 단계 높은 쪽으로 진화시킬 수 있어야 해요."

지금껏 쓴 책만 열 권이 넘고, 한곳에서 강연을 시작하면 10년에서 20년까지 롱런하는 유경희 대표와 하는 대화는 생기가 넘쳤다. 오랜 지인인 양정원 선생이 그를 일컬어 "야성과 지성을 동시에 갖고 있는 사람"이라고 했다는데, 어떤 말인지 알 것 같았다. 정신분석학 박사이기도 한 까닭에 이야기는 미술사와 미학, 정신 분석과 심리를 넘나들었고 카를 융과 지그문트 프로이트, 자크 라캉과 질 들뢰즈가 수시로 등장했다. 그리고 그 사이사이 김원일의《마당 깊은 집》에서처럼 어릴 적 마당을 중심으로 여덟 가구가 옹기종기 모여 있는 큰 한옥에 살며 너무 일찍 인생을 알아 버렸다는 이야기며, 어둑한 분위기에서 책 읽고 공부하는 시간이 좋아 정릉 집에 살 때도 남쪽으로 난 창은 다 막아 버렸다는 에피소드가 꿀처럼 맞물려 들어갔다. 고 이어령 선생을 뵈었을 때도 두 시간여 동안 진행한 인터뷰가 질문지 한 번 들여다볼 필요 없이 매끈하게 흘렀는데 그녀와 하는 인터뷰도 그랬다. 이렇게 매력과 생기가 분출하는 지성이라니.

## 대강의 정신으로 지은 반침의 집

착착 건축사무소의 김대균 건축가도 그의 이런 매력에 꼼짝없이 포위당했을 거라 본다. 알아 온 시간만 20여 년. 김대균 건축가는 "사물을 바라보는 감도도 다르고, 배우는 것도 많아 커뮤니케이션이 즐겁지요. 워낙 좋아하는 선생님에

---

1   이 집의 하이라이트 중 하나인 토벽. 담장에 구현한 박서보의 묘법이라고 할까? 많이 사용하는 네모반듯한 화강암이 아니라서 더 특별한 표정으로 와닿는다.
2   대문을 열고 들어가면 만나는 정원. 땅과 하늘에 큰 공간을 선뜻 내주는 것이 한옥의 오랜 매력이자 철학이다.

오랫동안 모은 찻사발 수십여 점을 벽에 진열한 다실. 이곳에 앉
으면 맞은편으로 탁 트인 후원이 펼쳐진다.

요"라고 했다.

'이상의 집' 레노베이션 같은 공공 건축부터 빌라와 공유 주택, 그리고 농農을 주제로 열린 하우스비전에서 선보인 '컬티베이션 하우스'까지 다양한 프로젝트를 선보이는 그는 유경희 대표와 지은 서촌 한옥에서도 특유의 기분 좋은 위트와 실험 정신, 그리고 감각을 발산했다.

가장 돋보이는 것은 외벽. 한옥 담장이라고 하면 보통 화강암 재질의 네모반듯한 사고석과 기단석이 먼저 떠오르는데 그가 선택한 것은 토벽. 흙을 다진 후 골강판을 댔다 떼어 만든 것으로, 흙벽에 일정한 간격으로 길게 골이 패어 저 멀리서부터 색다른 미감으로 와닿는다. 유경희 대표는 "딱 박서보 화백의 묘법"이라며 웃었다. 현관의 위치도 두고두고 만족도가 높은 대목이다. 한국 전통 건축의 핵심 중 하나가 집으로 곧장 들어가지 않고 빙 돌아 에둘러 가며 환유의 풍경을 누리는 건데, 대문을 정문이 아닌 오른쪽 측면에 둬 마당을 지나 집으로 들어가기까지 짧은 산책을 하는 것처럼 달콤한 기분을 맛보게 한다. 그렇게 들어선 마당에는 잘생긴 넓적돌과 우물 돌이 단정하게 들어앉아 있다. 위로는 하늘이 뻥 뚫려 있고.

정원은 내부에서도 이어진다. 거실 뒤편이자 다실의 오른쪽으로 난 또 하나의 후원. 마사토로 바닥을 다졌는데 등고선처럼 약간의 높낮이가 있고, 앞뒤로 한 움큼의 옥잠화와 사시사철 아름다운 남천이 있다. 내부 공간과 정원 사이에는 한지 창이 있고, 그 주변으로는 쪽마루 같은 공간을 만들어 언제든 그곳에 걸터앉아 책 보고 음악 들으며 느긋하게 시간을

보낼 수 있도록 했다.

설계의 묘가 도드라지는 부분은 반침이다. "많게는 20명 가까이 모여 강연도 하고 파티도 하는 공간이지만, 사적 공간이기도 하니 쉬면서 충전도 할 수 있도록 공간에 정취가 있으면 좋겠다는 생각을 했는데 그 해법으로 한옥의 전통 요소 중 하나인 반침을 적용했습니다. 작업실, 주방, 뒷마당 창까지 거의 모든 공간에 밖으로 반침을 냈지요. 이렇게 하면 구조 기둥 밖에 공간이 하나 더 생겨 입체적 레이어가 만들어지고, 집도 한층 넓게 쓸 수 있어요. 공간과 구조가 유연해지면서 내부와 외부의 중간 지대에 걸터앉아 있는 것 같은 기분도 들고요. 이 집을 반침의 집이라 부르는 이유예요." 김대균 건축가의 말이다.

건축가에게 공간에 대한 철학이 있느냐 없느냐 하는 것은 집에 정신이 깃들어 있느냐 아니냐와 같은 의미다. 당연하게도 건축가에게 철학이 없으면 그저 번듯한 외연을 구축하는 데 그치고 만다. 건축주 입장에서는 건축가의 그 철학이 곧 그 집에 사는 즐거움이 된다. 이 집에 담고 싶던 김대균 건축가의 철학은 '내외부로 자연스럽게 뻗어 나가는 대강의 집'. "반침의 집에서 신경 쓴 것은 내부와 외부의 연결이었어요. 옛것과 새것의 연결이기도 했고요. 반듯하고 대단한 게 아니라 어수룩하지만 편안한 공간을 만드는 것이 중요했습니다. 대강과 대충은 달라요. '자세하지 않은, 기본적인 부분만을 따낸 줄거리'가 대강의 뜻이에요. 뜨개질을 할 때 큰 틀만 짜면 나머지는 패턴으로 자연스럽게 흘러가는 것과 비슷하지요. 대충은 말 그대로 성의가 없는 거고요. 한옥은 대강의 집이고, 사람을 쉬게 한다는 큰 원칙과 덕목을 갖추고, 나머지 세세한 부분은 그 입지와 상황에 맞게 자연스럽게 줄거리를 잡아 나가는 것이 중요해요. 반침을 통해 건축주의 일과 휴식, 공적 시간과 사적 시간이 확장되고 연결되길 바랐습니다."

좋은 건축주가 좋은 건축가를 만난다고 했던가. 세상에서 제일 좋은 게 무엇이고 또 그 이유가 무엇인지 설명할 수 있는 이가 유경희 대표지만, 집 짓는 일은 건축가에게 일임하다시피 하고 이 기간 동안 《반 고흐: 오베르쉬르우아즈 들판에서 만난 지상의 유배자》란 책을 탈고했으니 이 내공은 또 뭔지 싶다. 그런 믿음과 지지에 부응하고자 건축가는 또 최선의 최선을 찾아내고. 옆집이나 앞집의 민원도 일일이 공유하지 않았는데, 김대균 건축가는 "그런 건 당연한 것"이라며 웃

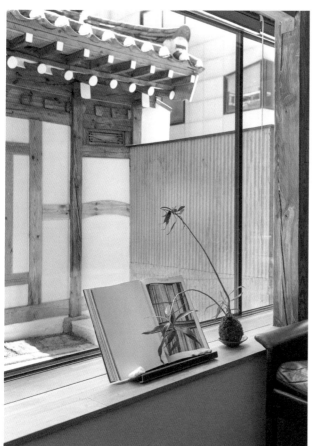

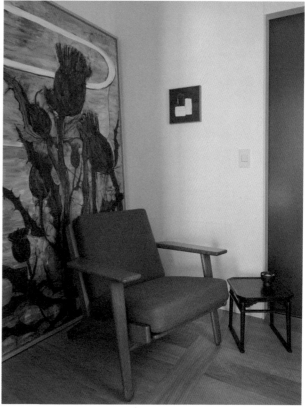

유경희 대표의 관심사와 미학을 알아볼 수 있는 물건들.

거실 뒤쪽으로 펼쳐진 후원. 정원은 눈 쉬고 마음 쉬는 일상의 심산유곡이다.

었다.

　　유경희 대표는 인터뷰를 하는 동안 "나를 초월하게 하는 빛이 중요하다. 그 빛은 책과 집에 있더라. '내면의 빛을 찾아서'가 나의 인생 철학이다"라는 말을 많이 했다. 빛을 한껏 끌어들이는 고딕 양식보다 적당한 어두움이 있어 내면에 눈을 뜨게 하는 로마네스크 양식을 좋아하는 이유도 그 때문이라고. 기능적이고 장식적인 것에서 탈피한 이런 본질적 말과 생각은 그 자체로 건축가에게 가이드라인이자 미션이 될 것 같았다. 그리고 바로 그 지점에서 풍성하고 건설적 교신이 일어나는 것이 집 짓기의 진정한 즐거움은 아닐지. 서촌 골목길에서 이 집을 볼 때마다 그 안의 시간과 풍경이 궁금할 것 같다.

# 평온하고 자적한 삶을 위하여

한옥을 짓기로 마음먹고 완공하기까지 2년 반 정도 걸렸다. 공간 구성과 자재 선택은
기본이고, 지붕의 수막새(수키와 끝부분에 달린 동그란 부분)와 지네철(양쪽의 박공
을 연결해 고정하는 꺾쇠 모양의 철물)까지 원하는 대로 맞춤 제작했다. 다시 부부만
의 평온하고 자적한 삶을 살기 위해, 공예품처럼 하나하나 매만져 지은 한옥이다.

부부 둘이 살다가 아이가 태어나면 삶의 방식이 아이 중심으로 바뀌고, 아
이가 장성해 독립할 나이가 되면 다시 부부 둘의 삶으로 돌아갈 준비를 해야 한
다. 부부가 지향하는 삶에 대해 다시금 생각해 보고, 집 규모와 구성을 그에 맞게
재정비할 기회를 갖는 것이다. 결혼해서 줄곧 강남에서 살아온 윤종하(금융업), 김
은미(대학교수) 부부는 이런 시기가 다가오자 한옥에 살아 보기로 마음먹었다. 김
은미 씨는 어린 시절 조부모가 살던 경운동의 큰 한옥에 대해 좋은 기억이 있고,
외국 생활을 오래 한 윤종하 씨는 한옥을 경험한 적이 없지만 언젠가 꼭 살고 싶
다는 바람이 있었다. 부부는 꿈꾸던 한옥을 찾아 다녔다.

부부가 찾은 한옥은 1930년대에 지은 데다 몇 년이나 방치돼 있었다. 도저
히 리모델링으로 복구할 수 있는 상태가 아니라서 전부 철거하고 다시 지어야 했
다. 사실 관리가 안 된 오래된 한옥을 개축하기보다는 신축하는 편이 시간과 비용

다이닝룸에 베이 윈도와 벤치를 만들었다. 한쪽 창은 스테인드글
라스로 장식했다. '동서양의 교차' 콘셉트를 가장 잘 구현한 공간
이다. 오른쪽 문으로 나가면 마당과 바로 이어진다.

을 훨씬 아낄 수 있다. 게다가 이 집 같은 경우에는 신축하면서 한옥 아래에 지하 공간을 만들고 주차장까지 마련할 수 있었다. 무엇보다 서쪽에 면한 벽을 허물면 동네 일대와 인왕산까지 시원하게 펼쳐질 터였다. 부부는 이 풍경을 살뜰히 품은 서향집을 짓기로 했다. 설계는 한옥건축 경험이 풍부하고 오래전부터 알고 지내던 황두진 건축가에게 의뢰했다. 작은 마당에는 웃자란 풀이 무성하고 오래 보살피지 않아 쇠진한 한옥을 보고 건축가는 아주 오래전 기억을 떠올렸다. 신기하게도 그가 건축학과 학생이었을 때 실습차 실측하러 온 바로 그 한옥이었다. 아직도 남아 있는 30여 년 전의 실측 도면에는 한옥의 구조뿐 아니라 살림살이 하나하나, 마당의 강아지와 개집까지 세밀하게 그려져 있다. 그들이 이 한옥을 만난 건 어떤 오묘한 인연이 작용한 덕분인지 모른다. 부부의 한옥 짓기는 첫 장부터 흥미진진했다.

## 한옥은 '동사動詞'의 공간

부부는 한옥 짓기를 결정하고 나서 어떤 집을 지을지 구체적으로 구상하기 시작했다. 한옥에 관한 책을 여러 권 통독하고 건축, 인테리어 관련 책과 잡지를 보면서 마음에 드는 이미지를 스크랩해 건축가와 공유하며 세세한 의견을 수도 없이 주고받았다. 부부끼리 의견이 맞지 않은 부분은 서로 조금씩 양보하고 조율했다. "부부는 아이가 크면서 점점 공유할 소재

가 떨어지고 각자 바쁘다 보면 자연스레 같이하는 시간도 줄게 되거든요. 그런데 우리는 한옥을 지어야 하니까 고궁과 고택을 같이 다니고, 한옥 관련 책을 번갈아 읽고, 열심히 토론하고, 앞으로 한옥에서 어떻게 살 것인지 고민하면서 이야깃거리가 끊이지 않았어요."

부부는 일생에 단 한 번뿐일 한옥 짓기의 과정에 여유를 두고 적극 참여하며 진정으로 즐겼다. "상량식을 하는 날에는 남편이 좋아하는 동양화가 문봉선 화백이 상량에 붓글씨로 '穩睦閑自適(온목한자적)'을 일필휘지하는 퍼포먼스를 했어요. '온목한자적'은 우리 부부가 지향하는 삶의 방식을 한자 다섯 글자로 표현한 거예요. 여기에서 마지막 두 글자 '자적'을 당호로 지었고요. 자신의 속도 대로 편안하게 즐기면서 살자는 뜻을 담고 있습니다." 부부는 공사가 본격적으로 시작되자 매주 현장에 나갔다. 건축가와 대목을 만나 이야기를 나누고 한옥이 조금씩 완성되어 가는 모습을 지켜보았다.

### 한옥의 포근함, 유연함, 반전

자적당은 대청마루를 중심으로 양쪽에 부엌과 침실이 이어지는 ㄷ 자형 한옥이다. 대청은 서쪽으로 훤히 트인 마당을 마주한다. 창호가 많은 한옥에서는 창호 자체가 장식 요소가 되는데, 이 집에서도 한쪽 벽을 채우는 화려한 창살과 그 옆의 둥근 문이 분위기를 주도한다. "창덕궁 낙선재의 만월창과 그 창살을 구현한 거예요. 한옥을 지은 정영수 대목이 창호까지 작업하셨지요. 원래 창호는 소목이 하는 일인데 정영수 대목은 소목부터 시작한 분이라 저희가 원하는 창호를 다 만들어 주셨어요. 무엇보다 감동한 부분은 굵은 보의 가장자리를 부드럽게 둥글린 거예요. 육중한 나무를 가정집에 어울리도록 포근하게 만들어 주신 거죠. 저희는 신경 쓰지 못한 부분인데, 이런 디테일이 한옥의 멋을 굉장히 살려 주거든요."

대청에서 부엌 쪽으로 몸을 돌리면 성당에서 볼 법한 스테인드글라스가 깜짝 등장한다. 그 창을 마주 보며 부엌으로 들어가면 또 다른 반전을 보게 된다. 튼실한 보와 도리가 드러난 높은 천장 아래에 베이 윈도bay window가 보이고 그 아래에는 벤치도 있다.

"외국 생활을 오래 한 우리 부부의 라이프스타일을 잘 아는 황두진 건축가

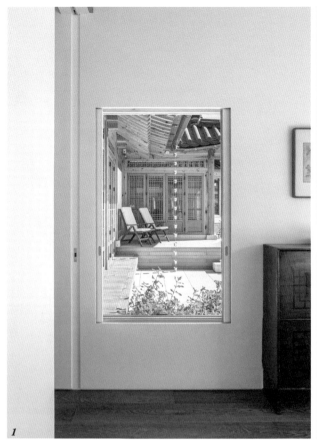

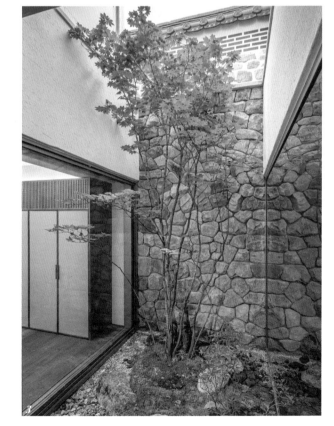

1  부부 침실의 창으로 마당이 보인다. 마주 보이는 공간은 다
   이닝룸.
2  부부 금실을 기원하는 원앙 한 쌍을 대들보 아래에 조각해
   넣었다.
3  현대식으로 지은 한옥 지하 공간에 빛과 바람을 들이기 위
   해 작은 성큰 가든을 만들었다. 성큰 가든에는 그늘에서도
   잘 자라는 산단풍나무를 심었다.

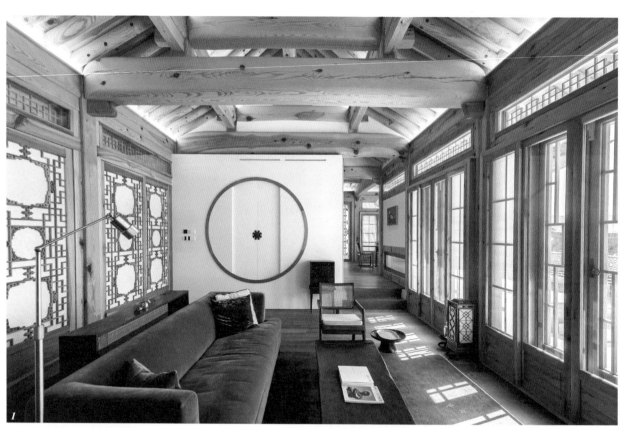

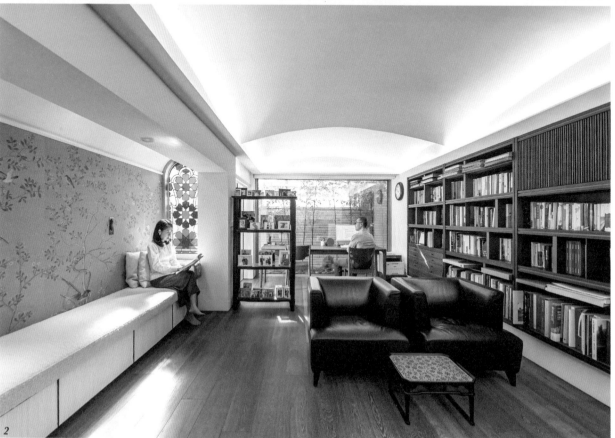

가 '동서양의 교차'라는 콘셉트를 제안했어요. 부엌의 스테인드글라스는 프랭크 로이드 라이트의 집에 있는 것을 차용했습니다. 지하의 서재에도 스테인드글라스가 있는데 남편이 아랍 건축 책에 나온 도안을 참고해 직접 그린 거예요."

건축가와 대목이 완성한 한옥에 조화로움과 실용성을 더한 사람은 인테리어 디자이너다. 이로디자인의 육연희 대표는 부부가 메인 테마로 정한 '모던 맥시멀리스트 한옥'에 맞게 전체적인 컬러와 타일, 벽지 등의 마감재를 정하고 붙박이 가구와 수납장을 디자인했다. 한옥 구석구석에는 부부의 취향과 관심사를 반영한 요소가 숨어 있다. 그중 가장 참신한 것은 남편이 좋아하는 잉글랜드 프리미어리그의 프로축구 클럽, 맨체스터 시티의 하늘색을 부부 침실의 우물천장에 넣은 것이다. 한옥 고유의 정취를 즐기면서 지금의 생활에 불편하지 않게 현대식 설비를 갖추고, 여러 양식을 혼합하거나 공예품처럼 취향대로 맞춤 제작했다.

"전에 살던 집보다 크기는 작은데 관리하기는 더 힘들어요. 그래도 수십 년간 잊고 살던 바람 소리, 빗소리를 즐기고 조금만 걸어 나가면 미술관, 맛있는 빵집을 갈 수 있으니 삶은 더 여유로워졌어요. 동네를 걸어 다니는 삶이 참 좋아요." 부부가 언젠가 현역에서 은퇴하는 날이 오면 지금보다 훨씬 더 자적한 한옥살이를 누릴 수 있을 것이다. 부부만의 오롯한 삶이 깊어질수록 대들보의 뽀얀 속살도 점점 짙어질 테다.

1   금강송으로 만든 묵직한 대들보 아래 자리한 대청마루. 흰 벽에 낸 둥근 문과 왼쪽의 창살은 창덕궁 낙선재의 만월창과 그 창살을 구현한 것이다.
2   지하에 만든 부부의 서재. 오죽을 심은 작은 마당이 보이는 창 앞에 긴 책상을 놓고 의자 두 개를 나란히 두었다. 한쪽 벽에는 알코브처럼 아늑한 공간을 만들고, 화려한 벽지로 화사함을 더했다. 둥근 창의 스테인드글라스는 남편이 직접 디자인했다.

# 다시, 집으로

경기도 화성시 기산동. 아파트가 즐비한 신도시를 지나 한산한 구도로에 진입하면 아직
개발이라는 변화를 맞지 않은 작은 마을이 나온다. 시부모님이 살던 집터에 3대가 함께
살 집을 짓고 이사한 지 5년. 한옥과 현대 건축을 접목한 백정숙 씨 가족의 화성 주택은,
외피는 단단하고 속은 새콤달콤한 과일처럼 안과 밖이 서로 다른 매력을 선사한다.

프랑스 철학자 가스통 바슐라르는 "집은 우리가 경험하는 최초의 세계"라
고 말했다. 어머니의 자궁에서 무의식적으로 느꼈을 안온함과 평화로움을 우리는
집이라는 물리적 공간에서 기대한다. 태어나고 자란 유년 시절의 집을 추억하고,
고향으로 회귀하고 싶어 하는 것은 자연스러운 본능인 셈이다.

백정숙 씨는 6년 전 시부모님이 살던 한옥을 고칠 요량으로 건축가를 수소
문하던 중 임지수 소장을 소개받았다. 지은 지 50년이 훌쩍 넘은 집은 노모 혼자
지내기에 불편한 부분이 많았고, 관리가 필요했다.

"시부모님과 남편이 살던 집이고, 제가 결혼해서 신혼을 보낸 집이기도 해
요. 이 집에서 둘째까지 태어났으니 아이들에게는 고향이나 마찬가지죠. 처음에는
단순히 혼자 계시는 어머님이 편하게 쓰실 수 있도록 레노베이션을 구상 중이었
어요. 그러다 소장님을 만나고 대수선에서 신축으로 계획이 전면 수정됐죠."

133

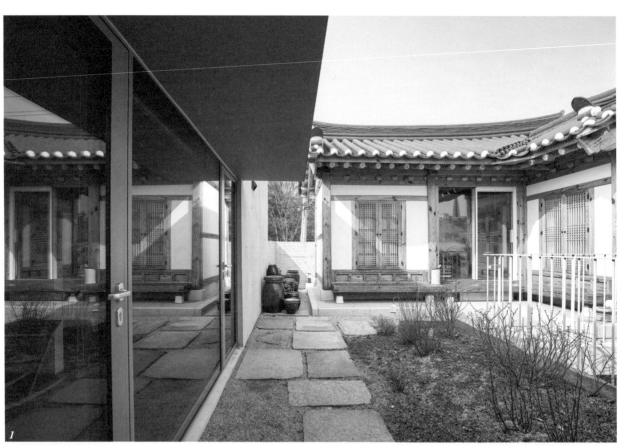

## 한옥과 콘크리트 건물의 동거

설계를 맡은 와이엠스튜디오 임지수 소장은 대지의 컨디션을 체크한 뒤 한옥의 스토리와 장점을 살리되 단점을 보완하는 프로젝트로 현대 건축을 접목하는 아이디어를 제안했다. 먼저 대지 특성상 남쪽과 북쪽의 단 차이가 커 한옥이 푹 꺼진 듯 앉혀 있고, 습기가 많다는 단점이 있었다. 질서 없이 개발된 주변 환경은 외부로 열려 있는 전통 가옥보다 닫힌 구조의 현대 건축이 적합하다고 판단했고, 중정으로 바람길을 만들어 습한 대지 환경을 극복하고자 했다.

"건축주는 미혼인 두 아들과 아파트에 거주하고 있었어요. 시어머님이 계신 한옥을 소중히 여기는 애틋한 마음과 관리해야 하는 부담감을 동시에 느끼고 있었죠. 두 집을 관리하는 것보다 한집으로 살림을 합치는 게 어떨지 조심스럽게 물었어요. 콘크리트조의 현대 주택 2층에 작은 한옥을 사랑채처럼 올리는 방법을 제안했고, 3대가 함께 살기 불편하지 않도록 공간을 배치하고 동선을 구획했죠."

설계는 마인드맵 건축사사무소 최하영 소장과 함께 진행했다. '디자인'과 '주택에서의 삶'이라는 관점에서 중점을 둔 것은 '균형'이다. 한옥과 콘크리트 구조의 현대 건축물을 자연스럽게 연결해 나가는 작업에서 적용할 재료의 조화는 물론, 어색할 수 있는 비율을 세심하게 정리하는 것이 중요했다. 두 아들이 모두 분가했을 때 관리하기 편하도록 본채와 별채를 분리하고, 결혼한 딸 내외도 편안하게 오갈 수 있도록 2층으로 올라가는 계단을 따로 냈다. 나무 대문으로 들어서면 중정 너머로 주방과 다이닝룸이 있는 본채가 바라보이고, 주차장 옆쪽으로 작은아들이 사용하는 별채가 자리한다. 현관 옆 우측 계단을 오르면 본채 2층과 연결되는 작은 마당 너머로 소담한 한옥이 나오는 구조다.

1  작은 거실과 간이 부엌, 침실, 드레스룸으로 구성한 본채 2층에서는 야생화 정원과 한옥의 정취를 즐길 수 있다.
2  돗자리를 깔고 낮잠을 자거나 바비큐 파티를 즐길 수 있는 널찍한 주차 공간. 왼쪽은 본채, 오른쪽은 야외 창고와 별채로 구성했다.

"마치 성처럼 닫혀 있는 노출 콘크리트의 매스 사이로 살짝 드러나 보이는 한옥 지붕과 조경이 이 집의 관전 포인트예요. 강원도와 파주에서 구한 목재를 건조하고 다듬는 기간에 콘크리트 본공사를 진행했어요. 2층 골조가 완성된 후 한옥팀이 합류해 조립 작업을 이어 갔죠. 이 집의 단초인 옛집의 기억이 연결될 수 있도록 기존 한옥의 대들보는 대문 옆에 벤치처럼 두고, 돌기와는 중정과 외부 계단 바닥 그리고 장독대 등의 마감재로 활용했고요."

## 매일 다른 풍경

집 안에 들어오면 집 밖에서 예상한 것과는 완전히 다른 열린 공간이 펼쳐진다. 중정과 프레임 역할을 하는 오픈 벽면의 레이어를 통해 열리고 닫히는 장면은 바라보는 각도에 따라, 계절에 따라 매 순간 새로움을 경험하게 한다.

"수많은 공간 이미지를 소비하는 시대인 만큼 오히려 건축은 무던하고 조용한 배경이 되어 중심을 잡아 주는 것이 필요하다고 생각해요. 집은 어쩌면 우리가 가장 오래 사용해야 하는 소비재잖아요. 고정적이며 화려한 재료를 사용한 인테리어보다는 계절에 따라, 날씨에 따라 변화하는 환경이 주는 즐거움을 제공하는 것이 이 시대 건축의 역할이죠. 창밖의 정원이 하나의 공간으로 읽히는 것보다 그 너머 다른 공간이 연속해서 있다는 것이 포인트예요. 같은 나무지만 어디서 보느냐에 따라 다른 얼굴을 보여 주죠."

공간 구성의 백미는 마감재나 가구가 아닌 공간마다 적용한 한 뼘 정원이다. 주방과 거실은 물론 각 방에서도 자연을 경험할 수 있도록 작은 뜰을 구성한 것. 조경 디자인은 '뜰과숲'의 권춘희 소장이 맡았다. 1층 다이닝룸과 연결되는 메인 중정은 단풍나무, 소나무 등 큰 나무를 심어서 2층에서도 보일 수 있게 했고, 주방과 연결되는 북쪽 정원은 계수나무와 자귀나무를 고즈넉하게 배치했다. 2층은 참골무꽃, 조팝나무, 눈개승마, 용머리, 원평소국 등 야생화를 심고 콘크리트 본채와 한옥을 디딤석과 마사토로 자연스럽게 연결했다. 노출 콘크리트의 차가운 공간에서는 이른 봄부터 늦가을까지 다른 꽃을 즐기고, 한옥 툇마루에서는 사계절 파란 하늘을 바라볼 수 있다.

변화하는 환경이 주인공인 만큼 인테리어는 최대한 담담한 톤 앤드 매너로

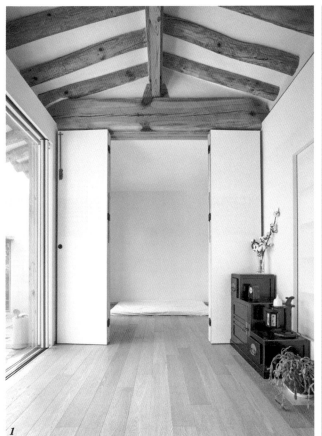

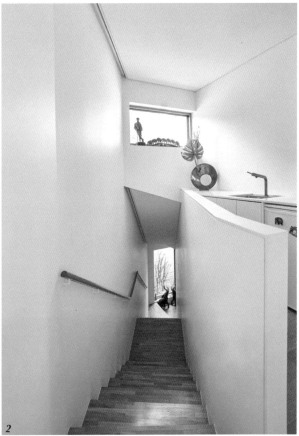

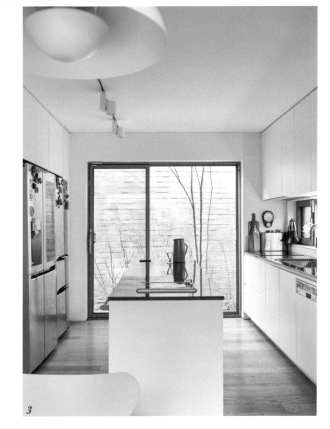

1   화성 주택의 사랑방 역할을 하는 2층 한옥. 온돌방과 거실,
    욕실로 구성해 딸 내외를 비롯해 친척들이 놀러 오면 게스
    트룸으로 활용하기 좋다.

2   대지 형태에 맞춰 사선으로 설계한 북쪽 입면. 계단실과 쪽
    창이 공간에 입체적 매력을 더한다.

3   본채 1층 다이닝 공간에서 주방을 바라본 모습. 방은 물론
    부엌까지 작은 뜰을 만들어 어디서든 자연을 볼 수 있다.

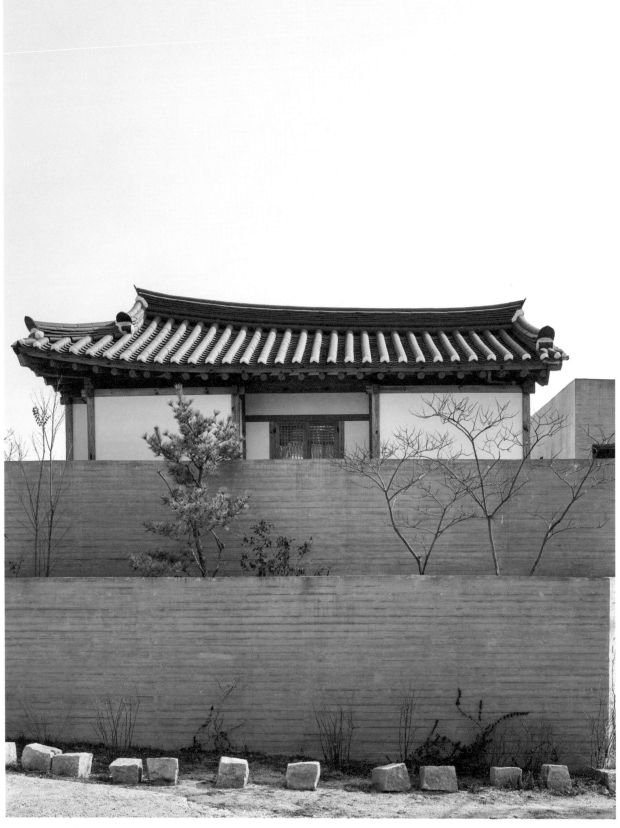

콘크리트 건물과 작은 한옥을 함께 구성한 화성 주택.

완성했다. 가구와 벽 도장 컬러, 원목 바닥재, 외부 콘크리트와 창호 라인 등의 경계가 도드라져 보이지 않도록 디자인하고, 큰살림에 필요한 수납공간을 최대한 많이 구성했다. 기본 붙박이장 외에도 계단 하부 구조, 방과 방 사이의 다용도실, 팬트리, 외부 창고까지 마련해 라이프스타일이 서로 다른 3대가 함께 살며 때론 늘어나고 때론 줄어드는 짐에 대한 걱정이 없다.

주택을 짓고 산다는 것은 누구에게나 특별한 경험일 터. 특히 대가족이 아파트에서 살다가 주택으로 옮겨 간다는 것은 특별함을 넘어 불편함에 대한 어느 정도의 각오도 필요한 부분이다. "물론 많은 살림과 건물, 조경 관리에 대한 걱정도 있었어요. 하지만 층별로 독립된 공간과(본채 2층, 별채, 사랑채 모두 화장실과 간이 주방을 구성했다) 다 같이 모여 즐길 수 있는 중정처럼 아파트에서 경험하지 못하는 다각적 공간에 대한 바람이 더 컸던 것 같아요. 소장님들과 미팅 때 이야기를 나누다 보니 오래전 한옥에서 생활하던 때가 하나둘 떠오르더라고요. 이사 와서 거실에 앉아 정원 너머 달을 보았을 때 참 행복했고요. 딸 내외가 불편해하지 않고 자기 집처럼 편안하게 지내는 모습을 보면 집을 정말 잘 지었다는 생각이 들어요. 실제로 집을 짓고 코로나19가 오기 전까지는 집이 늘 손님들로 북적북적했어요. 주차장에 돗자리 깔고 고기도 구워 먹고, 한옥 툇마루에서 낮잠도 자고… 다들 저마다의 방식으로 이 집을 편안하게 즐겼죠."

지난 코로나19 팬데믹 기간을 돌아보면 우리가 가장 누리지 못한 것은 '중간 공간'이었다. 집과 일터를 오가는 중간에 들르던 카페나 공원 등 소소한 휴식과 여가 공간이 우리 삶에서 하나둘 희미해졌고, 자유로운 외출도 통제하며 '집'에 머무를 수밖에 없는 시간. '중간 공간'이 있는 건축은 상황에 맞춰 방이 될 수도 마당이 될 수도, 함께할 수도 따로 지낼 수도 있다. 외피는 단단하지만 속은 새콤달콤한 과육이 있는 과일처럼 매 순간 변화하는 환경을 즐기며 익어 가는 화성 주택의 '집의 시간'이 옹골차게 느껴지는 이유다.

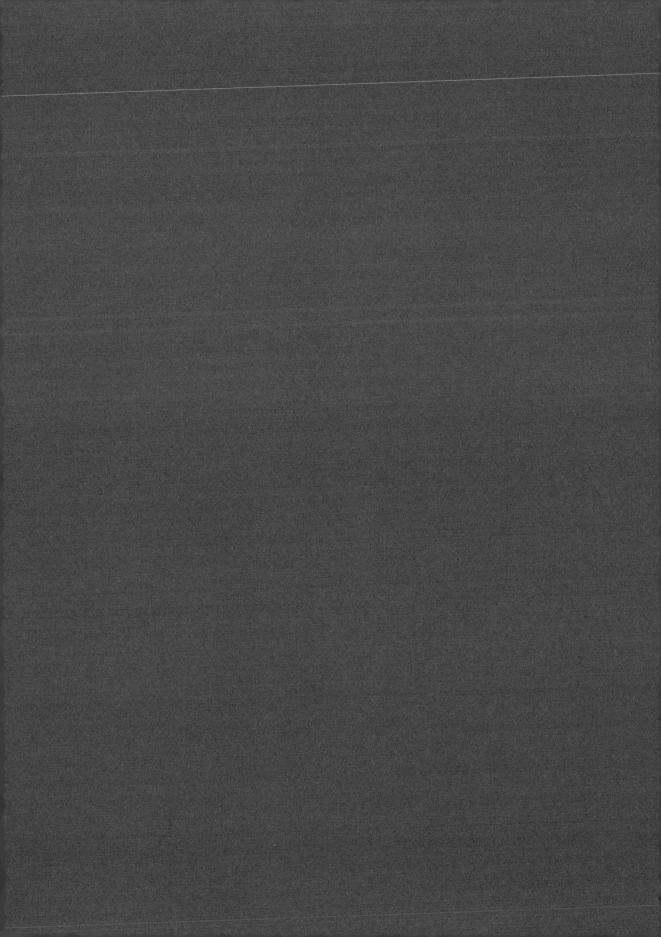

사람이 오가고 문화가 흐르는 집

# 한옥 마당에 차를 펼쳤다

함양당에는 문화가 흐른다. 연극, 영화계의 원로인 김정옥 선생이 처음 광주 이석리에 터를 잡았고, 이어 김병종 화백이 왕십리의 100여 년 된 한옥을 해체해 이 터에 집을 짓고 '함양당含陽堂'이라 이름 붙였다. 이제는 류효향 선생이 아름다운 차 향기 가득한 문화 공간으로 꾸려 나가려고 한다.

류효향 선생의 차 이야기부터 시작할까. 대기만성이란 어쩌면 선생을 가리키는 말인지도 모른다. 류효향 선생이 차인茶人의 길을 걷기 시작한 것은 마흔이 넘어서다. 아이를 키우고 좋은 대학을 보내는 게 일생일대의 꿈인 삶을 살다가 밖으로 나와 우연히 차에 마음을 뺏겼다. 자신이 집에서 시간을 보내는 동안 사람들이 너무 아름다운 것을 행하고 있음을 보고 그 자리에서 차를 배우기로 결심했다. 차를 공부한 지 10년 되었을 때 부산 달맞이고개에 차실 '비비비당'을 열었다(비비비당은 현재 선생의 작은며느리가 물려받아 운영한다).

선생은 자신이 다도 생활을 계속해야겠다고 마음먹은 순간을 기억한다. "선생님이 조선 시대 다완으로 수업을 하시는 거예요. 다완을 손에 딱 쥐는 순간, '이게 뭐예요?'라고 물었죠. 너무 아름다워서요." 그때가 류효향 선생이 맞은 인생의 전환점이었고, 문화적인 안목을 갖추는 기초가 되었다. 류효향 선생은 다른 사

창과 문이 나뉘지 않은 한옥의 특성처럼 안과 밖, 어디에서든 차를 즐긴다. 이번 레노베이션을 하며 새로 만든 툇마루는 아름답고 편안한 휴식처다.

람에게도 자신과 같은 순간을 만들어 주고 싶었다. 한 번의 작은 경험이 얼마나 소중한지 잘 알기에. 특히 젊은이에게는 이러한 기회가 더욱더 많아야 한다고 생각했다. 그렇게 비비비당을 시작했고, 이제 그 토대를 한옥으로 옮겼다. 자연 속 한옥의 아늑함과 함께 차 문화를 경험할 수 있는 차실. 선생은 한국 전통차 문화 체험과 수업 등을 준비 중이며, 이곳의 이름은 여전히 함양당이다.

## 차와 한옥은 하나로 이어진다

본격적인 차 행법(차를 다려 마시는 일련의 과정을 수행으로 삼는 다법) 수업을 시작하기에 앞서 류효향 선생은 차 행법 숙우회 회원들을 함양당에 초대했다. 차에는 이를 아름답게 마실 수 있는 다법이 존재하고, 이를 행하는 것은 수련과 같다. 하지만 어디서든 차를 마실 수 있기에 장소의 경계는 중요하지 않다. 이와 비슷하게 한옥에는 창과 문이 나뉘어 있지 않다. 바람이 다니면 창이고, 사람이 다니면 문인 것이다. 함양당의 100년 된 우물가, 햇볕을 품은 마당이, 별채와 대청마루가 선생과 숙우회 회원들의 차실이 됐다. 한옥은 차가 가장 자연스럽게 어울릴 수 있는 곳인 셈이다. 건축가 유현준은 "건축의 묘미는 경험하는 자의 신체의 크기, 과거의 경험, 무의식 등에 따라 완전히 다르게 해석될 수 있는 데 있다"라고 했다. 물건과 공간 안에 자리한 심미성을 찾아내려면 노력이 필요하다. 차를 통해 오롯이 느끼는 법을 수련해 온 숙우회 회원들은 누구보다 한옥을 잘 느끼는 사람들이다. 차를 배운 지 6년 됐다는 강나겸 씨처럼. "차를 즐기면서 차의 멋과 한국의 멋을 알게 됐어요. 그 귀함을 알기 때문에 이곳이 얼마나 귀하고 멋진지 더 잘 보이죠."

함양당에 차향이 흐르게 된 데에는 류효향 선생의 며느리 권연아 씨의 공이 컸다. 골동 미술품 컬렉터이자 집의 안주인인 권연아 씨는 함양당을 더 편리하게 레노베이션하며 이곳에 시어머니 류효향 선생의 차 문화가 더해지길 원했다. 권연아 씨의 진두지휘 아래 함양당은 안팎으로 많이 달라졌다. 단열과 난방에 신경 써 난방이 되지 않던 대청마루를 바닥까지 완전히 개조했고, 공간을 증축해 새로운 부엌과 욕실이 생겼다. 류효향 선생의 다구를 보관할 벽장도 함께. 대청마루의 100년 된 마룻장은 그대로 새로운 툇마루에 사용했다. 본채를 한 바퀴 두른 툇

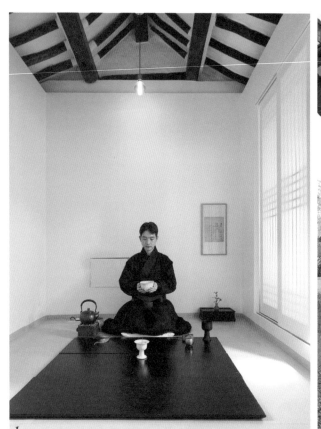

마루는 여럿이 옹기종기 앉아 쉬어 가는 쉼터다. 전통의 아름다움을 추구하면서도 그에 얽매이지 않는 권연아 씨의 자유로운 감성은 한옥 전체에 녹아 있다. 한국적인 부드러움이나 편안함이 느껴지는 유럽의 디자인과 재료를 적극 활용했다. 예를 들어 흙을 바른 듯 우둘투둘한 질감의 연한 황토색 타일은 황토칠한 한옥의 느낌을 자아낸다.

### 간소한 삶의 즐거움

류효향 선생은 보름은 이곳 함양당에서, 보름은 본가인 부산에서 보낸다. 새들이 안락하게 쉬는 마을이라는 조안鳥安리가 바로 옆이어서일까, 이석二石리 돌담 너머 들려오는 새벽 새소리로 아침을 연다. "여기서는 일어나자마자 대청마루 문을 열고 나가 이불을 털어요. 잠자리를 정리하고, 밤새 먼지가 내려앉은 마루를 닦는 게 루틴이 되었죠."

팔당호수를 마주한 볕 잘 드는 터에 자리한 함양당은 낮에는 햇볕이, 밤에는 달빛이 마당을 채운다. 가진 게 적을수록 우리는 선명해지고, 비로소 자연 속에서 풍족해진다. "배고프면 밥 먹고, 해 뜨면 눈뜨고, 목마르면 물 마시고. 과거에 읽은 선시禪詩 속 삶이 이제야 와닿는 것 같아요. 일상이 도道라더니, 한옥에 와서야 오롯이 느끼네요." 차에 집중하며 스스로 고요함을 자각하던 것처럼, 류효향 선생이 함양당에서 보내는 일상도 차와 같다.

**함양당**
경기 광주시 남종면 이석길 15 | 010-6507-2770

1   홀로 명상하며 차를 즐길 수 있다. 작은 화병이 놓인 가구는
    조선 시대 선비가 벼루나 먹 등을 보관하던 연상硯床이다.
2   뒷마당에서 바라본 별채.
3   대청마루는 난방 설비를 해 방처럼 만들었다.

# 자연과 사람, 예술이 만나는 자리

빛과 바람이 수시로 드나드는 공간은 자연과 사람을 소통하게 한다. 선명한 계절의
자취가 시간의 밀도를 높이고 번잡한 일상 속에서 잊힌 것, 사라져 가는 소중한 것을
상기시킨다. 예술이 우리 삶에 필요한 이유도 이와 같을 터. 정종미 작가가 서촌의 낡
은 한옥을 개조해 예술을 들인 이유다.

　　　　　　　　문득 어떤 풍경이 다가와 마음에 각인되는 순간이 있다. 무작위로 생을 스
치던 평범한 일상의 틈에서 돌연 강렬하게 오감을 사로잡는 순간. 그 찰나의 빛깔
과 질감, 냄새, 공기의 흐름까지도 선연히 기억에 남아 두고두고 기묘한 정서를 불
러일으키곤 한다. 정종미 작가에겐 10여 년 전 서촌의 어느 골목을 지나던 순간이
그랬다.

　　　　　　　　저명한 한국 화가이자 고려대 디자인조형학부 교수로서 바쁜 일상을 보내
던 그는 우연히 맞닥뜨린 경복궁 서쪽의 오래된 풍광에 마음을 뺏겼다. 햇살이 켜
켜이 포개지는 나지막한 고택과 물길처럼 그 사이를 흐르는 좁은 골목골목, 더딘
시간을 삼키며 더욱 선명해지는 계절의 농담. 어쩌면 그에겐 삶의 전환점 같은 순
간이었을 터다. 그길로 부동산을 찾아 70년 된 일본식 가옥과 바로 옆의 한옥을
새로운 터전으로 삼고는 또 얼마 지나지 않아 이끌리듯 한옥 한 채를 추가로 마련

과거 마당의 절반을 차지하던 연탄 광을 철거하고 새로 벽과 대
문을 만들었다. 건물 아래 조명을 설치한 덕분에 밤이 되면 마당
전체에 물이 고인 듯 은은한 푸른빛이 번진다.

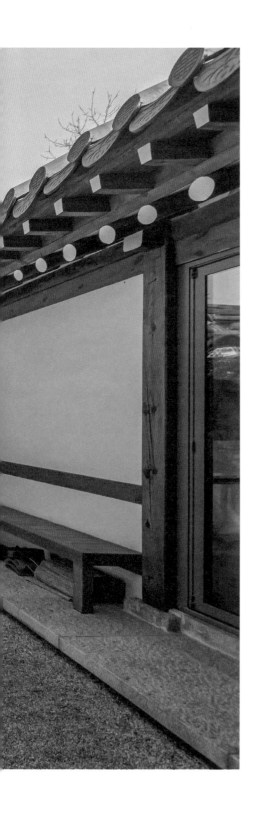

했으니까. 정년 퇴임 후 하고 싶은 일과 그걸 하기 위한 공간에 대해 틈틈이 생각해 보던 즈음이었다.

"사실 작가라면 누구나 자신의 작품을 걸어 두고 사람들에게 보여 줄 수 있는 공간을 희망하잖아요. 개인적으로도 그런 꿈이 있었는데, 누가 등 떠밀 듯 정말 우연히 이 공간이 저에게 주어진 거예요."

물론 쉬운 결정은 아니었다. 마주한 순간 "가슴에 딱 안기던" 첫 번째 집과 달리 급매물로 나온 1950~1960년대 한옥은 한눈에도 무척 험해 보였고, 무분별한 개조와 증축 탓에 양옥인지 한옥인지 분간하기조차 힘든 상태였다. 다만, 내부 폭이 일반 한옥에 비해 넓어 잘 수리하면 전시 공간으로 활용할 수 있겠다는 판단이 섰다. 그로부터 9년이 흐른 2022년 6월, 효자동의 오래된 골목 어귀에 '정종미 갤러리'가 문을 열었다.

## 안과 밖이 하나 되는 건축

입구에 들어서면 우선 정면으로 길게 뻗은 메인 홀이 시야에 가득 들어온다. 좌측 회랑을 지나면 바 테이블이 놓인 작은 홀과 미닫이문이 달린 방 하나가 중정을 사이에 두고 반대편 홀과 마주 보는 구조다. 갤러리 겸 카페로 운영하지만 딱히 경계를 구분하지 않고 그저 전시장을 찾은 관람객이 차 한잔과 함께 편안히 쉬어 가도록 구석구석 테이블을 마련해 뒀다. 오래 고생하며 고치고 다듬은 만큼 보다 많은 사람과 이 공간을 나누고자 한 까닭이다. 실제로 폐가나 다름없던 옛 한옥이 지금의 모습을 갖추기까지 꼬박 1년 3개월이란 시간이 걸렸다고. 한옥 전문가인 김길성 대목

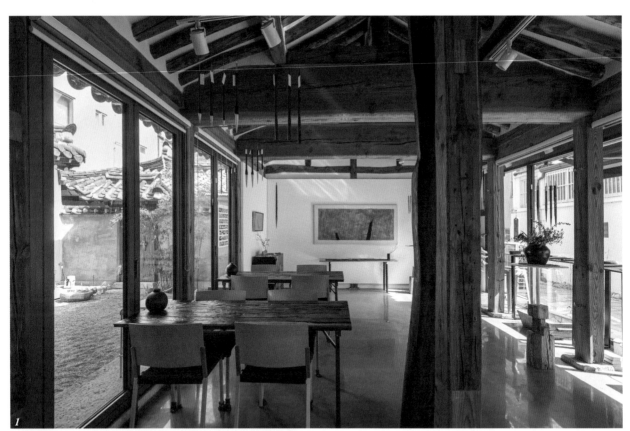

장과 함께 이 여정을 안팎으로 진두지휘한 이는 정종미 대표 자신이다.

먼저 건물 전체의 동선부터 새롭게 짰다. 본래 작은 한옥 두 채가 대문을 사이에 두고 마주 보고 있었는데, 대문과 지붕이 자리하던 마당 부분을 실내로 끌어들여 ㄷ 자 형태의 건물을 완성했다. 동네와의 호흡 역시 중요했다. 실내 면적을 조금씩 줄여 건물을 감싼 양쪽 골목에 각각 1m와 60cm를 더 내준 것도 동네 전체가 아름다워야 그 안의 공간이 함께 아름다울 수 있다는 믿음 때문이다. 정 대표가 가장 중요하게 여긴 포인트는 마당. 과거 마당 면적의 절반을 차지하던 연탄광을 철거하고 벽을 쌓은 뒤 대문을 새로 냈다. 문 양옆으로 작은 툇마루를 놓고 가장자리를 따라 대나무도 심었다.

"이 문이 공간의 핵심이 됐어요. 실제 사용하는 문은 아니지만, 사람들이 보면서 무언가 상상할 수 있는 여지가 생긴 거지요. 저 문을 지나면 또 다른 세계가 열릴 것 같기도 하고요."

그는 이 갤러리가 전시는 물론 공연과 세미나 등 폭넓은 활동이 이뤄지는 복합 문화 공간이 되기를 꿈꾸며 마당은 무대로, 실내는 객석으로 상정했다. 안쪽 벽면 대부분을 통유리 슬라이딩 도어로 마감해 실내 어디서든 마당을 바라보거나 드나들 수 있도록 했다. 문을 열면 안과 밖의 경계가 사라지고 온전히 하나의 공간만이 남도록. 실제로 정 대표가 직접 머물고 가꾸면서 느껴 온 한옥의 가장 큰 매력 역시 '소통'이다. 자연과 인간이 쉽게 소통하고 교감하는 공간, 언제나 빛과 공기가 들락날락하는 반쯤 열려 있는 공간. 그러니까 마당이 있어야만 비로소 한옥의 의미가 살아난다는 것이 그의 신조다.

1   입구와 가까운 남쪽 홀은 갤러리의 메인 전시 공간이다.
2   바 테이블과 소파가 놓인 북쪽 홀은 안팎의 풍경을 감상하며 차 한잔 즐기기에 더없이 좋다. 시시각각 한옥을 스쳐 가는 계절의 흐름을 한눈에 담을 수 있다.
3   전시 중이었던 유필무 필장의 노필이 정종미 대표의 매화도와 정교한 조화를 이룬다.

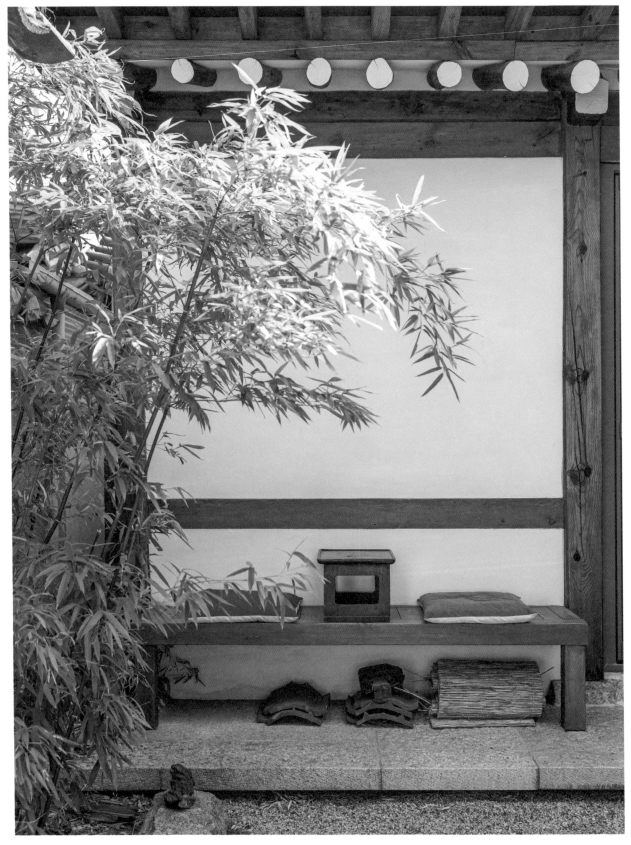

마당 한쪽에 자리한 툇마루. 빛과 바람을 한껏 머금은 대나무가 그윽한 정취를 더한다.

정 대표는 많은 사람이 이곳에서 건축과 예술을 감상하는 것은 물론, 공간이 주는 즐거움도 함께 느끼기를 소망한다. "한옥은 자연을 끌어들이는 건축이다 보니 굉장히 계절을 타요. 계절마다 느낌이 전부 다르죠. 우리가 아파트에 살면서 계절을 느끼기는 쉽지 않잖아요. 제가 살아 보니 그게 보통 행복이 아니더라고요. 한옥에서 보내는 시간은 무엇보다 자연을 가까이서 즐기는 기회라고 생각해요."

## 전통, 사라져 가는 것에 대하여

물론 정성껏 빚은 그릇일수록 그 쓰임도 중요한 법. 정종미 대표는 전통 미술 분야의 장인에게 지속적인 관심을 갖는 형태로 갤러리를 활용하려는 포부를 밝혔다. 국악 공연 프로젝트와 협업도 추진하고 있으며, 자신의 전공 분야인 재료학에 관한 강좌도 준비 중이다. 한옥이 품에 안는 사계절 빛과 자연은 사실 화가로서 그의 궤적과도 깊이 맞닿아 있다.

"한국화를 전공하다 보니 한때 동양 철학에 굉장히 심취했어요. 그런데 동양 철학의 정수는 결국 생명 철학이거든요. 나무 한 그루를 그려도 나무와 내가 서로 동등한 관계로 만나는 지점에서 비로소 예술이 성립된다고 봐요. 생명주의 사상이 여전히 강세였다면 지금 우리 삶이 이렇게까지 척박해지지는 않았겠지요. 예술의 기능이란 그런 사라진 것을 부활시키고 환기시켜 사람들과 나누는 것이라 생각해요. 그런 면에서 그림만이 아니라 이 공간도 제 작품이나 마찬가지예요."

**정종미 갤러리**
서울시 종로구 자하문로 68-19 | 070-4141-1103 | jungjongmeegallery.modoo.at

# 검소하면서 화려한 현대식 사랑방

조선 시대 사랑방을 현대적으로 풀어낸 공간이 북촌에 문을 열었다. 한옥이 주는 아
늑함 속에서 우리의 전통문화를 직접 경험할 수 있는 애가헌愛家軒 이야기.

"건축은 상황에 기인한다. 장소는 건축이 무엇이 될 수 있을지에 관한 형이
상적이고 시적인 연결 고리이다." 세계적 건축가 스티븐 홀의 말처럼 건물의 정체
성은 그것이 위치한 장소와 주변 맥락에 의해 자연스레 결정되곤 한다. 1994년부
터 국내 최초로 한옥 호텔을 운영하며 전통의 아름다움을 널리 알려 온 락고재가
도심 속 거리 박물관이라 부르는 북촌에 마을 호텔 개념을 도입한 것도 그러한 연
유다. 객실을 연결하는 수직적 엘리베이터 대신 수평적 골목이 자리하고, 북촌 곳
곳에 위치한 한옥이 객실이 된다. 숙박객은 북촌의 아기자기한 골목을 거닐고, 담
벼락을 마주하고, 처마를 바라보며 마을 전체를 온전히 경험하게 된다.

### 지하 공간이 있는 한옥
오랜 시간 숙박 위주의 경험을 제공해 온 락고재가 2019년 사랑방의 문을

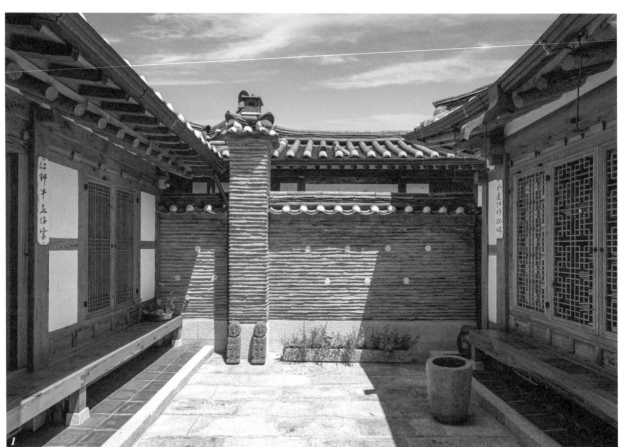

열었다. 식문화를 매개로 다양한 문화 행사를 전개하는 락고재 컬쳐 라운지, 이름은 애가헌이다. 국내 차 산지에서 수확한 차를 선보이는 브랜드 '티컬렉티브'와 함께하는 라운지부터 작가의 기물 전시, 쿠킹 클래스, 프라이빗 다이닝 등 다채로운 문화 행사의 장이 되어 왔다.

골목길 모퉁이, 높게 쌓은 담 사이의 대문을 열고 들어서면 오른쪽 누마루에 이어 작은 마당 너머 ㄱ 자 한옥이 시야에 들어온다. 그곳이 바로 락고재 컬쳐 라운지의 메인 공간. 삼베를 바른 창문과 송아지 가죽을 덧댄 손잡이 등 작은 디테일에도 공을 들인 흔적이 역력하다. 단아하면서도 세련된 분위기가 물씬 풍기는 이곳이 특별한 이유는 다름 아닌 지하 공간이 있다는 것이다. 입구 쪽에 난 계단을 따라 아래로 내려가면 여덟 명은 거뜬히 앉을 수 있는 다이닝 테이블과 큼지막한 주방이 나온다. "한옥은 지하 공간을 만드는 경우가 많지 않아요. 특히 방수 문제가 까다롭거든요. 그래도 저는 오픈 키친 스튜디오를 만들고 싶은 마음에 대목님께 부탁했어요. 이 공간이 없었다면 정말 아쉬웠을 것 같아요." 락고재 컬쳐 라운지의 대표이자 운영을 맡고 있는 김예목 원장의 말이다.

무려 5년의 시간 동안 대수선과 신축을 거듭한 이곳은 한국가구박물관을 작업한 문화재 대목 기능장 정영수 대목의 손을 거쳤다. 나무부터 돌, 기왓장 한 장까지 모두 고재를 고집한 탓에 현대의 것이 흉내 낼 수 없는 시간의 흔적과 정취가 고스란히 살아 숨 쉰다. 락고재는 한옥이 세대를 이어 발전해 나가기 위해서 골동이 있되 불편하면 안 된다는 원칙을 고수하는데, 대청이 있는 곳을 제외하고 단을 낮춰 신발을 신고 내부로 들어갈 수 있게 만든 이유도 바로 그 때문이다.

"이 한옥은 저희 부모님께서 물려주신 곳이에요. 예전 주인이던 노부부가

1   두 채의 한옥 사이에 자리한 작은 중정. 왼쪽은 대수선을 거친 ㄱ 자 한옥, 오른쪽은 새로 신축한 누마루다.
2   8인용 테이블과 대형 대면형 주방으로 꾸민 지하 공간. 한옥에서 느낄 수 없는 모던함이 매력인 이곳에서는 쿠킹 클래스와 프라이빗 다이닝 등 다양한 행사를 진행한다.

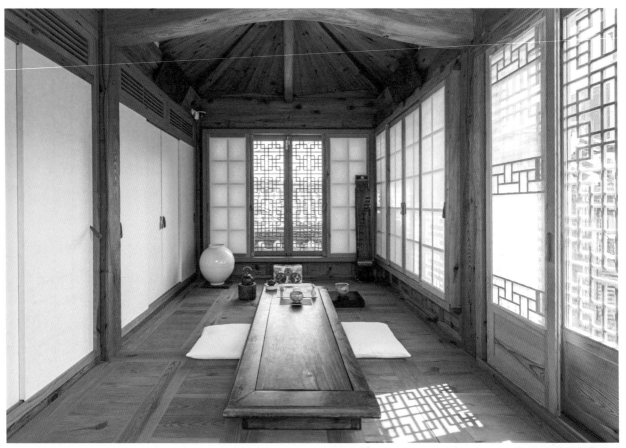

다도 체험이 진행되는 누마루 내부 전경. 전문 다예사가 엄선한 사계절에 맞는 수제 차를 맛보며 한국 차 이야기를 들을 수 있다.

이 집에서 여섯 남매를 길렀는데, 언제나 참 화목했다고 해요. 그 기운을 받들어 사랑하는 가족을 위한 집이라는 의미를 담아 애가헌이라 이름 붙였죠."

## 한식으로 즐기는 풍류

애가헌은 한국의 전통 접빈 다례를 체험해 볼 수 있는 우리 차 수업과 우리 술 시음, 한식 쿠킹 클래스 등의 프로그램을 운영한다. 애가헌의 풍류를 온전히 만끽할 수 있어 유튜브 창업자 등 해외 VIP들의 발걸음도 끊이지 않는다. 차 체험 프로그램이 없는 날에는 가야금 연주회를 열기도 한다.

"저는 어릴 때부터 외국 생활을 오래 한 터라 한국의 전통 문화에 대한 갈증이 컸어요. 어느 날 친구들이 한국에 여행 가면 무얼 하느냐고 질문했는데 저도 모르겠더라고요. 그때부터 부러 한국이라는 나라에 대해 더욱 깊이 알아 가려고 한 것 같아요. 떨어져 있었기에 그 소중함을 일찍 깨달은 거죠. 앞으로 이곳에서 검소하되 누추하지 않고, 화려하되 사치하지 않다는 뜻의 '검이불루 화이불치儉而不陋 華而不侈' 정신을 계승해 나가려고 합니다."

**락고재 컬쳐 라운지**
서울시 종로구 북촌로11가길 16 | 010-3882-3106 | rkj.co.kr/ko-culturelounge

# 동백 인생

---

오전 7시, 목장갑을 끼고 정원 곳곳을 누비며 나무와 돌을 꼼꼼히 살피는 동백 언덕의
터줏대감. 양언보 회장이 40여 년간 일군 언덕은 사계절 피고 지는 동백처럼 시간의
경계가 존재하지 않는다.

해발 250m의 척박한 황무지. 모자를 쓴 중년 남성이 허허벌판에 서 있다.
남자는 이곳에 피어날 동백꽃을 상상한다. 이른 봄 분홍 참꽃을 시작으로 은은한
치자 향으로 물든 여름을 지나 하얗고 붉은 꽃망울의 추백秋栢을 맞는 시간. 제주
의 돌과 바람, 물과 조화를 이루는 동백 언덕의 사계는 언제나 출발선으로 되돌아
가는 남자의 인생 좌표와 같다.

### 움트는, 봄

'카멜리아 힐Camellia Hill'은 말 그대로 동백 언덕이다. 6만여 평의 동산에는
가을부터 봄까지 시기를 달리해서 피는 동백나무 6,000그루가 자연 모습 그대로
의 숲을 이룬다. "일본 출장길에 우연히 동백꽃을 봤는데, 어린 시절 고향 대평리
언덕에서 보던 꽃이 떠올랐어요. 흔히 피어난 새빨간 동백꽃이 봉오리째 뚝뚝 떨

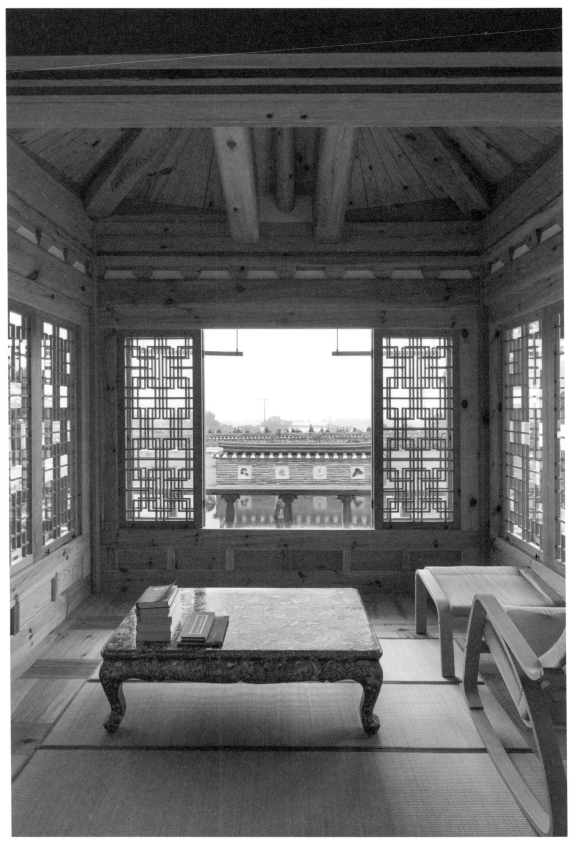

매일 아침 명상하고 책을 읽는 누마루. 창을 열면 멀리 산방산과 마라도가 한눈에 들어온다.

어지고, 하얀 눈밭에서 또다시 붉게 피어나는 모습이 뇌리에서 지워지지 않았죠."

　　1960년대 고구마 전분 공장을 시작으로 과수원, 건설업체를 운영하며 사업가로서 탄탄히 내실을 다져 온 양언보 회장은 1984년 과수원의 감귤나무를 모두 베어 내고 동백나무를 심기 시작했다. 당시 감귤나무는 두 그루만 있으면 자식 대학 공부를 시킨다고 할 정도로 수익성이 좋던 수종이라 그의 결정을 두고 걱정하는 사람이 많았다. 하지만 동백에 대한 열정은 쉽게 잠재워지지 않았고, 1998년부터는 아예 건설에서 조경으로 업을 바꿔 지금의 카멜리아 힐을 본격적으로 조성해 나갔다. 처음 동백나무를 심은 감귤밭을 중심으로 부지를 확장하고, 섬 전체를 돌며 특이하고 오래된 동백나무를 구했다. 국내에는 동백 전문가가 없을뿐더러 관련 서적이나 논문도 찾기 힘들어 일본, 중국, 유럽 등을 다니며 자료와 품종을 모았다. 그리고 2009년 온 세상의 동백을 다 모아 둔 수목원 카멜리아 힐이 문을 연다.

　　"돈은 많이 벌었지만 삶이 무의미하다는 생각이 들었어요. 맨주먹으로 30년간 사업을 하면서 한길을 걸었으니 또 다른 길도 필요하지 않을까? 인생을 어떻게 마무리할 건지 고민하기 시작할 즈음이던 것 같아요. 동백은 사군자의 부족한 부분을 채워 줘요. 겨울에도 푸르고, 눈 속에서도 꽃을 피워 내는 강인함이 있죠. 게다가 꽃이 질 때마저 아름다워요. '피어날 때는 힘겹게, 떨어질 때는 아름답게', 동백처럼 떠나는 뒷모습이 아름다운 사람이 되는 게 꿈입니다."

## 향기로운, 여름

　　가브리엘 샤넬은 향기도 가시도 없는 카멜리아의 절제미에 매료됐다. 추사 김정희는 제주 유배 시절 아내에 대한 애틋한 마음을 붉은 동백꽃의 아름다움에 빗대어 표현하곤 했다. 우리는 동백을 향기가 없는 꽃 또는 흰 눈 속에 피어나는 붉은 꽃으로 알고 있지만, 동백 언덕에서 마주한 동백은 이러한 통념에서 한참 벗어난 팔색조의 매력을 품고 있다.

　　먼저 동백은 겨울꽃의 여왕으로 불리지만 겨울에만 피는 것은 아니다. 봄부터 겨울까지 꽃 피는 시기에 따라 춘백春栢, 하백夏栢, 추백秋栢, 동백冬栢으로 나눈다. 하얀색, 분홍색, 노란색까지 꽃잎의 색도 다양하다. 하얀색만 해도 족히 50종

은 찾을 수 있다. 향기가 없다는 것도 잘못된 정보다. 카멜리아 힐에는 전 세계의 향기 나는 동백 8종 중 6종을 식재해 달콤하고 매혹적인 동백 향기에 취할 수 있다.

"카멜리아 힐에서는 세계 각지에서 서식하는 2,000여 종의 동백 중에서 제주 땅에 적응해 살아남은 500여 품종을 만날 수 있어요. 우리나라에서는 하백을 기르기가 가장 힘든데, 덴마크 수종의 동백을 몇 번 가지고 왔지만 모두 실패했어요. 대신 9월 말부터 피는 동백부터 전국 방방곡곡에서 심기를 바라는 마음으로 육성한 주황색 '무궁화 동백'까지… 우리 동백 고유의 진면목을 만날 수 있지요."

카멜리아 힐의 동백나무는 그냥 보고 즐기는 것을 넘어 뿌리부터 잎과 꽃, 열매까지 버리는 게 하나도 없다. 전통적으로 미용 재료로 쓰인 동백 오일을 활용한 화장품과 동백꽃 차(동백은 차茶과 나무다)를 선보이는 것은 물론, 원료 재배부터 제조까지 직접 맡아 한다. 관광객을 위한 굿즈는 젊은 여행객에게 인기가 높다. 이른바 1차 산업부터 6차 산업까지, 부가가치 높은 작물과 관광, 문화 콘텐츠가 결합된 '동백'의 비전을 엿볼 수 있는 대목이다.

6만 평의 부지에 열여섯 코스의 수목원 관리가 녹록지만은 않다. 동백 언덕의 하루 일과는 아침 7시에 시작한다. 전 직원이 6시 40분에 출근해 10분간 '동백 사랑운동' 체조를 한 뒤 관람객이 입장하기 전까지 700여 종의 꽃과 나무, 돌 하나하나를 세심하게 체크한다. 그 정성은 관람객이 가장 먼저 알아본다. "손님들이 좋아하는 모습을 보면 무더위에도, 비바람에도 힘이 솟지요. 눈이 모자라서 다 못 보겠다며 달뜬 목소리로 감탄하는 분도 계시고, '친구들 다 데리고 올걸' 하며 아쉬워하는 분도 계세요. 좋은 향기는 만 리를 간다고 하잖아요. 동백의 아름다움을 나누고 싶은 제 마음처럼 좋은 건 나누고 싶은 마음이 통한 거지요."

1   여름에는 곱고 아름다운 수국과 보랏빛 맥문동, 은은한 치자 향이 가득한 녹색 숲이 우거진다.
2   제주도의 전통 초가를 볼 수 있는 구역에는 포대화상과 돌탑들이 자리 잡고 있다.

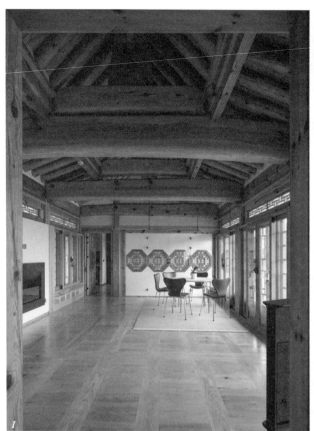

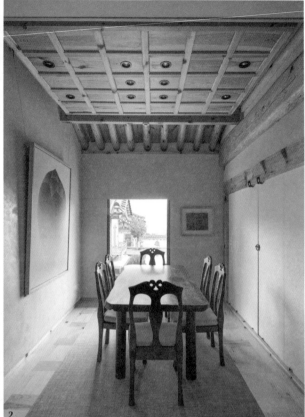

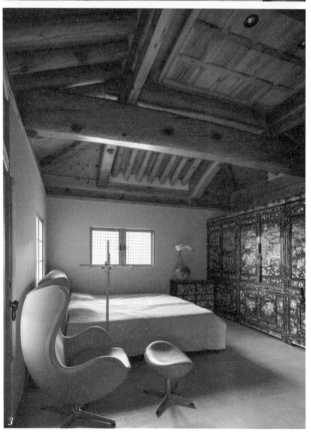

1   리빙룸 역할을 하는 안채의 대청. 기둥, 보, 도리, 서까래 등
    대부분의 목부재는 강원도 삼척 지방의 육송을 사용했다.
2   입식으로 설계한 부엌과 다이닝 공간. 실용적으로 사용할
    수 있도록 벽면은 스터코 도장으로 마감했다.
3   자개장과 에그 체어가 색다른 조화를 이루는 침실. 편백나
    무 재질이 포함된 천연 벽지, 삼베로 만든 한식 바닥재 등 친
    환경 재료를 다채롭게 활용했다.

## 무르익은, 가을

가을은 50분 코스로 체험할 수 있는 동백 올레길의 진면목을 만날 수 있는 계절이다. 1년의 기다림을 끝으로 동백나무는 하얗고 붉은 꽃망울을 터뜨리고, 맥문동과 억새는 보라색과 황금색으로 들판을 수놓는다. 치자 향 가득하던 녹색 숲은 서서히 단풍으로 물들면서 계절에 깊이를 더하고, 자연 그대로 제주 화산의 얼굴이 담긴 검은 돌은 있는 듯 없는 듯 눈길을 끈다.

"동백 언덕의 주인공은 동백이지만, 보물은 바로 초가삼간이에요. 귤밭을 갈아엎고 가장 먼저 저희 조부모와 부모님이 사셨고, 제가 나고 자란 전통 초가집을 옮겨 지었어요. 이곳에서 아내와 20년을 지냈습니다." 답은 현장에 있기 때문이다. 전기도 들어오지 않는 허허벌판에 초가집을 옮겨 놓고 매일 해 뜰 때부터 해질 때까지 빛과 바람을 관찰하며 나무를 한 그루, 두 그루 심었다. 밭을 일구는 데 학위는 필요 없다. 땅의 섬세한 소리에 귀 기울이면 그만이다.

"나의 스승은 자연이고, 토양입니다. 자연은 절대 정복하는 게 아니죠. 기념관을 지을 때 콘크리트 건물이 아닌 한옥을 선택한 것도 같은 이유예요. 제주의 좋은 자연과 어우러지는 집으로 한옥만 한 게 또 있나요?"

양언보 회장의 호를 딴 '향산 기념관'은 동백의 가치와 철학을 나누는 공간이다. 회장 내외가 거주하는 안채와 라이브러리 역할을 하는 사랑채, 다실로 구성한 기념관은 이곳을 찾는 관람객은 물론 지인까지 다양한 프로그램을 이용할 수 있도록 계획했다. 먼저 대문을 지나 계단을 오르면 제주의 바다와 한라산의 백록담을 떠올리게 하는 수水 공간을 지나 안채와 다실이 연결된다. 채와 채 사이의 동선은 꽃담과 징검다리를 활용해 각 채가 서로 독립적 기능을 한다.

"습기가 많은 제주는 사실 한옥의 불모지예요. 23년 전부터 한옥을 짓겠다는 바람으로 전국의 유명하다는 한옥은 다 보러 다녔어요. 언젠가 지을 한옥을 위해 편백나무를 심었어요. 몇 해 전에는 예행연습 삼아 작은 정자를 지었습니다. 불가능을 가능으로 만드는 건 결국 사람의 노력이지요."

한옥 설계는 대한민국 한옥 공모전 대상을 받은 황두진 건축가가 맡았다. 제주 민가뿐 아니라 관덕정, 제주 목관아, 대정향교 등 조선 시대의 공공 한옥을 폭넓게 답사한 황두진 소장은 일반 한옥의 구법과 공간 구성을 적용하면서 제주

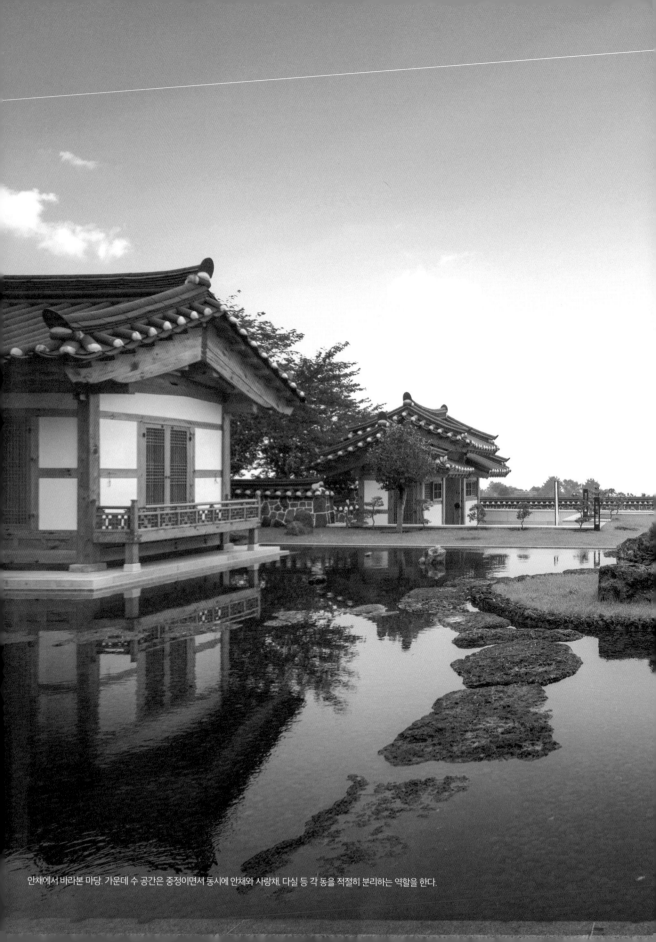

안채에서 바라본 마당. 가운데 수 공간은 중정이면서 동시에 안채와 사랑채, 다실 등 각 동을 적절히 분리하는 역할을 한다.

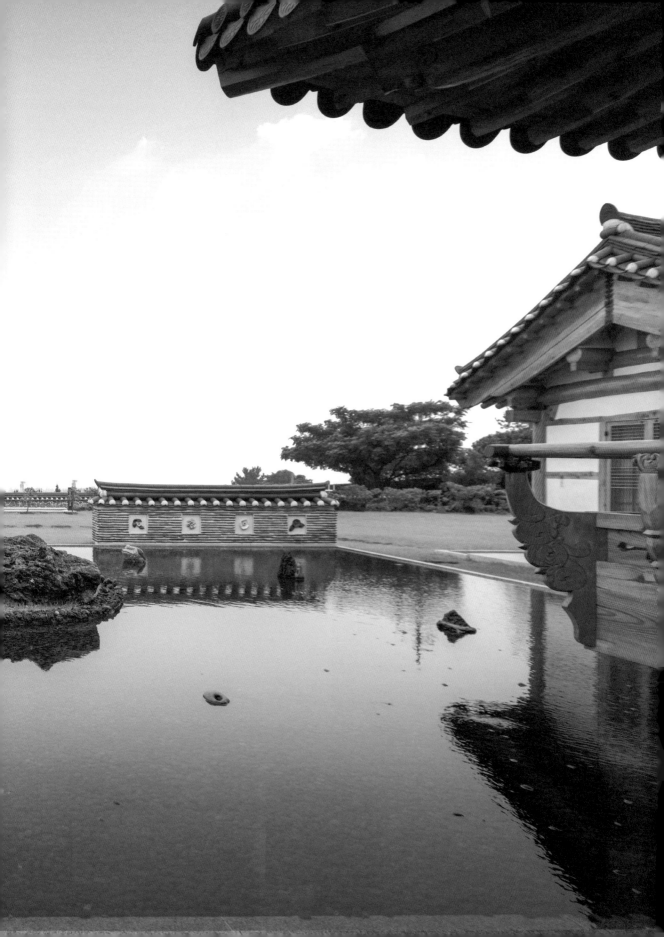

*1,2* 카멜리아 힐에서는 어디서든 동백꽃 장식을 발견할 수 있다.

*3* 돌담 안에 옹기종기 모인 제주 옹기. 된장, 고추장, 장아찌와
각종 효소, 과일까지 담겨 있는 천연 저장고.

고유의 재료와 공법을 활용했다. 또한 기와는 건식 공법을 적용하고 기둥 초석에 축을 만들어 기둥이 밀리는 것을 방지하고 추녀는 금속으로 보강했다.

"우리 한옥의 백미는 차경借景입니다. 안채에 오르면 거실, 누마루, 부엌 등 어디에서든 제주 앞바다를 볼 수 있지요. 날씨가 좋으면 집 안으로 마라도, 가파도, 산방산이 들어와요. 한라산과 바다를 다 품은 이런 집이 또 어디 있습니까?"

### 준비하는, 겨울

매서운 바람이 눈 대신 꽃잎을 땅에 떨구는 멋진 겨울을 만끽해 본 적이 있는가. 카멜리아 힐의 겨울은 사계절 중 가장 아름다운 시간이다.

"누구나, 언제나 봄 속에 살지는 못하잖아요. 겨울에 해야 할 일을 제대로 알아야 봄을 맞을 자격이 있지요. 자연에 대입하면 삶의 모든 문제가 단순 명료해집니다. 나무가 건강하게 자라려면 땅속뿌리가 단단해야 해요. 적당한 서리는 땅의 흙을 잘게 부수고 해로운 해충을 없애 줍니다. 드러나지 않고 묵묵히 건강한 뿌리를 만드는 것이 저의 역할이라면, 열매를 맺는 것은 다음 세대가 할 일이지요."

모든 자연이 쉬어 가는 겨울, 하얀 눈밭을 새빨갛게 물들인 동백꽃길은 결승선이 아닌 새로운 출발선이 된다. '세상의 동백을 한자리에 모으겠다'는 아버지의 뜻을 이어 카멜리아 힐을 함께 일구는 가족들이 다시 출발선에 섰다. 그 모습을 보니 열혈 정원가 카렐 차페크의 저서《정원가의 열두 달》속 구절이 떠오른다.

"한 해는 언제나 봄이고 인생은 언제나 청춘이며 꽃은 언제고 핀다. 가을이 왔다고 말은 하지만 사실 우린 다른 방법으로 꽃을 피우고 땅 밑에서 자라며 새로운 싹을 펼쳐 내느라 여념이 없다. 주머니에 손을 넣고 있는 자들이나 한 해가 저물어 간다는 말을 쉽게 내뱉는 법이다. 1년 열두 달, 11월에도 꽃을 피우고 열매를 맺는 존재들은 가을, 겨울을 모른다. 찬란한 여름만이 계속될 뿐이다. 그들에게 쇠락이란 없다. 오직 발아만 존재한다."

**카멜리아 힐**
제주도 서귀포시 안덕면 병악로 166 | 064-800-6296 | www.camelliahill.co.kr

여유로운 쉼과 특별한 머묾, 한옥 스테이

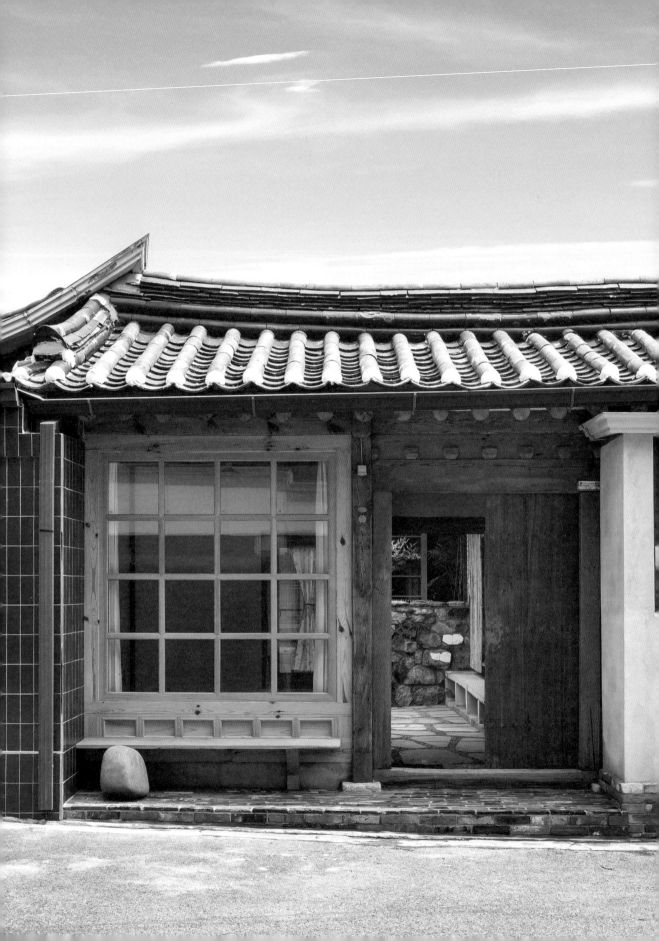

# 80년에 걸친 삶의 자취들이 혼재된 곳

한옥이 다시 대중에게 관심을 받기 시작한 것은 불과 10~20년 전의 일이다. 이 시절
의 도시 한옥은 옛 모습을 그대로 재현해 놓은 듯한 형태가 대부분이었다. 하지만 한
옥이 천천히 발전하며 시대를 품어 왔다면 어땠을까? 2017년에 오픈한 한옥 호텔 '혜
화 1938'에서 그 해답을 찾을 수 있었다.

지역 특유의 정취가 깃든 곳을 방문하면 좋은 기운을 느끼곤 한다. 취재차
방문한 혜화동이 그랬다. 혈기 넘치는 대학로 메인 거리를 조금 벗어나니 정말 거
짓말처럼 한적한 골목이 펼쳐졌는데, 그야말로 '동네'란 단어가 잘 어울리는 곳이
었다. 그리고 그곳에 한옥 호텔 '혜화 1938'이 어우러져 있었다. 이곳은 2014년 시
작한 참우리건축이 만들고 운영하는 곳이다. 참우리건축은 한국 고유의 건축물인
한옥을 전문으로 짓는다. 건축가가 지은 호텔은 많이 봤지만 직접 짓고 운영까지
하는 한옥 호텔이라니 더 특별하다. "2014년 사무소를 바로 옆 한옥에서 시작했어
요. 한데 직원이 늘어나면서 공간이 협소해졌고, 마침 주거 공간이던 이곳을 사용
할 수 있게 됐죠. 사무실로만 사용하기엔 공간이 넓어 방안을 모색하다 건축가만
이 할 수 있는 서비스가 무엇이 있을까 고민했고, 한옥 호텔을 만들기로 결정했지
요." 올해로 여든다섯 살인 이 한옥은 일제강점기에 조선 한복판에 대량으로 들어

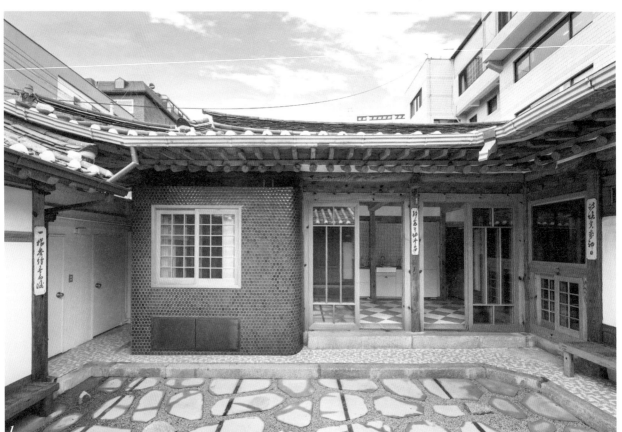

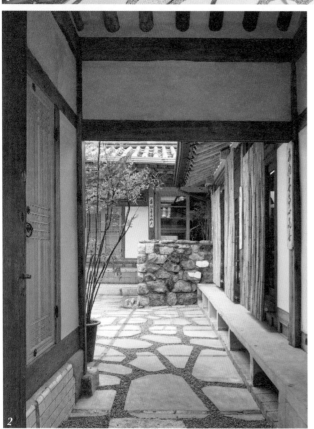

1 혜화 1938은 벽, 바닥 등 한옥에서 찾아보기 힘든 다양한 색을 찾는 묘미가 있는 공간이다. 또한 이곳이 다른 한옥에 비해 독특한 점은 신을 신고 출입할 수 있다는 점. 마당은 콘크리트 디딤돌로, 한옥 내부는 타일로 마감한 덕분이다.

2 대청 바닥을 25cm 낮추며 나온 폐석재로 작은 객실 앞에 돌담을 쌓았다.

선 주거 형태로 시작했고, 1980년대 이후 대학생의 하숙집으로 30년간 사용했다. 하숙집을 운영하던 주인이 식탁에 숟가락 하나 더 놓는다는 생각으로 학생들을 하나둘 받았듯, 참우리건축도 사무실로 사용하고 한편을 손님들과 공유하니 모양은 다르지만 취지가 비슷해 동네에 자연스럽게 어우러지는 듯했다.

## 옛것과 새것이 교차하다

한옥은 흐르는 정방형 대지 위에 16평 정도의 집이 ㅁ 자형 평면으로 앉아 있다. 전면은 여러 집이 이어진 겹집 형태라 사무실과 이어지는 벽을 허물고 내부를 이어 결과적으로 호텔을 방문하는 손님은 ㄷ 자형 공간을 사용할 수 있게 됐다. 호텔은 두 개의 객실로 구성하며, 본래 대청이던 곳은 다이닝룸으로 널찍하게 남겨 됐다.

건축가들이 처음 이 한옥을 마주했을 때 세월의 자취를 곳곳에서 발견할 수 있었다고 한다. 목수가 서까래에 새긴 글씨, 1980년대 가정집에서 볼 법한 패턴의 나무 천장, 각기 다른 색감의 나무 기둥 등 한옥의 골조는 원형을 유지하고 있지만 여러 시대가 혼재한 것. 건축가들은 이러한 요소를 유지하되 그들만의 개성을 부여하기로 했다. 새로운 것 또한 변화하는 하나의 과정으로 언젠가 이 한옥이 과거의 일부로 품을 수 있다는 생각에서다. "건축가들과 이 공간을 디자인할 때 한 가지 원칙을 정했어요. 바로 '원 구조만 부수지 말자'였죠. 이 집은 최대한 원래 구조를 살리고 싶었습니다."

참우리건축의 건축가들은 이 원칙 아래 그동안 한옥을 지으며 시도하고 싶었던 아이디어를 마음껏 표출하기 시작했다. 타일이 깔려 있던 마당은 5cm 두께의 콘크리트 발판을 징검다리처럼 배치하고 틈새엔 흙 대신 굵은 모래를 깔았다. 서울 도시 한옥은 보통 마당을 중심으로 대지 경계까지 건물이 꽉 들어차 빗물이 마당으로 고스란히 떨어지며 배수구로 흘러가는데, 굵은 모래가 물길 역할을 해 배수구로 빠져나가지 못한 낙엽이 배수구 주위에 옹기종기 모이기도 한다. 대청엔 신을 신고 들어갈 수 있도록 설계했다. 기존 바닥을 25cm 낮춰 입식 공간으로서 높이를 확보하고, 바닥을 낮추면서 나온 폐석재를 모아 마당에 돌담을 쌓았다. 한옥의 바닥은 으레 나무로 마감하지만 타일을 시공해 보기로 했다. 대신 기둥과

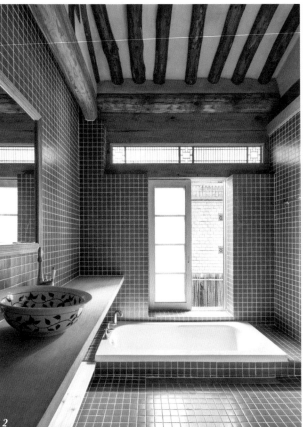

1   널찍하게 비워 둔 다이닝룸. 참우리건축의 건축가들은 엔티
    크 가구 매장에서 고른 가구와 조명등으로 한옥 호텔을 손
    수 완성했다.
2   오랜 세월을 품은 이곳은 그 흔적을 곳곳에서 발견할 수 있
    다. 욕실 천장의 나무 색감이 다른 곳에 비해 약간 어두웠지
    만 이를 그대로 살렸다.
3   혜화 1938 바로 옆엔 이 공간을 만든 참우리건축의 사무실
    이 있다.

주춧돌이 돋보이도록 다이닝룸의 테두리는 직선으로, 가운데는 대각선으로 시공해 마치 카펫이 깔린 것처럼 연출하니 기존 구조와 잘 어우러졌다.

## 모두가 완성하는 곳, 공간에 문화를 심다

사실 건축가가 자신이 만든 공간을 사용하는 모습을 관찰하기는 쉽지 않은 일이다. 하지만 이곳은 다르다. 사무실이 호텔 옆에 붙어 있고, 직접 관리하기 때문이다. "북에서 남으로 바람이 흐를 수 있도록 낮은 창을 하나 냈어요. 한 가족이 투숙한 적이 있는데, 어린아이가 이 창을 문으로 사용하는 거예요! 생각지 못한 쓰임새, 그리고 저희가 만든 공간을 그들 식으로 해석하고 활용하는 모습에 큰 감동을 받았지요." 모든 벽을 막지 않고 길에 닿아 있는 사랑채 창문을 유리창으로 만들고, 앞에 작은 마루를 두어 주민이 쉬어 갈 수 있게 했다.

한옥은 분명 예스러운 건물이라 현재 서울 풍경에서는 튈 수도 있는 존재다. 하지만 어떻게 바라보고 활용할 것인지 관점을 확립하고 대한다면 지금 이 시대에도 자연스럽게 공존할 수 있을 터. 한옥 호텔 혜화 1938은 앞으로 한옥이 발전해야 할 바람직한 모델이 되기에 충분한 공간이었다.

**혜화 1938**
서울 종로구 성균관로 16 | 02-765-8542 | hyehwa1938.com

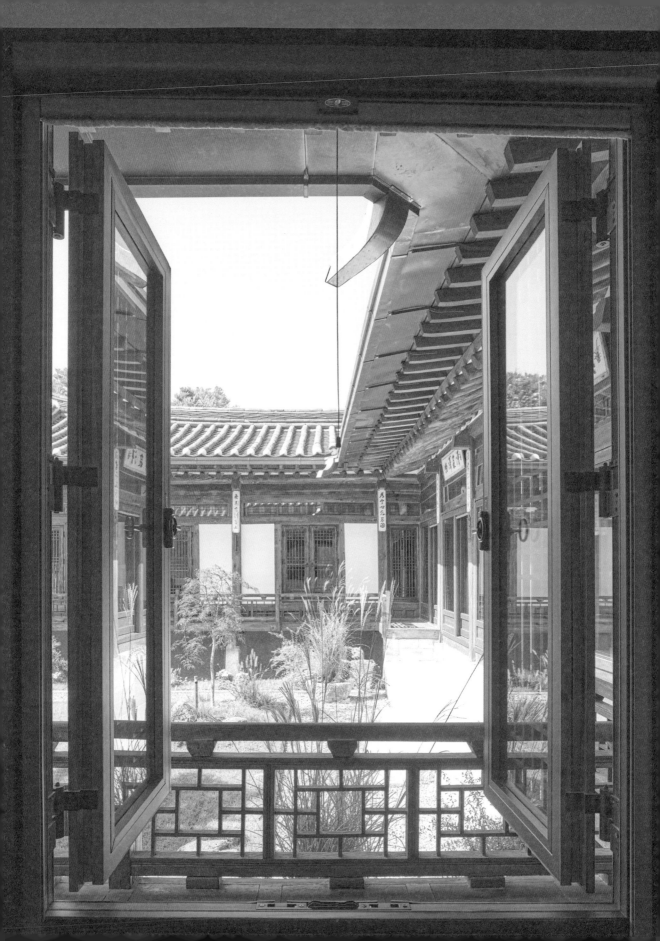

# 형형색색 다양한 매력을 담은 독채 한옥

한옥 호텔은 젊은 세대에는 새롭고, 기성세대에는 추억이 되는 오래된 미래를 보여
준다. 노스텔지어의 한옥 호텔에서는 계절을 따라 한옥에 스며든 멋진 자연의 풍광과
사람과 공간이 함께하는 주거 철학을 고스란히 느낄 수 있다.

대부분의 사람은 되돌아가고 싶은 과거의 한순간을 간직하고 있다. 마르셀
프루스트는 "과거는 우리의 의식이 닿지 않는 아주 먼 곳, 우리가 전혀 의심해 볼
수도 없는 물질적 대상 안에 숨어 있다"며 기억이 주는 의미가 어떤 사물에 깃들
어 있다고 말했다. 심오한 과거로 들어가는 문을 여는 열쇠는 마들렌처럼 흔한 간
식일 수도, 골목길 한옥처럼 익숙하면서도 낯선 추억의 장소일 수도 있다.

"2년 전 뉴욕에서 어릴 때 미국으로 이민 간 한국분을 만나 친분을 쌓게 됐
어요. 그간 발전한 한국을 궁금해하고 그리워하는 모습을 보고 언젠가 서울에 오
면 좋은 호텔에 모시겠다고 했더니 한옥에 묵고 싶다고 하더군요. 어린 시절의 어
렴풋한 기억, 그리움, 향수…. 그때 '노스텔지어nostalgia'라는 브랜드를 생각했죠."

노스텔지어는 한옥 호텔 브랜드다. 북촌의 대표적 풍경을 보여 주는 가회
동 31번지에서 운영 중인 독채 한옥 호텔 세 채를 제외하고 앞으로 두 채를 더 오

픈할 예정이다.

　노스텔지어를 기획한 박현구 대표는 브랜딩 전문가다. 20여 년간 브랜딩 회사 (주)브랜딩컴을 운영하며 여러 대기업의 사명과 서비스를 개발했다. "한국에 돌아와 다양한 한옥 스테이에 묵어 봤는데, 기대한 한옥과는 달랐어요. 한 집에 여러 팀이 묵는 형태라 프라이빗한 공간이 한정됐고, 저녁 8시 이후에는 정원에 나가 대화를 하거나 함께 시간을 보내는 것을 금지해 한옥 스테이의 고즈넉함을 만끽하기 어려웠죠. 노스텔지어가 독채 한옥 호텔을 고집하는 이유예요."

　박 대표는 기존 관행에 따른 일률적 서비스가 아닌, 다른 각도의 서비스나 콘텐츠를 보여 줄 수 있는 문화 관광 브랜드로서 '노스텔지어'를 구상하고 함께할 파트너를 모았다. 이수경 부사장은 디자인 전공자로 관련업을 하고 있고, 나머지 주주들도 컨설팅, 인테리어 등 각자의 본업이 있는 게 특징이다. 모두 숙박이나 관광업 쪽의 경험이 전무한 비전문가라는 점도 주목할 만한 대목이다.

　"대표님 부부처럼 저희 부부도 여행을 많이 다녔어요. 여행지마다 로컬 문화를 담은 숙소를 찾곤 했는데, 막상 한국은 특급 호텔 말고는 떠오르는 스테이가 없었어요. 세계적으로 한국의 콘텐츠가 더욱 강성해지고 있는데 문화 관광 분야에서도 대표하는 브랜드가 있으면 좋겠다는 생각을 했고, 서울 북촌을 기점으로 한국의 맛과 멋을 살린 독채 한옥 호텔을 만들고 싶어 부사장이자 주주로서 프로젝트에 기꺼이 합류했죠."

1　블루재의 ㄷ 자 한옥에서 마당이 바라보이는 중심에 주방과 거실, 다실을 구성했다. 마당이 프라이빗한 구조라 가족 모임이나 소규모 행사를 즐길 수 있다.

2　블루재의 양쪽 날개를 연결하는 툇마루의 깊이가 집의 규모를 짐작할 수 있게 한다. 현재는 툇마루와 대청을 구분하는 기둥만 남기고 주방과 다이닝룸으로 재구성했다.

3　블루재의 침실에서는 통창 너머로 탁 트인 전망을 바라보며 반신욕을 즐길 수 있다.

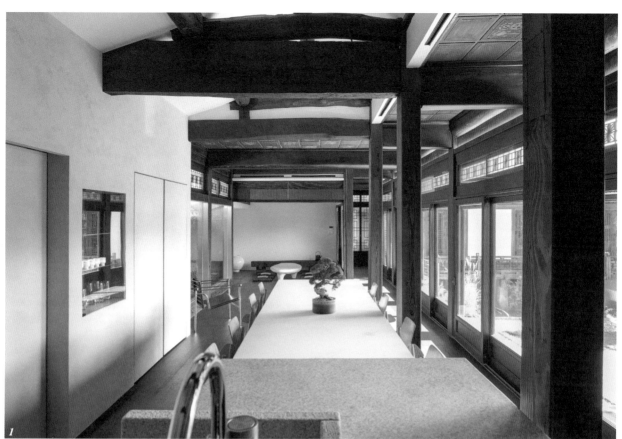

블루재 침실 너머로 두른 쪽마루와 창호의 화려한 살 짜임, 옛 그
림 모두 기존 한옥 모습을 그대로 보존했다.

## 기분 좋은 첫인상, 웰컴 투 서울

노스텔지어의 한옥 호텔은 북촌에서도 가회동에 집중하고 있다. 가회동은 예부터 명문가와 관료들이 살던 지역으로 특히 31번지에는 크고 반듯한 한옥이 잘 보존되어 있다. 박현구 대표는 단순한 스테이를 넘어 한옥을 온전히 즐길 수 있는 서비스를 장착하기 위해서는 어느 정도 규모 있는 한옥이 필요했다고 설명한다.

"블루재는 100평 남짓한 ㄷ 자형 한옥인데, 가족 행사나 브랜드 론칭 행사, 파티를 하고 싶다는 문의가 많아요. 40평 남짓한 힐로재와 히든재는 독채 다이닝룸과 야외 욕조를 마련해 친구들을 초대해 시간을 보낼 수 있고요. 내국인뿐 아니라 관광이나 비즈니스로 한국을 찾은 외국인이 한옥에 머물며 한국의 세련된 멋과 감성을 즐길 수 있도록 다양한 체험 서비스와 콘텐츠를 제공하고 있습니다."

기존 한옥 스테이와 가장 다른 점은 체크인과 체크아웃을 할 수 있는 별도의 '웰컴 센터'를 마련했다는 점이다. 요즘 스테이는 모바일로 비밀번호를 보내주면 혼자 누르고 들어가는 언택트 방식의 체크인이 대부분이라 아쉽게도 '웰컴'을 할 수 없다. 웰컴 센터는 노스텔지어의 첫인상이다. 체크인을 하면서 한옥과 이용 가능한 체험 콘텐츠 및 대여 서비스를 설명하고, 캐리어를 각각의 한옥으로 옮겨 주는 포터 서비스도 진행한다.

노스텔지어의 한옥은 공간마다 콘셉트와 느낌이 모두 다른 것이 특징이다. 쉬운 영어에 '재齋'를 붙인 이름에 각 공간의 콘셉트와 특징이 직관적으로 담

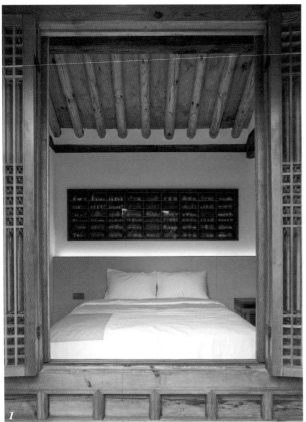

1   힐로재 위채로 들어서면서 바라보이는 메인 침실. 그릇장을
    형상화한 박찬우 작가의 사진 작품이 시선을 사로잡는다.
2   힐로재 침실과 욕실 사이 벽에 널찍한 세면대를 구성하고
    이은 작가의 세라믹 부조를 상부 장처럼 매치했다.
3   힐로재 위채의 대청은 반침이 있던 벽을 확장한 뒤 통창으
    로 바꾸고, 수납장과 디스플레이 장을 구성했다.

겨 있다.

　　먼저 블루재는 가회동 31번지에서 몇 안 되는 100평 규모의 한옥으로, 청와대를 지을 때 사용한 청기와를 담장에 올려 블루재라 이름 지었다. 청기와 외에도 ㄷ 자 구조, 우물천장, 기단 등 전통 한옥의 고유한 멋을 살리기 위해 최대한 유지하고 보존하는 방향으로 레노베이션의 초점을 맞췄다. 히든재는 안채 안쪽에 방공호로 사용하던 동굴이 남아 있는 한옥으로, 별채에 저쿠지를 구성했다. 집이 품고 있는 고유하면서도 신비로운 스토리는 살리되, 디자인은 젊은 고객의 감각에 맞춰 최대한 모던하게 풀었다. 북촌 7경 언덕 위에 자리한 힐로재는 지은 지 10년 된 한옥으로, 전통 그대로 유지하고 보존하기보다는 과감하고 감각적인 공간으로 연출했다.

　　"각 한옥마다 다른 디자이너에게 레노베이션을 맡겼어요. 가장 전통적인 블루재는 외려 힙한 상업 공간을 디자인하는 '스튜디오언라벨'에서 진행해 한옥의 입체적 공간감을 살리는 작업에 집중했고, 히든재는 '오픈스튜디오'의 모던한 감각을 입혔죠. 힐로재는 마감과 디테일은 물론 공예, 미술 작품까지 좀 더 강력한 스토리텔링을 부여할 수 있는 디자인으로 '길연'에서 맡아 주셨어요."

　　각각의 한옥이 모두 전통과 현대가 어우러진 아름다움을 담고 있지만, 특히 힐로재는 그 자체가 하나의 거대한 공예품이라고 할 수 있다. 40평 남짓한 한옥은 위채와 아래채 두 채로 구성되었다. 길연의 이길연 대표와 권용석, 김근태 디자이너는 웅장하고 멋지다는 느낌보다 편안하고 포근한, 묵고 싶은 집 같은 느낌을 주는 데 집중했다. 가장 중요한 키워드는 '생활 속 예술'이다.

　　위채 대청에 자리 잡은 허명욱 작가의 롱 테이블, 수작업 흔적이 돋보이는 이헌정 작가의 세라믹 테이블, 탄화목으로 만든 임정주 작가의 스툴, 빛의 스펙트럼을 보여 주는 박원민 작가의 레진 협탁, 박찬우 작가의 사진과 이은 작가의 부조 모두 쟁쟁한 작품이지만 마치 풍경처럼 공간에 자연스럽게 녹아든다. 권은영 작가의 다과함, 류연희 작가의 쓰레받기와 주전자 그리고 이윤정 작가의 수건걸이 등 작은 기물까지 기성품은 하나도 없다. 한옥 지붕과 나무 아래 툭툭 놓은 이헌정 작가의 도자 꽃을 마주하는 순간 절로 탄성이 쏟아진다. 디자이너 스스로 미술 및 공예 애호가이면서 사용자이기에 가능한 디테일이다.

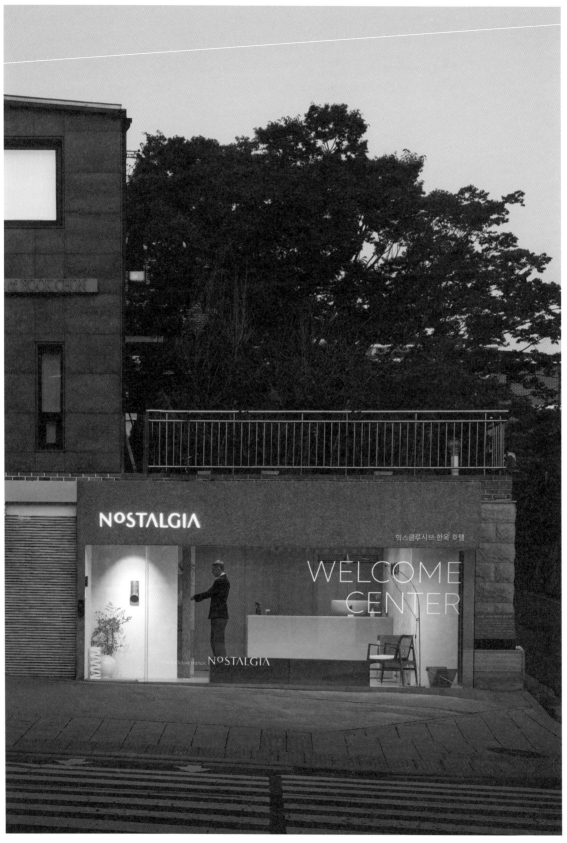

가회동 대로에 자리한 노스텔지어 웰컴 센터. 웰컴 마스터가 손님을 맞으며 각 한옥의 특징과 이용 가능한 콘텐츠, 서비스 등을 설명한다.

이길연 대표는 고이 모셔두기만 하는 작품이라면 소장하는 의미가 있는지 반문한다. 실생활에서 써야 예술도 내 것이 되므로 주거 공간을 디자인할 때도 아트 퍼니처를 실제 사용하는 가구로 많이 제안하는데, 아끼고 모셔둘 거라면 절대 사지 말라고 조언한다.

### 변하는 것과 변하지 않는 것

한옥은 그 자체로 완성이자, 하나의 거대한 공예 작품이다. 그래서 무언가를 덧붙이는 것도, 힘을 빼는 것도 쉽지 않다.

"주거의 관점에서 바라보면 한옥은 만만하고 편한 집은 아니지만 '호텔'로 접근하면 단점이 모두 장점으로 바뀌어요. 주차할 필요 없고 냉난방 전기료 걱정 없이, 기단을 오르락내리락하는 며칠의 불편함은 낭만으로 즐길 수 있으니까요. 게다가 한옥은 그대로 있는 것만으로도 향수를 불러일으키죠. 트렌디하게 매년 리뉴얼할 수도, 또 하지 않아도 된다고 생각해요." 한옥을 K-콘텐츠의 중심으로 만들고자 하는 박현구 대표의 말이다.

너무 많은 마음이 앞서면 정작 하고 싶은 말을 고르고 고르다 아무 말도 꺼내지 못한다. 장고 끝에 악수 나듯 고민이 깊어지면 아무것도 시작할 수 없다. 박현구 대표와 이수경 부사장은 3년 전 노스텔지어라는 이름을 지은 순간부터 지금까지 고민은 짧게, 시행착오는 언제든 겪을 수 있다는 생각으로 한옥을 하나둘 유연하게 하나씩 고쳐 나가며 완성하고 있다.

**노스텔지어**
서울시 종로구 북촌로8길 1 1층 | 02-3673-3666 | www.nostalgiaseoul.com

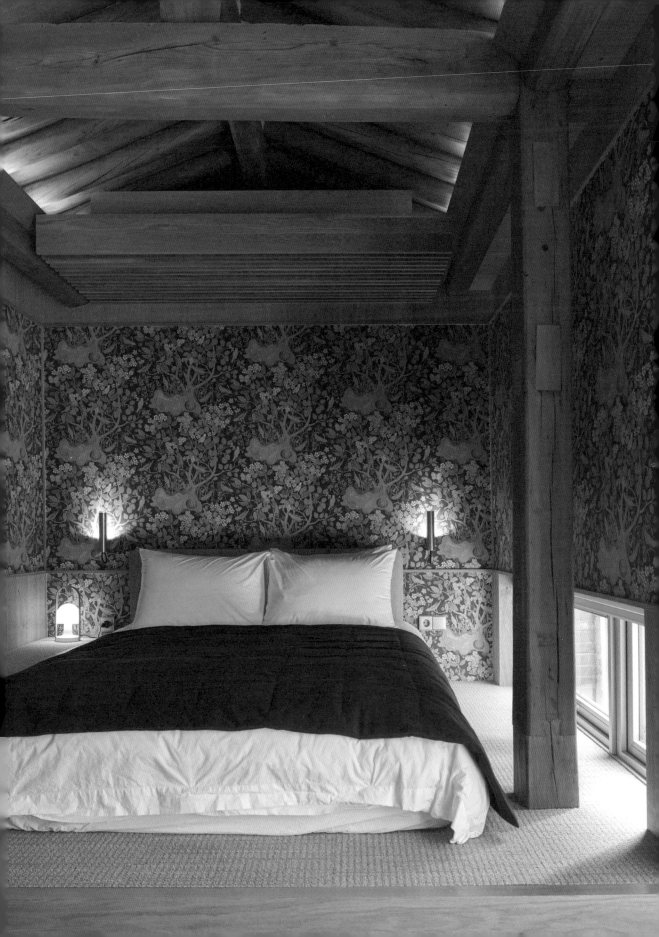

# 넘치지도 모자라지도 않게, 스웨덴 시골집처럼

기와지붕을 얹은 붉은 벽돌 벽, 그 위에 작게 자리한 낯선 알파벳 단어 Häbre. 이곳은
작은 한옥 스테이, 헤브레다. 서울 북촌과 서촌에 모여 있는 한옥 스테이마다 나름의
이야기를 품고 있지만, 이곳은 외관만으로도 특별해 보인다.

헤브레 이야기는 2018년 발간한《Hanok: The Korean House》(Tuttle Publishing)라는 책 소개부터 시작해야 할 것 같다. 헤브레의 주인이자 이 책의 저자인 박나니 씨는 어릴 때 미국 하와이로 이민 가서 생활하다가 25년 전에 한국으로 돌아왔다. 이민 가기 전 어린 시절을 한옥에서 보낸 그는 수십 년이 지나 완전히 새로워진 현대적 한옥과 재회하면서 한옥에 더욱 관심을 갖게 되었다. 일러스트레이터로, 미술 선생님으로 일하면서 책을 만들어 본 경험은 없었지만 외국에 한옥을 알리는 책이 거의 없다는 사실을 알고 미국 출판사에 기획안을 꾸준히 보내 마침내 첫 책《Hanok: The Korean House》를 출간했다. 이 책이 나오고 다음 해에는 한글판《한옥》을 펴냈고, 올해 세 번째 한옥 책《한옥, 오늘》을 펴냈다. 두 번째 한옥 책에는 비교적 큰 주거용 한옥을 실었다면, 세 번째 책에는 다양한 용도로 활용되는 상업용 한옥을 소개했다.

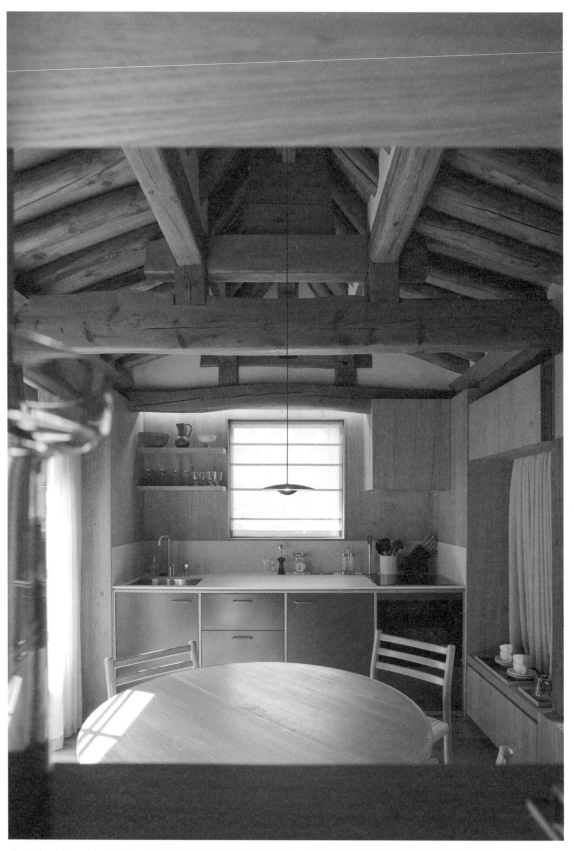

참나무 마감에 스웨덴을 상징하는 파란색과 노란색을 더한 부엌. 전체적으로 오래된 대들보와 서까래가 드러난 한옥이면서 산장 같은 분위기를 느낄 수 있다.

"세 번째 책에 소개할 한옥을 찾아보다가 서촌 골목 안에 자리한 작고 예쁜 한옥 스테이를 알게 되었어요. 거기 주인과 연락이 닿아 한옥을 찾아갔더니 제 책을 갖고 있더라고요. 얼마나 많이 들춰 봤는지 책이 너덜너덜해졌어요. 그분 말이 이 책을 보고 영감을 얻어 한옥을 지었다고. 그런데 제가 연락해서 너무 놀랐다고 하시더라고요."

이 놀라운 인연을 시작으로 박나니 씨는 서촌에 자리한 다른 매력적인 한옥과 그곳에 사는 사람들을 만났고, 이 동네와 작은 한옥을 사랑하게 되었다. "한옥을 사랑하는 사람들은 특별해요. 지향하는 라이프스타일과 가치관이 비슷해서 서로 공감하는 부분이 많고, 그 덕분에 대화하기도 정말 편해요. 세 번째 책을 준비하면서 만난 서촌의 한옥 주인들과 '서벤져스'라는 모임을 만들었어요. 그분들과 자주 교류하고 동네의 작고 맛있는 식당도 알게 되면서 이 동네가 더 좋아졌습니다."

박나니 씨는 자연스럽게 서촌에서 한옥을 알아보기 시작했고 몇 달 만에 이 집을 만났다. 젊은 부부가 부모에게 물려받아 살고 있던 오래된 한옥은 옛날에 지은 그대로 고치지 않은 상태였다. 마당은 시멘트로 덮여 있었고 좁은 땅에서 거주 공간을 조금이라도 넓히려고 벽은 최대한 바깥쪽으로 밀어 놓았다. 심지어 원래 부엌이던 방에 있는 붙박이장을 뜯어냈더니 바로 옆집 벽이 나왔다. 그래도 전부 허물지 않고 대들보와 서까래, 기둥 등의 뼈대를 매만져 그대로 살리고 나머지는 대대적으로 레노베이션했다.

## 형태는 달라도 본질은 통한다

박나니 씨는 애초에 이 한옥을 '스테이폴리오'와 연계한 프라이빗 스테이로 계획하고 레노베이션을 지랩에 맡겼다. 건축사무소 지랩에서 만든 스테이폴리오는 머무름 자체를 여행으로 만드는 감각적 숙소를 큐레이팅해 소개하는 플랫폼이다. 이미 한옥을 포함해 여러 형태의 스테이를 디자인해 온 지랩은 박나니 씨가 생각한 확고한 콘셉트를 60㎡ 남짓한 작은 한옥에 맞춤하게 풀어냈다. "시어머니가 스웨덴 분이에요. 여름마다 스웨덴 북부 마을에 있는 별장에서 휴가를 보내곤 하는데 그 집을 참 좋아해요. 스웨덴 사람들은 보통 작은 별장을 한 채씩 갖고 있어

요. 한국 사람들이 생각하는 것처럼 대저택이 아니고, 소박한 통나무집이죠. 그곳에 가서 두세 달간 그냥 쉬다가 오는 거예요. 그 통나무집의 느낌을 한옥에 담고 싶었어요. 서울 시내에 자리하지만 조용한 시골집에 있는 것처럼 편안하게 머물며 쉴 수 있는 공간을 만들고 싶었지요." 스웨덴에서는 '헤브레'라는 목조 창고를 개조해 별장으로 활용하는 경우가 많은데, 그런 이유로 헤브레는 창고, 별장, 시골집 등의 의미를 지닌다. 원래의 용도를 다하고 새로운 공간으로 태어나는 헤브레처럼 이 한옥 역시 완전히 다른 모습으로 되살아났다.

　　헤브레는 거실을 겸한 부엌과 침실, 욕실 등 꼭 필요한 공간으로만 단출하게 구성했다. 대들보와 서까래, 굵직한 기둥이 드러난 실내는 한옥이면서 산장 같은 느낌도 자아낸다. 벽면이 곧 창인 한옥에서는 장식적인 창살이 분위기를 주도하는데, 이 한옥에는 의도적으로 모던한 창호를 사용했고 투박한 질감의 오크로 벽면을 둘러 차분한 산장 같은 분위기를 낸 것이다. 그러면서 창을 집 안과 밖을 이어 주는 요소로 적절히 활용했다. "목련나무를 심은 마당을 볼 수 있도록 부엌에는 마당 쪽으로 창을 크게 냈어요. 맞은편 벽에도 창을 만들었는데 그 창을 통해 작은 뒤뜰을 볼 수 있어요. 실내 면적이 좀 줄더라도 안과 밖이 유동적으로 연결되는 한옥의 장점을 살리고 싶어서 원래 없던 공간을 마련했고요. 앞뒤로 뚫린 창을 통해 바깥 풍경이 안으로 들어오고, 실내 공간은 그만큼 확장되는 거죠."

　　침대만으로 꽉 차는 침실에는 누웠을 때 마당을 볼 수 있도록 벽 아래에 길고 좁은 창 하나만 만들었다. 나머지 벽은 나무와 새, 물고기, 꽃 등이 어우러져 초

1　ㄱ 자형 한옥 헤브레. 침실에서 바라보면 앞에 욕실이, 왼쪽에 부엌이 있다. 투박한 질감의 참나무로 마감한 둥근 벽이 공간을 부드럽게 이어 준다.

2　욕실과 화장실 사이에 마련한 세면대. 이곳 벽도 침실과 같은 벽지로 마감했다.

3　스웨덴에서 가져온 무스 옷걸이. 나무를 손으로 깎아 만든 것이다.

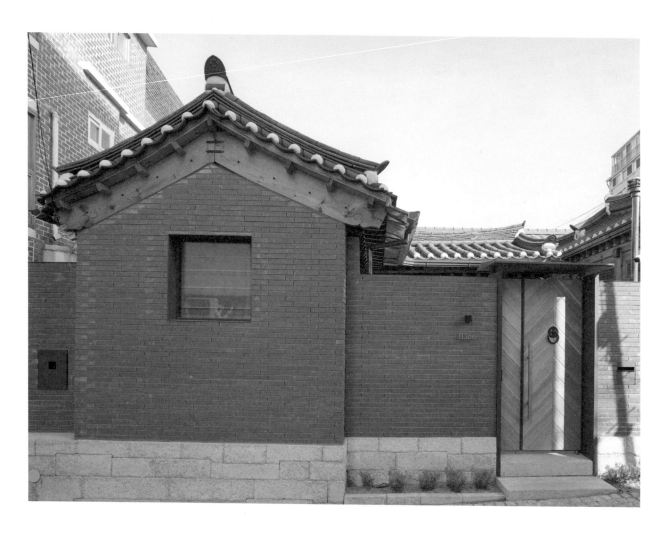

돌 기단에 붉은 벽돌 벽을 쌓고, 그 위에 기와지붕을 얹었다.

현실적 분위기를 자아내는 벽지로 마감했다. '천국Paradiset'이라는 이름의 이 벽지는 1924년 설립한 스웨덴의 라이프스타일 브랜드 스벤스크트텐의 제품이다. 스웨덴을 대표하는 디자이너 요제프 프랑크가 1940년대에 디자인한 패턴으로, 지금도 숙련된 기술자가 옛날 방식으로 제작한다. "한옥에 스웨덴 문화와 예술을 담고 싶어서 이 벽지를 선택했어요. 패턴은 화려하지만 톤 다운된 컬러라 한옥의 분위기와도 잘 어울리죠. 그리고 스웨덴에서는 특히 여름에 백야가 지속되기 때문에 침실에 검은 커튼을 달아요. 그처럼 잠을 편히 잘 수 있도록 어둑한 분위기를 연출했어요."

스웨덴 사람들이 중요하게 여기는 삶의 가치 중 '라곰'이 있다. 넘치지도 모자라지도 않는, 각자의 삶에서 가장 적절한 상태인 '중용'을 의미하는 이 말은 지속 가능성, 균형 등의 가치와 이어진다. 그런 점에서 한옥과도 통한다. 스웨덴 문화를 깊이 사랑하고 이해하는 박나니 씨는 한옥에 이를 넘치지도 모자라지도 않게 담아냈다. "한옥은 필요에 따라 다양하게 변화시킬 수 있어 매력적이에요. 한국 사람은 물론 외국인이 헤브레에 머물면서 색다른 한옥을 경험하기를 바랍니다."

**헤브레**
서울시 종로구 필운대로 26-10 | 0504-0904-2707 | www.stayfolio.com/findstay/habre

# 곳곳에 시선이 머무는 특별한 경험

그동안 강원도 영월을 단종애사端宗哀史가 깃든 곳, 혹은 국내 최고의 래프팅 명소로만 기억했다면 이젠 관점을 전환할 때가 됐다. 한옥 미학의 정점이라 일컫는 차경을 제대로 구현한 더한옥헤리티지하우스는 영월이 품고 있는 자연의 결을 온전히 담아냈다.

강원도 영월! 유네스코 세계문화유산으로 지정된 단종의 무덤 장릉과 그의 유배지이던 청룡포가 있는 곳. '지붕 없는 박물관'으로 부를 만큼 다양한 박물관이 즐비한 곳. 래프팅과 카누, 패러글라이딩 등 다양한 레저 스포츠를 즐길 수 있는 곳. 청정 지역에만 산다는 반딧불이와 찬란하게 빛나는 별 무리를 만날 수 있는 곳. 이렇듯 영월에 가야 하는 이유는 차고 또 넘쳤지만, 200여km에 달하는 물리적 거리와 그에 못지않은 심리적 거리는 자꾸만 영월행을 주저하고 망설이게 했다. 이유는 단 하나! 마음에 드는 숙소를 발견하지 못했기 때문이다. 여행지를 고를 때 무엇을 우선순위에 둘지는 사람마다 다르겠지만, 내 선택은 언제나 '편안한 쉼'에 있었다. 내 여행이 늘 까다로운 숙소 선별로 시작된 건 이런 이유에서다. 그런 점에서 영월에 국내 최대 규모의 한옥 호텔이 개장한다는 소식은 더할 나위 없는 희소식으로 다가왔다.

그렇게 출발한 영월행. 끝없이 밀리는 길과 뜨거운 햇살, 초여름 더위를 뚫고 간신히 도착한 영월은 그야말로 기대 이상이었다. 어딜 가든 초록 숲과 맑은 물이 피곤에 지친 몸과 마음을 달래 주었고, 빼어난 경관과 청량한 바람은 머릿속 복잡한 생각을 말끔히 비워 주었다. 더욱이 영월 중심가에서 20여 분 거리에 위치한 이번 여행의 목적지 더한옥헤리티지하우스는 영월의 자연 지형을 그대로 살려 지어 한 점의 그림처럼 아름다웠고, 날아갈 듯한 곡선의 처마와 독특한 색감의 기와는 한옥의 정취를 배가했다. 현재 계획 중인 더한옥헤리티지하우스의 총 규모는 건축 연면적 16,332㎡의 전통 한옥 호텔 78동 137실. 여기에 문화 전시장, 야외 연회장, 세미나실, 스파, 실내 수영장, 간이 운동 시설 등이 더해질 예정이지만 아직은 그중 두 동의 '영월종택'만 오픈한 상황이다.

## 과학적 설계와 예술적 감성의 컬래버레이션

"더한옥헤리티지하우스는 까다롭게 선별한 목재의 수분 함유량을 최대치인 15%까지 낮췄습니다. 목재가 마르면서 발생하는 변형과 뒤틀림을 차단해 한옥의 단점으로 꼽히는 웃풍과 창문의 어긋남을 보완한 것이죠. 창문을 삼중으로 설계해 단열을 강화하고, 투명 방충망으로 한옥 미학의 정수인 차경을 제대로 구현한 것도 장점입니다."

조정일 더한옥호텔앤리조트 대표의 설명처럼 더한옥헤리티지하우스는 전통 한옥에 과학적 설계를 덧입혀 여름엔 시원하고 겨울엔 따뜻한 게 특징이다. 뼈대는 한옥이지만 단열재 등은 첨단 소재를 활용해 편의성을 더했고, 내부에는 젊은 작가들의 회화와 조형물 및 인테리어 소품 등을 곳곳에 배치해 예술적 감성을

*1*  영월종택 B동 대청에 놓인 모던한 좌탁과 좌식 의자. 벽에 걸린 강렬한 색감의 예술 작품이 멋스러움을 더한다.

*2,3*  다양한 형태의 창과 독특한 문양의 창살은 주변 경관을 내부로 끌어들여 완벽한 차경을 완성한다.

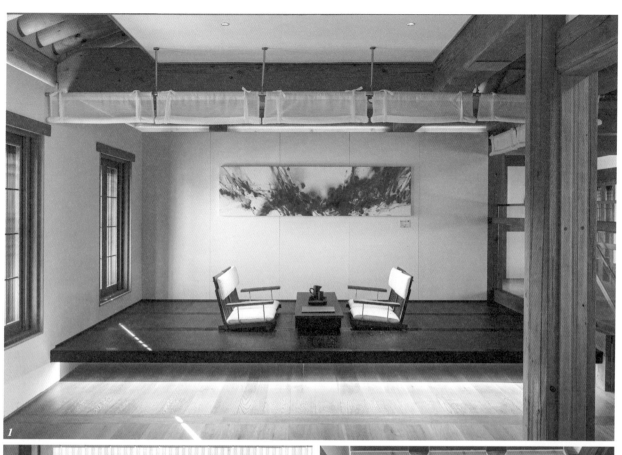

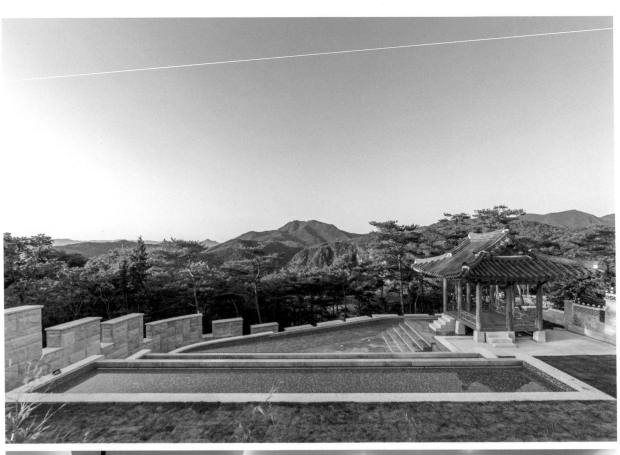

살렸다.

　　　　지붕에는 흔히 쓰는 먹색의 그을림 기와 대신 자연스러운 색감의 변색 기와를 얹어 운치를 더했고, 한옥 내부를 지탱하는 보는 기존 한옥 들보보다 긴 것을 사용해 천장고가 높고 개방감이 탁월하다. 또한 주변 경관을 고려해 건물 높이에 차등을 두어 차경을 적극적으로 담아냈다.

　　　　각 동의 구조 역시 차별화했다. A동은 건식 사우나 시설을 갖추어 여유로운 쉼을 즐기기에 제격이고, A동보다 높은 지형에 위치한 B동은 객실의 누마루와 대청에서 영월의 명승지 중 하나인 선돌을 감상할 수 있다. A동에서 B동으로 향하는 길목에는 영월의 비경을 바라보며 물놀이를 즐길 수 있는 야외 수영장을 배치했다. 볼거리, 즐길 거리에 못지않은 최고급 한식 다이닝 코스도 준비할 예정이다.

　　　　겉모습만 한옥풍이 아닌 한옥 전통 건축 기법을 온전히 적용한 더한옥헤리티지하우스에서는 빼어난 자연 경관과 한옥의 정취를 통해 여유로운 쉼과 특별한 머묾의 경험을 만끽할 수 있다.

**더한옥헤리티지하우스**
강원도 영월군 남면 문개실길 37-150 | 033-823-9500 | thehanokhotel.com

1　수영장에서는 영월의 산세와 울창한 숲을 바라볼 수 있어
　　경관과 수영을 동시에 즐길 수 있다.
2　영월종택 B동 지하에 위치한 플레이룸에는 노래방 시설이
　　마련돼 있다.

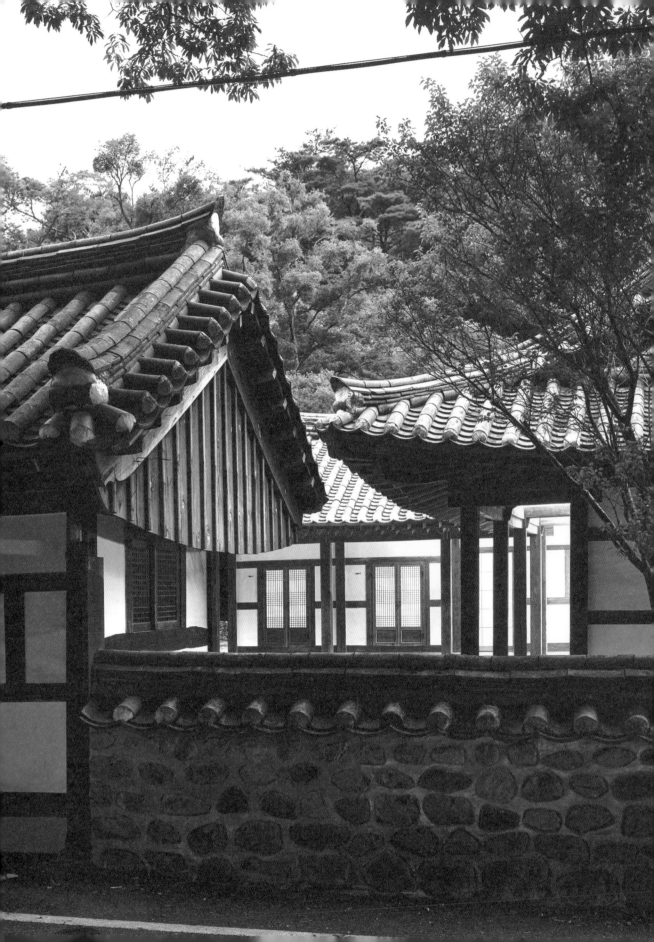

# 자연을 벗 삼는 풍류 스테이

피안彼岸을 향해 떠난 이들의 종착지, 대한민국 최남단에는 100년 역사를 지닌 우리
나라 최초의 여관 유선관이 있다. 치장을 내려놓고 단정한 매무새로 고쳐 입은 유선
관은 변화무쌍한 대자연의 풍광과 오감으로 합일한다.

해남 두륜산 입구, 굽이굽이 아홉 번 굽이친 숲길이 봄에 거닐기 좋다 하여
이름 붙은 '구곡장춘九曲長春'. 그 길을 따라 유유자적 걷는다. 4km 남짓한 길에 삼
나무, 측백나무, 편백나무, 동백나무, 너도밤나무 고목이 동굴처럼 우거져 끝도 없
이 숲을 이룬다. 그 길의 끄트머리에 천년 고찰 대흥사가 자리한다. 우리나라 차
문화를 이끈 초의선사가 다산 정약용, 추사 김정희와 머물며 우정을 나눴다는 도
량. 서산 대사는 이곳을 "전쟁을 비롯한 삼재가 미치지 못할 곳(三災不入之處)"이라
일컬었다.

　　이곳과 멀지 않은 곳에 유선관이 있다. 남쪽 땅끝을 향해 정행했을 객인과
수도승을 위해 1914년에 지은 객사. 자연 경관이 빼어나 예로부터 남도의 문인과
예인이 즐겨 찾았다니 신선이 노닌다는 뜻의 '유선遊仙'관이라는 이름이 더없이 걸
맞다. 1970년대부터 일반인에게도 개방해 영화 〈서편제〉, 〈천년학〉을 비롯한 여러

영화의 배경이 되기도 했다. 전 문화재청장 유홍준의 저서《나의 문화유산답사기》 1권에서도 유선관을 향한 애틋함이 담뿍 묻어난다.

## 비우고 덜어 내 완성하다

생활의 흔적으로 인해 본래 모습이 많이 퇴색된 근래의 유선관. 2018년 유네스코 세계문화유산으로 지정된 대흥사의 가치에 걸맞은 새 단장이 필요했다. 해남에서 나고 자라 두륜산을 벗 삼아 뛰놀던 한동인 대표는 한국 전통 의식주를 현대적으로 재해석하는 라이프스타일 브랜드 '비애이BAE 컬쳐'에 총괄 기획 및 운영을 맡겼다. 전반적인 설계와 시공은 착착 건축사무소의 김대균 건축가가 담당했다. 유선관에 모인 그들이 가장 먼저 한 일은 바로 '덜어 내는 것'. 중정을 가득 메운 인공 조경과 시멘트 블록을 걷어 내고 그 자리에 흙을 깔았다. 주변과 구획한 철제 난간을 치우고 50cm 높이의 낮은 돌담을 빙 둘렀다. 마당을 비우고 나니 되레 유선관을 둘러싼 울창한 풍광과 빛깔이 더욱 선명해졌다.

"과수원의 원두막은 안과 밖의 경계가 없잖아요. 유선관도 별장別莊이 아닌 별서別墅가 되었으면 했어요. 마치 밭 한가운데 있는 농막처럼 건물 대신 자연이 주가 되는 거죠. 본래 이곳의 모습을 떠올렸어요. 화려하거나 기교가 있는 건물은 아니거든요. 심하게 노후한 곳을 보수하고, 자연에 이질적인 부분을 정리 정돈하는 게 주된 목적이었습니다." 김대균 소장은 건물이 대단하게 보이지 않도록 하는 것이 큰 과제였다고 덧붙였다. 길가에 나 있던 대문의 위치를 부러 멀찌감치 옮긴 이유도 두륜산의 봉우리를 감상하며 마당 안으로 들어올 투숙객을 상상했기 때문이다. 세월과 자연이 중첩되고 겹겹이 쌓여 만든 고아한 정취가 비로소 제 모습을 드러냈다.

1   한지 도배로 자연스러운 멋을 더한 유선관 객실 전경. 비애이 홈의 목화솜 보료와 명주솜 이불로 쾌적하고 안락한 수면을 경험할 수 있다.
2   투숙객 대상으로 예약 운영하는 프라이빗 스파. 외부와 차단된 야외 정원에서 자연을 오롯이 감상할 수 있다.
3   카페 유선의 모습.

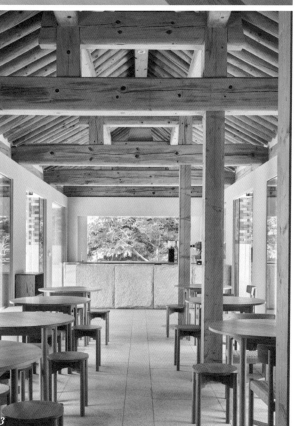

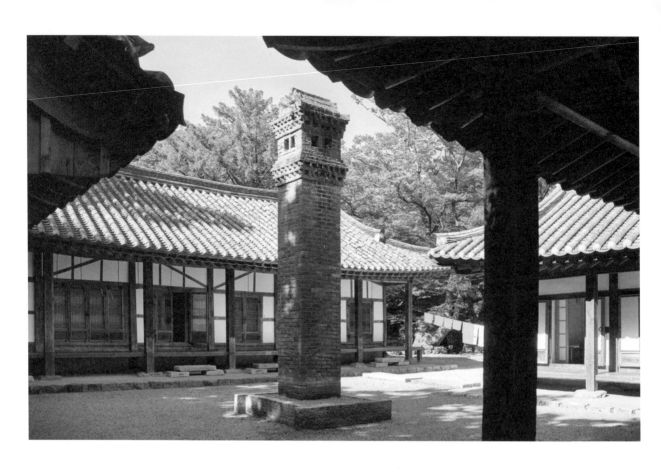

복잡하던 마당을 정리하고 말끔히 비워 냈다. 콘크리트 블록을
걷어 낸 자리에는 흙을 깔았다.

## 최고의 놀이는 풍경

들쑥날쑥하던 방의 크기는 2인 기준에 맞춰 여덟 개의 객실로 재탄생했다. 이전엔 야외에 자리해 불편하던 공동 샤워장과 화장실을 각각의 방 안으로 들이고, 침실을 분리하는 한식 파티션을 세워 공간 활용도를 높였다. 자연을 거스르지 않는 최소한의 조도를 위해 간접등조차 삼베로 감쌌다. 객실 내부는 한지 도배를 고집했는데, 그 결과 새어 들어온 햇살이 벽마다 은은하게 비친다. 새롭게 단장한 유선관의 백미는 바로 프라이빗 스파. 계곡과 면한 작은 마당을 품고 있어 끊임없이 흐르는 물소리와 짙은 숲 향기를 온몸으로 받아들이게 된다. 유선관의 세부 계획을 짜고 브랜딩을 구축할 수 있었던 것은 실질적 운영을 맡은 배시정 총괄 디렉터가 있었기에 가능한 일이었다. 준비 기간 동안 해남에서 네 계절을 모두 겪은 이이기도 하다.

"유선관이 그동안 쌓아 온 여러 겹에 한 겹을 더할 뿐이라고 생각해요. 긴 시간의 찰나에 잠시 저희가 머물고 있는 거죠. 그래서 더욱 조심스러운 부분도 있어요. 공간이나 서비스가 화려하거나 뛰어나지 않지만, 자연을 느끼는 데 불편함이 없도록 하려 합니다. 오롯이 숲을 거닐고, 처마를 바라보고, 나무를 감상하는 사유의 시간을 누릴 수 있도록요." 공동 샤워장으로 쓰던 별채는 카페로 문을 열었다. 국립 공원으로 지정된 두륜산 내에서 커피를 마실 수 있는 유일한 공간이라 더욱 의미가 남다르다. 천천히 흐르는 시간의 흐름 속에서 유선관의 정원과 숲, 고요한 휴식을 즐겨 보는 것도 좋겠다.

**유선관**
전남 해남군 삼산면 대흥사길 376 | yusungwan.kr

산청 율수원

# 스스로 덕을 닦는 집

'율수率修'는 유교 사상을 담은 경전 《시경》에 나오는 말로 스스로 갈고닦아 덕을 쌓는

다는 뜻이다. 산청 율수원은 재능그룹 박성훈 회장이 조상의 덕을 이어 다시금 새로

쌓아 올린 격조 높은 한옥 스테이다.

산이 높고 물이 푸르다(山高水淸)는 경상남도 산청으로 향하는 길은 말 그
대로 내내 푸르렀다. 산청山淸의 원래 이름은 주위가 푸른 산으로 둘러싸여 응달진
곳이라 산음山陰이었다고 한다. 해발 1,108m 높이의 깊고 좁은 황매산의 골짜기를
타고 흩어졌던 바람이 잦아들고, 계곡을 따라 내려오는 신등천은 단계천과 만나
산청을 대표하는 경호강을 지나 진주 남강까지 흘러간다. 바람과 물이 모여드는
분지로 예로부터 땅이 비옥하고 기운이 생동하는 땅이었음이 틀림없다.

산청 단계마을에 도착해 낮은 돌담길을 따라 20여 분 걷다 보니 비범한 한
옥 한 채를 마주했다. 이곳은 본래 1900년에 지은 '고헌고택'으로 재능그룹 박성
훈 회장 부친인 박휴창 옹의 생가였다. 100년이란 시간이 흘러 이곳저곳 손볼 곳
이 많아지자 박성훈 회장은 개·보수 작업을 중지하고 다시 짓자는 결론을 내렸다.
"한옥은 1,000년을 가는 집입니다. 단, 제대로 짓고 제대로 관리했을 때 가능한 이

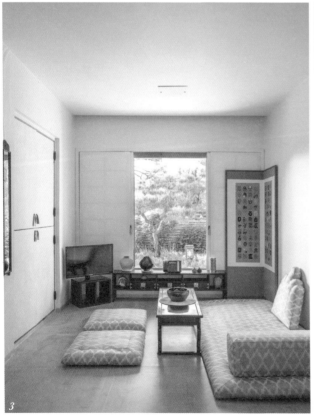

야기죠. 우리가 지금부터 1,000년 가는 한옥을 제대로 지어 많은 사람이 이곳을 체험할 수 있는 기회를 줍시다." 이렇게 그의 뜻대로 고헌고택 터에 새로 들어선 산청 율수원은 4년의 공사 끝에 2013년 한옥 스테이로 문을 열었다.

## 마음을 합한 집 짓기

총 일곱 채의 건축물, 연못과 정자를 갖춘 산청 율수원에 사용한 목재는 무려 총 20만 재才이고, 기와는 약 3만 장이다. 이 거대한 프로젝트를 위해 설계와 시공은 각각 건축사사무소 삼간일목의 권현호 소장과 가은앤파트너스 이문호 소장이 맡았으며, 이 밖에도 풍수 전문가 김대환, 대목장 징영수, 와공 정태용, 전통 조경 전문가 안계동 등 각계 전문가가 힘을 합했다.

기본적으로 한옥은 목조 건물이므로 우선 좋은 소나무를 찾는 것이 관건이었다. 강릉에 수령 90년 된 소나무가 있다는 전화를 받자마자 한달음에 달려가 어렵사리 구한 목재는 강원도 삼척에서 자란 금강송이었다. 율수원의 모든 기둥과 보는 수령이 최소 50년에서 최대 150년 이상 된 금강송을 사용한 것이다. 건물 배치는 안채를 중심으로 식당채, 목욕채, 안사랑채, 바깥사랑채, 대문채 총 다섯 채가 안채를 감싸며 보좌하는 형세를 띠도록 설계했는데, 그중 바깥사랑채 고헌, 안사랑채 농암, 안채 하계재를 숙박 공간으로 꾸몄다. 모든 방의 벽면은 닥종이로 도배하고, 바닥은 한지로 초배한 후 기름 먹인 닥종이를 깔아 단아한 기운을 자아낸다.

1   산수유, 백일홍, 모감주, 수국 등 외래종보다는 선조가 집 안에 즐겨 심은 꽃들로 세심하게 꾸민 정원은 감탄을 자아낼 만큼 아름답다.
2   안채 기둥에 달린 주련에는 기옹 박공구의 시구가 적혀 있다. '모든 풀은 하룻밤 서리에 시들어 떨어지는구나'라는 뜻이다.
3   안채 하계재의 안방에서는 방문 너머로 잘 가꾼 정원이 내다보인다.
4   위에는 이불장을, 아래에는 바깥 풍경을 내다볼 수 있는 낮은 살문을 설치한 바깥사랑채 안방.

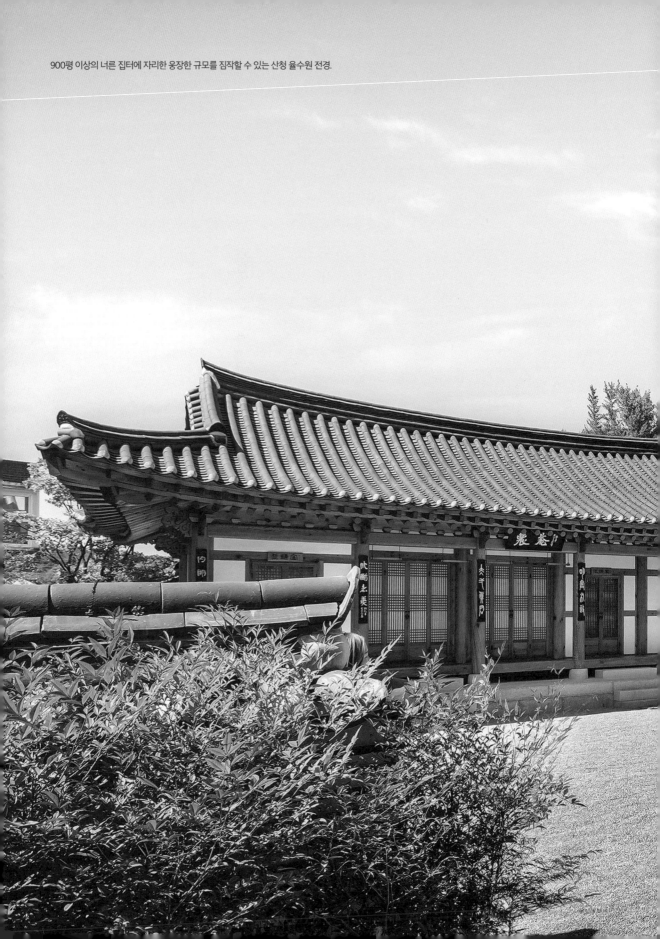

900평 이상의 너른 집터에 자리한 웅장한 규모를 짐작할 수 있는 산청 율수원 전경.

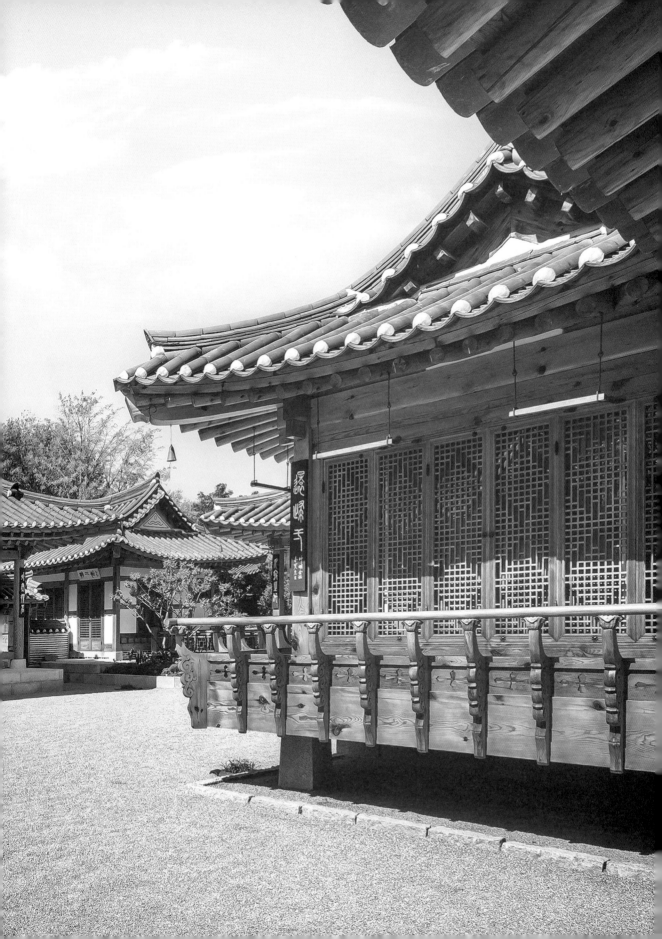

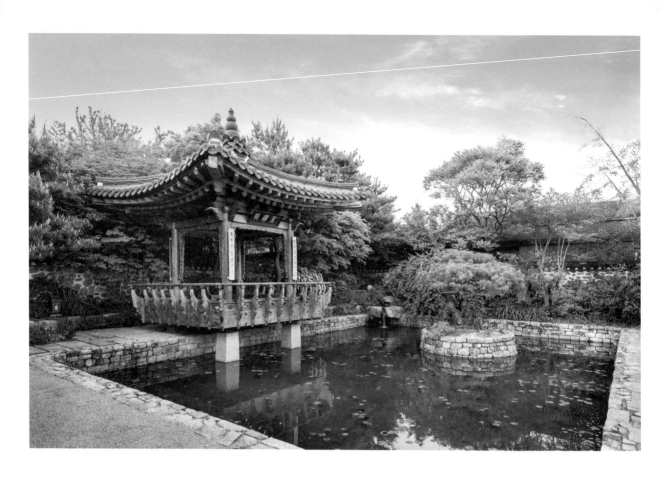

식당채와 바깥사랑채 사이에 있는 양희문을 지나면 용담정이란 정자와 연못을 만날 수 있다.

산청 율수원의 가장 큰 특징은 각 채에 그 위상에 걸맞은 당호를 짓고 현판을 단 것이다. 당우와 방마다 각각의 이름을 쓴 현판 33개를 달고 집과 정자 기둥에는 47개의 주련을 달았다. 기둥 주련에는 남명 조식, 율곡 이이, 용담 박이장의 시를 걸었으며, 80개의 편액과 주련 글씨를 박원규, 정도준 등 한국 대표 서예가 열두 명이 썼기에 한국 서단의 서풍을 한눈에 볼 수 있는 서예 박물관이기도 하다. 선조의 지혜가 담긴 글귀를 하나씩 음미하며 돌아보는 것도 한옥의 고즈넉함을 즐기는 방법이 될 터이다.

## 궁궐이 아닌 쉬러 오는 곳

산청 율수원은 전통의 아름다움을 추구하면서도 그에 얽매이지 않는 자유로움을 보여 준다. 기존 전통 한옥과 달라진 것이 있다면 건축 양식의 관례다. 예를 들어 원기둥은 전통적으로 '남자의 것'으로 여겨 안채에는 쓰지 않지만 이곳 안채 앞에는 원기둥을, 뒤에는 각기둥을 사용했다. 또한 경상도 사대부가와 서울 양반가의 건축 양식이 적절히 혼재하고 있다. 대표적 예로 펼친 부채 모양의 선자서까래를 들 수 있다. 바깥사랑채의 나비 문양으로 깎은 계자각(누마루나 대청 난간의 짧은 기둥)은 또 어떠한가. 이처럼 수수한 경상도 방식과는 달리 서울식 한옥 양식의 보가 화려한 자태를 뽐낸다. 변하지 않은 것이 있다면 중용을 지켜 음양의 어우러짐을 잘 구현한 것이다. 900평 넘는 규모의 집에 비해 대문과 기단 높이는 굉장히 겸손하다. 웅장하지만 결코 위압되지 않는다. 집이 사람을 넘보지 않고, 사람이 집을 누리는 곳이다. 누마루에 기대어 너그러운 풍류의 정취에 빠져 있다 보면 스스로 덕이 쌓이는 착각마저 든다. 율수의 도道는 현판 안에 머물러 있지 않았다.

**산청 율수원**
경상남도 산청군 신등면 신등가회로 36 | 055-974-0221 | www.yulsuwon.com

# 한옥의 매력을 발견하는 즐거움,
# 행복작당과 지우헌

한옥 구경 잘 마치셨나요? 한옥은 공간 자체가 하나의 거대한 공예품이라고 해도 과언이 아닙니다. 목구조를 바탕으로 정성스럽게 한 땀 한 땀 손으로 완성한 집은 별다른 장식 없이도 조형적 아름다움이 가득하고 구석구석 디테일을 들여다보는 묘미가 있지요. 나무로 지은 집은 아이부터 노인까지 건강하게 머무는 친환경 주거의 대표 주자이자, 용도에 따라 합치고 분리하며 유연하게 변하는 형식은 지금 이 시대에 꼭 필요한 '레이어드 홈'의 좋은 사례입니다. 그래서일까요. 최근 한옥은 세련된 안목을 지닌 이들이 선호하는 트렌디한 주거 형태로, 브랜드 철학과 가치를 보여 주는 쇼룸, 갤러리, 카페 등 상업 공간으로도 주목받고 있습니다.

1987년 창간 후 수많은 한옥을 취재하며 K-하우스의 탁월한 가치를 전해온 《행복이 가득한 집》이 한옥의 속살을 들여다볼 수 있는 오픈 하우스 프로그램 '행복작당'을 기획한 이유가 바로 여기에 있습니다. 《더 한옥》과 《행복이 가득한 집》에서 소개한 한옥을 직접 방문해 눈 호사 한껏 하는 시간! 평소 담벼락만 보았던 북촌 한옥의 대문이 활짝 열리고, 라이프스타일 브랜드와 작가, 스타일리스트가 협업한 높은 수준의 감각적인 전시를 통해 '열린 한옥'이 지닌 무한한 가능성도 살펴볼 수 있습니다. '행복을 짓는 집' 행복작당作堂. 안채와 사랑채, 소담한 마당의 운치를 즐기며 잠시나마 한옥살이를 꿈꿔 보시는 건 어떨까요.

**《행복이 가득한 집》 편집장 이지현**

2022년에 오픈한 지우헌은 디자인하우스에서 운영하는 한옥 갤러리로 북촌 한옥 마을에 있습니다. 초반에는 국내를 대표하는 가구 명장과 회화 작가의 전시를 개최했으나 활동의 폭을 더 넓히고자 캐스퍼 강, 백현진, 김태윤, 박종진, 정관, 조경재, 윤석원과 같은 젊은 현대 미술 작가뿐 아니라 김혜주, 박현성, 헬렌 코흐Helene Koch 등 신진 작가도 기용하고 있습니다.

'지우헌'이라는 이름은 신영복 선생님께서 지어 주셨습니다. '어리석음을 깨닫는 집'이라는 뜻으로 사유의 전환이 활발하게 일어나는 전시 공간의 특징을 잘 담아내고 있습니다. 또 지우헌은 구석구석 전문가들의 손길이 닿지 않은 곳이 없습니다. 연꽃잎과 연밥을 모티브로 한 전시 공간 천장부터 조경, 흙 표면에 월석을 박은 담벼락, 구름 문양을 더한 합각 박공지붕, 처마에 나풀거리는 풍경까지 곳곳의 고풍스러운 포인트들은 관객들뿐 아니라 작가들의 마음까지 사로잡곤 합니다.

지우헌에 방문한 작가들이 모두 전시를 수락한 데서 전시 공간을 중요하게 생각하고 있음을 짐작해 볼 수 있습니다. 화이트 큐브 형태의 전형적인 갤러리에서만 전시하던 작품이 한옥에 놓인 순간 달리 보이는 경험을 하면서 작업적으로 환기할 수 있었다는 작가들의 후일담도 많이 듣습니다. 그런 점에서 지우헌은 현대 미술 갤러리로서 최적의 환경을 갖춘 셈입니다.

북촌은 현재 국내외 관광객들로 매일 북적이고 있습니다. 그러나 대부분 개인의 거주 공간이므로 한옥의 겉모습만 볼 수 있을 뿐이지요. 하지만 지우헌은 그 속까지도 내보이는 동시에 작품을 전시하고, 하동 전통 차와 문화 서적을 즐길 수 있는 북카페 라운지도 갖추고 있으니 이색적인 체험을 하기에 제격인 공간이라 생각합니다.

갤러리 지우헌 큐레이터 김아름

**행복작당**
2016년부터 시작해 매년 가을 종로구 한옥마을 일대에서 열리는 한옥 오픈 하우스 행사. 라이프스타일 브랜드와 작가들의 협업 전시, 취미 클래스, 인문학 강의, 골목 탐방 등 다양한 이벤트가 함께 마련된다.

**갤러리 지우헌**
서울시 종로구 북촌로11라길 13 | 02-765-7964 | instagram.com/jiwooheon_dh

# 글쓴이 · 찍은 이

# 더 한옥

1판 1쇄 발행 2023년 10월 30일
1판 2쇄 발행 2023년 12월 15일

**지은이** 행복이 가득한 집 편집부
**펴낸이** 이영혜
**펴낸곳** ㈜디자인하우스

**책임편집** 김선영
**디자인** 말리북
**교정교열** 이진아
**홍보마케팅** 윤지호
**영업** 문상식, 소은주
**제작** 정현석, 민나영
**미디어사업부문장** 김은령

**출판등록** 1977년 8월 19일 제2-208호
**주소** 서울시 중구 동호로 272
**대표전화** 02-2275-6151
**영업부직통** 02-2263-6900
**인스타그램** instagram.com/dh_book
**홈페이지** designhouse.co.kr

ⓒ 행복이 가득한 집
ISBN 978-89-7041-782-0 03540

디자인하우스는 독자 여러분의 소중한 아이디어와 원고 투고를 기다리고 있습니다.
원고가 있는 분은 dhbooks@design.co.kr로 기획 의도와 개요, 연락처 등을 보내 주세요.